List 22. 32

EGYPT **Museum With No Frontiers International Exhibition Cycle**

ISLAMIC ART IN THE MEDITERRANEAN

MAMLUK ART
THE SPLENDOUR AND MAGIC OF THE SULTANS

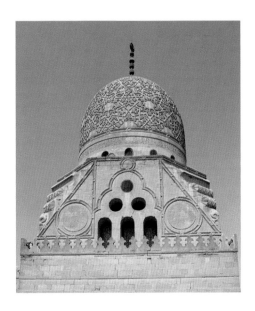

MUSEUM WITH NO FRONTIERS

EUROPEAN UNION
MEDA Programme
Euromed Heritage

Ministry of Culture
Arab Republic of Egypt

Foreign Cultural Relations
Department

Supreme Council of Antiquities

![MINISTERIO DE EDUCACIÓN, CULTURA Y DEPORTE — DIRECCIÓN GENERAL DE BELLAS ARTES Y BIENES CULTURALES]

The realisation of the Museum With No Frontiers Exhibition "MAMLUK ART: The Splendour and Magic of the Sultans" has been co-financed by the European Union within the framework of the MEDA-Euromed Heritage Programme
and received the support of the following Egyptian and international institutions:

Foreign Cultural Relations Department
Ministry of Culture, Arab Republic of Egypt

Supreme Council of Antiquities,
Ministry of Culture, Arab Republic of Egypt

Spanish Ministry of Education, Culture and Sports which has financed the scientific co-ordination of the international cycles "Islamic Art in the Mediterranean" and has contributed in the scientific process of different exhibitions, in collaboration with:

Federal Ministry of Foreign Affairs, Austria
Ministry of Cultural and Environmental Heritage (National Museum for Oriental Arts, Rome), Italy
Secretary of State for Tourism, Portugal
Museum of Mediterranean and Near-Eastern Antiquities, Stockholm, Sweden

ISBN: 1-874044-37-6
ISBN: 977-270-667-9 (Egypt)

Information:
www.mwnf.org

Egyptian Secretariat
Supreme Council of Antiquities
Department of Coptic and Islamic Monuments
4D Fakhry Abdel Nour Street
Al-Abbasiyya - Cairo
Tel: + 202 683 94 93 - 683 80 84
Fax: + 202 683 11 17

International Secretariat
Museum With No Frontiers
Barquillo, 15B-4°G
28004 Madrid
Spain
Tel: + 34 91 5312824
Fax: + 34 91 5235775
E-mail: msf.madrid@teleline.es

Idea and overall concept of Museum With No Frontiers Programme
Eva Schubert

Head of Project
Enaam Selim
Under-Secretary of State for Foreign Cultural Relations
Ministry of Culture, Arab Republic of Egypt

Co-ordinator of the Scientific Committee
Abdullah Abdel Hamid El-Attar
Under-Secretary of State for Coptic and Islamic Monuments
Supreme Council of Antiquities
Ministry of Culture, Arab Republic of Egypt

Scientific Committee
Gaballah Ali Gaballah, Cairo
Abdullah Abdel Hamid El-Attar, Cairo
Enaam Selim, Cairo
Mohamed Hossam El-Din, Cairo
Salah El-Bahnasi, Cairo
Mohamed Abd El-Aziz, Cairo
Atef Abdel Hamid Ghoneim, Cairo
Medhat El-Manabbawi, Cairo
Ali Ateya, Cairo
Tarek Torky, Cairo
Gamal Gad El-Rab, Cairo

Catalogue
Introductions
Salah El-Bahnasi, Cairo
Mohamed Hossam El-Din, Cairo
Mohamed Abd El-Aziz El-Sayed, Cairo
Tarek Torky, Cairo

Presentation of Itineraries
Scientific Committee

Technical texts
Tarek Torky, Cairo

Technical supervision
Sakina Missoum, Madrid

Photography
Sherif Sonbol, Cairo

General map
José Antonio Dávila Buitrón, Madrid

Sketches
Mohammed Rushdy, Cairo
Sergio Viguera, Madrid

Monument plans
Mohammed Rushdy, Cairo
Şakir Çakmak, Izmir
Ertan Daş, Izmir
Yekta Demiralp, Izmir
Sergio Viguera, Madrid

General Introduction "Islamic Art in the Mediterranean"

Text
Jamila Binous, Tunisia
Mahmoud Hawari, East Jerusalem
Manuela Marín, Madrid
Gönül Öney, Izmir

Maps
Şakir Çakmak, Izmir
Ertan Daş, Izmir
Yekta Demiralp, Izmir

Translation
Sarah Walker, Madrid

Copy editor
Mandi Gomez, London

Layout and design
Agustina Fernández, Madrid

Production
Electa (Grijalbo Mondadori, S. A.), Madrid

Technical co-ordination

Production Manager
Tarek Torky, Cairo

Production Assistant
Amal Mohammed Tawfik, Cairo

International Co-ordination
of the exhibition cycle "Islamic Art in the Mediterranean"

General co-ordination
Eva Schubert, Vienna-Madrid-Rome

Scientific committees, translations, editing and catalogue production
Sakina Missoum, Madrid

Administrative proceedings and documentation
Silvia Victoria Ronza, Rome

Acknowledgements

We thank the following institutions and authorities for their support, without which this project would not have been possible:

Ministry of Culture, Arab Republic of Egypt, Cairo
Supreme Council of Antiquities, Ministry of Culture, Cairo
Foreign Cultural Relations Department, Ministry of Culture, Cairo
Archaeological Sites in Egypt, Supreme Council of Antiquities
Centre for Documentation of Coptic and Islamic Monuments, Supreme Council of Antiquities, Cairo
Museum of Islamic Art, Cairo
Governorate of Cairo
Governorate of Alexandria
Governorate of Kafr al-Shaykh
Governorate of al-Beheira
Tourism Promotion Authority, Cairo

Museum With No Frontiers would also like to thank:

The Spanish Ministry of Foreign Affairs for its support throughout the project via the Spanish Agency for International Co-operation (AECI) and the Spanish Embassies in the participating Mediterranean countries,

as well as:

the Regional Government of Tyrol (Austria), where the Museum With No Frontiers pilot project was first set up, for its financial support in the training of Production Managers in charge of the technical co-ordination of exhibitions in participating countries in the "Islamic Art in the Mediterranean" exhibition cycle,

and Doctor Christian Régnier, Attaché to Parisian Hospitals, International Society for the History of Medicine.

Photographic references

See page 5, and
Ann & Peter Jousiffe (London), page 20 (Aleppo)
Archivos Oronoz Fotógrafos (Madrid), page 23 (Alhambra, Granada)

Plan references
R. Ettinghaussen and O. Grabar (Madrid, I, 1997), page 26 (Mosque of Damascus)
Z. Sönmez (Ankara, 1995), page 27 (Mosque of Divri_i and Istanbul) and page 28 (Mosque of Sivas)
Sergio Viguera (Madrid), page 28 (Minaret styles)
Blair, S. S., and Bloom, J. M. (Madrid, II, 1999), page 29 (Mosque and Madrasa Sultan Hassan).
R. Ettinghaussen and O. Grabar (Madrid, I, 1997), page 30 (Qasr al-Khayr al-Sharqi)
A. Kuran (Istanbul, 1986), page 31 (Khan Sultan Aksaray)

Preface

Great art exhibitions represent far reaching scientific and cultural events, which over the years have turned Art, in all its forms and manifestations, into an essential element in the creation of the image of a country. In this way, cultural events have come to be the privileged stage of important civic accomplishments and large companies invest in art in order to give their products a better position in the global market place.

The objective of the Museum With No Frontiers programme and of its exhibition cycle "Islamic Art in the Mediterranean" is to obtain the active participation of the Mediterranean countries in this process of political and economic enhancement of their cultural heritage.

This programme, based on a new exhibition format where the works of art remain in their places to be exhibited in their true context, combines research on specific topics with raising awareness about artistic heritage and aims to promote investment in the fields of restoration and preservation.

The Museum With No Frontiers Exhibitions are conceived around a special theme and for a particular geographic area (the exhibition "venue") and are organised along specific itineraries (exhibition "halls"). Each one deals with a particular aspect of the general theme. The visitor no longer moves within an enclosed space, but travels to find the artistic objects, monuments, archaeological sites, urban centres, landscapes and places that have been the theatre of transcendental historical events. The visitor follows an exhibition guide and a signposting system created by the Museum With No Frontiers to facilitate the identification of the works displayed.

The financial support of the European Union, within the framework of the MEDA-Euromed Heritage Programme (the regional programme for the enhancement of Euro-Mediterranean cultural heritage), has made the creation of the exhibition cycle "Islamic Art in the Mediterranean" possible along with the exhibitions carried out in Algeria, Palestine, Egypt, Jordan, Morocco, Tunisia and Turkey. Spain, Italy and Portugal have participated in the project providing their own financing. Other European Union Community finance allocated by the Community's policies covering tourism, heritage (RAPHAEL programme) and inter-regional co-operation (a pilot project involving co-operation by Spain, Portugal and Morocco) has enabled specific activities to be carried out at different stages of the project.

On behalf of the Museum With No Frontiers, I would like to express my sincerest gratitude to those who, personally or as representatives of numerous institutions, support our organisation and this project, and who have participated in the creation of this museum with no frontiers on Islamic Art in the Mediterranean.

Eva Schubert
President
Museum With No Frontiers

Advice

Transliteration of the Arabic

We have retained standard spelling for Arabic words in common use and included those in the English dictionary. We have maintained the phonetic transcription of names and Arabic words in accordance with Egyptian standards. For all other words, we have simplified the transcription. We do not transcribe the initial *hamza* nor do we distinguish between long and short vowels, which have been transcribed as *a, i, u*. The *ta' marbuta* has been transcribed as *a* (in its absolute), and as *at* (when followed by a genitive). The transcription for the 28 Arabic consonants is as follows:

ء	'	ح	h	ز	z	ط	t	ق	q	ه	h
ب	b	خ	kh	س	s	ظ	z	ك	k	و	u/w
ت	t	د	d	ش	sh	ع	'	ل	l	ي	y/i
ث	th	ذ	dh	ص	s	غ	gh	م	m		
ج	j/g/gu	ر	r	ض	d	ف	f	ن	n		

Words in italic in the text without an accompanying translation or explanation can be found in the glossary.

The Muslim Era

The Muslim era began with the exodus of the Prophet Muhammad from Mecca to Yathrib. Then the name was changed to *Madina*, "The City" or "the town of the Prophet". With his small community of followers (70 people including members of his family) recently converted to Islam, the Prophet undertook the *al-hijra* (literally "the emigration") and the new era began.

The date of the emigration is the first of the month of *Muharram* in year 1 of the *Hijra*, which corresponds to the 16th July of the year 622 of the Christian era. The Muslim year is made up of twelve lunar months, each month having 29 or 30 days. Thirty years form a cycle in which the 2nd, 5th, 7th, 10th, 13th, 16th, 18th, 21st, 24th, 26th and 29th are leap years having 355 days; the others are normal years with 354 days. The Muslim lunar year is 10 or 11 days shorter than the Christian solar year. Each day begins immediately after sunset, i.e. at dusk rather than after midnight. Most Muslim countries use both the *Hijra* Calendar (which marks all the religious events) and the Christian Calendar.

Dates

Dates are given according to the *Hijra* calendar followed by their equivalent date in the Christian calendar after an oblique stroke. The *Hijra* date is not indicated in references derived from Christian sources, European historical events or those that have occurred in Europe, Christian dynasties, or dates proceeding the Muslim era or subsequent to the English occupation of Egypt that began in 1882.
Exact correspondence between years in one calendar and another is only possible when the day and month are given. To facilitate reading, we have chosen to avoid intermediate years and, in the case of *Hijra* dates falling between the beginning and end of a century, both centuries are mentioned.
Dates before the Christian era are denoted by the abbreviation BC.

Abbreviations
AD = Anno Domini, BC = before Christ b. = born, d. = died, r. = reigned.

Practical Advice

The exhibition "Mamluk Art: The Splendour and Magic of the Sultans" includes Cairo, and the northern cities of Alexandria, Rosetta and Fuwa in Lower Egypt. The exhibition comprises eight itineraries, seven of which are one-day itineraries with Itinerary II being a two-day itinerary.

The use of a main road and street maps of cities is advisable. It is also recommended that each itinerary be followed in the suggested order so as to explore a route planned along a natural succession of themes and monuments.

An outline sketch of the route to help visualise and plan the whole journey accompanies each itinerary. Each stage of each itinerary (in Arabic and Roman numerals, respectively) is accompanied by technical indications in italics on how to reach the city and its monuments, opening times, (as at the time of publishing), etc. The catalogues include the main monuments along with optional site visits, "windows" complementary informative texts (see title on yellow background) and panoramic views chosen for their particular relevance to the sites (see italics on grey background).

The best time of year to visit Egypt is in either autumn or winter due to the warm and sunny climate. It may however rain in Cairo at this time of year, with a much higher risk of rain in Alexandria, Rosetta and Fuwa. In the summer, Alexandria (Itinerary VI) is the favourite retreat for Cairenes and can be fairly crowded.

In Cairo monuments may be reached by car though walking is highly recommended due to the fact that the narrow streets of Old Cairo are filled with pedestrians and passers-by. Construction dates for monuments in Cairo come from the *Register of Historic Monuments of Cairo*, collated by the Supreme Council of Antiquities, Department of Coptic and Islamic Monuments, Ministry of Culture, Arab Republic of Egypt and the Council of Ministers, Centre for Information and Resolution Adoption Support, Programme for Culture and Heritage, First Edition, 2000.

The Supreme Council of Antiquities is currently carrying out the Programme for the Restoration and Reconditioning of Islamic Monuments in Cairo, which is being carried out in various stages. Visitors may find that restoration work is in progress or has already finished on monuments where the catalogue states otherwise due to information available at the time of publishing. We hope that the visitor will bear this in mind in the event of any inconvenience.

The mosques, *madrasas* and *khanqas* are religious buildings in which prayers are held five times a day: at dawn, *al-fagr*; at midday, *al-duhr* (winter 12.00 and summer 13.00); during mid-afternoon, *al-'asr* (winter 15.30, summer 16.30); at sunset, *al-maghrab*; and at night, *al-'asha'*. The best times for visiting are before midday prayers and between midday prayer (*al-duhr*) and mid-afternoon prayer (*al-'asr*). It is important to bear in mind that the majority of Islamic monuments are located in the old part of town. As such, and due to the conservative nature of Cairene residents, appropriate and respectful behaviour is recommended as well as suitable clothing according to local standards. Shoes must be left at the entrance of mosques' *madrasas* as may be pointed out by the guards at each establishment. Entry fees to monuments should be paid in local currency.

The offices of the Supreme Council of Antiquities, museums and visitor reception centres serve as information points. The archaeological museums are open daily but their opening times vary between summer and winter. For information on cultural events during your stay, please contact the Ministry of Culture at 44 Mesaha Street, Dokki. + 20 2 748 56 03 and + 20 2 748 58 42

Museum With No Frontiers is not responsible for variations in opening times or for any inconvenience or injury caused during visits.

Tarek Torky
Production Manager

INDEX

ISLAMIC DYNASTIES IN THE MEDITERRANEAN

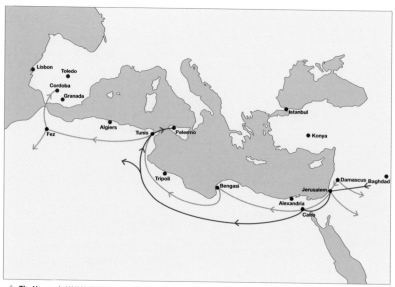

The Umayyads (41/661-132/750) Capital: Damascus
The Abbasids (132/750-656/1258) Capital: Baghdad

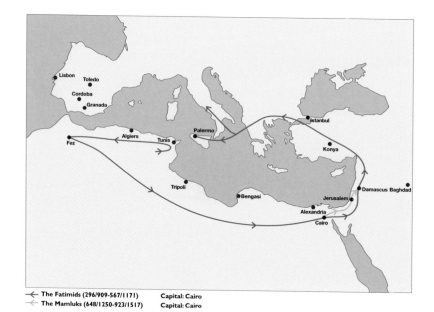

The Fatimids (296/909-567/1171) Capital: Cairo
The Mamluks (648/1250-923/1517) Capital: Cairo

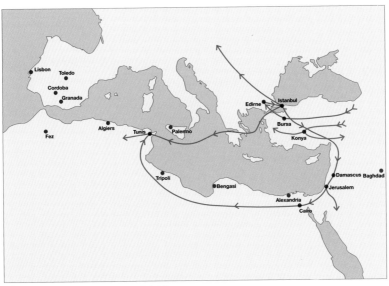

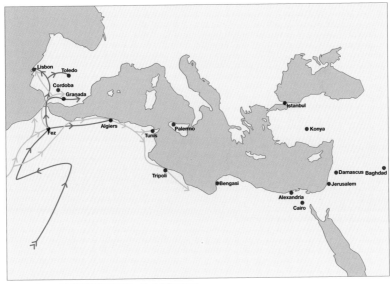

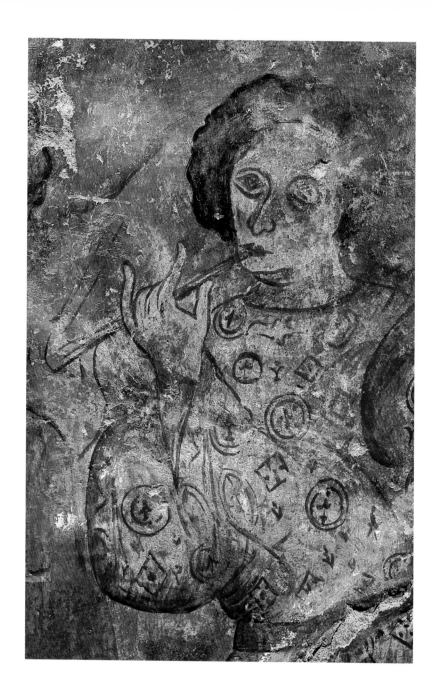

*Qusayr 'Amra, mural in
the Audience Hall, Badiya
of Jordan.*

ISLAMIC ART IN THE MEDITERRANEAN

Jamila Binous
Mahmoud Hawari
Manuela Marín
Gönül Öney

The Legacy of Islam in the Mediterranean

Since the first half of the $1^{st}/7^{th}$ century, the history of the Mediterranean Basin has belonged, in remarkably similar proportion, to two cultures, Islam and the Christian West. This extensive history of conflict and contact has created a mythology that is widely diffused in the collective imagination, a mythology based on the image of the other as the unyielding enemy, strange and alien, and as such, incomprehensible. It is of course true that battles punctuated those centuries from the time when the Muslims spilled forth from the Arabian Peninsula and took possession of the Fertile Crescent, Egypt, and later, North Africa, Sicily, and the Iberian Peninsula, penetrating into Western Europe as far as the south of France. At the beginning of the $2^{nd}/8^{th}$ century, the Mediterranean came under Islamic control.

This drive to expand, of an intensity seldom equalled in human history, was carried out in the name of a religion that considered itself then heir to its two immediate antecedents: Judaism and Christianity. It would be a gross over-simplification to explain the Islamic expansion exclusively in religious terms. One widespread image in the West presents Islam as a religion of simple dogmas adapted to the needs of the common people, spread by vulgar warriors who poured out from the desert bearing the *Qur'an* on the blades of their swords. This coarse image does away with the intellectual complexity of a religious message that transformed the world from the moment of its inception. It identifies this message with a military threat, and thus justifies a response on the same terms. Finally, it reduces an entire culture to only one of its elements, religion, and in doing so, deprives it of the potential for evolution and change.

The Mediterranean countries that were progressively incorporated into the Muslim world began their journeys from very different starting points. Forms of Islamic life that began to develop in each were quite logically different within the unity that resulted from their shared adhesion to the new religious dogma. It is precisely the capacity to assimilate elements of previous cultures (Hellenistic, Roman, etc.), which has been one of the defining characteristics of Islamic societies. If one restricts one's observations to the geographical area of the Mediterranean, which was extremely diverse culturally at the time of the emergence of Islam, one will discern quickly that this initial moment does not represent a break with previous history in the least. One comes to realise

that it is impossible to imagine a monolithic and immutable Islamic world, blindly following an inalterable religious message.

If anything can be singled out as the *leitmotiv* running through the area of the Mediterranean, it is diversity of expression combined with harmony of sentiment, a sentiment more cultural than religious. In the Iberian Peninsula – to begin with the western perimeter of the Mediterranean – the presence of Islam, initially brought about by military conquest, produced a society clearly differentiated from, but in permanent contact with Christian society. The importance of the cultural expression of this Islamic society was felt even after it ceased to exist as such, and gave rise to perhaps one of the most original components of Spanish culture, Mudejar art. Portugal maintained strong Mozarab traditions throughout the Islamic period and there are many imprints from this time that are still clearly visible today. In Morocco and Tunisia, the legacy of al-Andalus was assimilated into the local forms and continues to be evident to this day. The western Mediterranean produced original forms of expression that reflected its conflicting and plural historical evolution.

Lodged between East and West, the Mediterranean Sea is endowed with terrestrial enclaves, such as Sicily, that represent centuries-old key historical locations. Conquered by the Arabs established in Tunisia, Sicily has continued to perpetuate the cultural and historical memory of Islam long after the Muslims ceased to have any political presence on the island. The presence of Sicilian-Norman aesthetic forms preserved in architectural monuments clearly demonstrates that the history of these regions cannot be explained without an understanding of the diversity of social, economic and cultural experiences that flourished on their soil.

In sharp contrast, then, to the immutable and constant image alluded to at the outset, the history of Mediterranean Islam is characterised by surprising diversity. It is made up of a mixture of peoples and ethnicities, deserts and fertile lands. As the major religion has been Islam since the early Middle Ages, it is also true that religious minorities have maintained a presence historically. The Classical Arabic language of the *Qur'an,* has coexisted side-by-side with other languages, as well as with other dialects of Arabic. Within a setting of undeniable unity (Muslim religion, Arabic language and culture), each society has evolved and responded to the challenges of history in its own characteristic manner.

The Emergence and Development of Islamic Art

Throughout these countries, with ancient and diverse civilisations, a new art permeated with images from the Islamic faith emerged at the end of the $2^{nd}/8^{th}$ century, which successfully imposed itself in a period of less than 100 years. This art, in its own particular manner, gave rise to creations and innovations based on unifying regional formulas and architectural and decorative processes, and was simultaneously inspired by the artistic traditions that proceeded it: Greco-Roman and Byzantine, Sasanian, Visigothic, Berber or even Central Asian.

The initial aim of Islamic art was to serve the needs of religion and various aspects of socio-economic life. New buildings appeared for religious purposes such as mosques and sanctuaries. For this reason, architecture played a central role in Islamic art because a whole series of other arts are dependent on it. Apart from architecture a whole range of complimentary minor arts found their artistic expressions in a variety of materials, such as wood, pottery, metal, glass, textiles and paper. In pottery, a great variety of glaze techniques were employed and among these distinguished groups are the lustre and polychrome painted wares. Glass of great beauty was manufactured, reaching excellence with the type adorned with gold and bright enamel colours. In metal work, the most sophisticated technique is inlaying bronze with silver or copper. High-quality textiles and carpets, with geometric, animal and human designs, were made. Illuminated manuscripts with miniature paintings represent a spectacular achievement in the arts of the book. These types of minor arts serve to attest the brilliance of Islamic art.

Figurative art, however, is excluded from the Islamic liturgical domain, which means it is ostracised from the central core of Islamic civilisation and that it is tolerated only at its periphery. Relief work is rare in the decoration of monuments and sculptures are almost flat. This deficit is compensated with a richness in ornamentation on the lavish carved plaster panelling, sculpted wooden panelling, wall tiling and glazed mosaics, as well as on the stalactite friezes, or *muqarnas*. Decorative elements taken from nature, such as leaves, flowers and branches, are generally stylised to the extreme and are so complicated that they rarely call to mind their sources of origin. The intertwining and combining of geometric motifs such as rhombus and etiolated polygons, form interlacing networks that completely cover the surface, resulting in shapes often called arabesques. One innovation within the decorative repertoire is the introduction of epigraphic elements

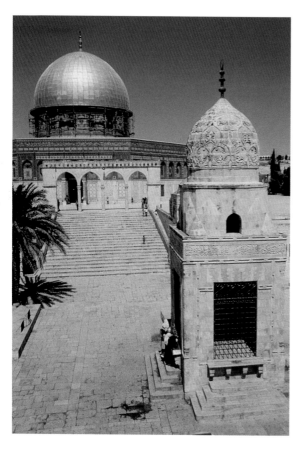

Dome of the Rock, Jerusalem.

in the ornamentation of monuments, furniture and various other objects. Muslim craftsmen made use of the beauty of Arabic calligraphy, the language of the sacred book, the *Qur'an*, not only for the transcription of the Qur'anic verses, but in all of its variations simply as a decorative motif for the ornamentation of stucco panelling and the edges of panels.

Art was also at the service of rulers. It was for patrons that architects built palaces, mosques, schools, hospitals, bathhouses, *caravanserais* and mausoleums, which would sometimes bear their names. Islamic art is, above all, dynastic art. Each one contributed tendencies that would bring about a partial or complete renewal of artistic forms, depending on historical conditions, the prosperity enjoyed by their states, and the traditions of each people. Islamic art, in spite of its relative unity, allowed for a diversity that gave rise to different styles, each one identified with a dynasty.

The Umayyad Dynasty (41/661-132/750), which transferred the capital of the caliphate to Damascus, represents a singular achievement in the history of Islam. It absorbed and incorporated the Hellenistic and Byzantine legacy in such a way that the classical tradition of the Mediterranean was recast in a new and innovative mould. Islamic art, thus, was formed in Syria, and the architecture, unmistakably Islamic due to the personality of the founders, would continue to bear a relation to Hellenistic and Byzantine art as well. The most important of these monuments are the Dome of the Rock in Jerusalem, the earliest existing monumental Islamic sanctuary, the Great Mosque of Damascus, which served as a model for later mosques, and the desert palaces of Syria, Jordan and Palestine.

When the Abbasid caliphate (132/ 750-656/1258) succeeded the Umayyads, the political centre of Islam was moved from the Mediterranean to Baghdad in Mesopotamia. This factor would influence the development of Islamic civilisation and the entire range of culture, and art would bear the mark of that change. Abbasid art and architecture were influenced by three major traditions: Sassanian, Central Asian and Seljuq. Central Asian influence was already present in Sassanian architecture, but at Samarra this influence is represented by the stucco style with its arabesque ornamentation that would rapidly spread throughout the Islamic world. The influence of Abbasid monuments can be observed in the buildings constructed during this period in the other regions of the empire, particularly Egypt and Ifriqiya. In Cairo, the Mosque of Ibn Tulun (262/876-265/879) is a masterpiece, remarkable for its plan and unity of conception. It was modelled after the Abbasid Great Mosque of Samarra, particularly its spiral minaret. In Kairouan, the capital of Ifriqiya, vassals of the Abbasid caliphs, the Aghlabids (184/800-296/909) expanded the Great Mosque of Kairouan, one of the most venerable congregational mosques in the Maghrib. Its *mihrab* was covered by ceramic tiles from Mesopotamia.

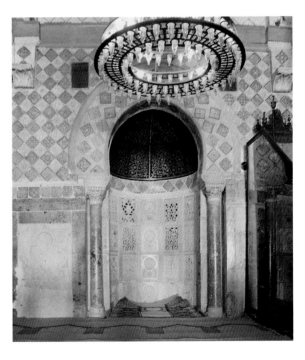

Kairouan Mosque, mihrab, Tunisia.

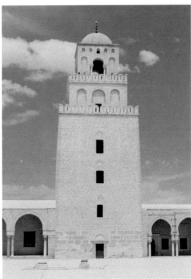

Kairouan Mosque, minaret, Tunisia.

Citadel of Aleppo, view
of the entrance, Syria.

Complex of Qaluwun,
Cairo, Egypt.

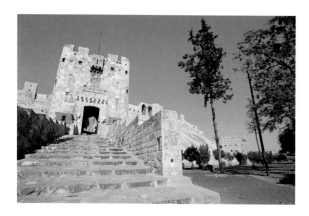

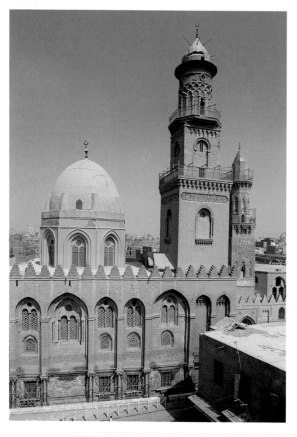

The reign of the Fatimids (297/909-567/1171) represents a remarkable period in the history of the Islamic countries of the Mediterranean: North Africa, Sicily, Egypt and Syria. Of their architectural constructions, a few examples remain that bear witness to their past glory. In the central Maghrib the Qal'a of the Bani Hammad and the Mosque of Mahdiya; in Sicily, the Cuba (*Qubba*) and the Zisa (*al-'Aziza*) in Palermo, constructed by Fatimid craftsmen under the Norman King William II; in Cairo, the Azhar Mosque is the most prominent example of Fatimid architecture in Egypt.

The Ayyubids (567/1171-648/1250), who overthrew the Fatimid Dynasty in Cairo, were important patrons of architecture. They established religious institutions (*madrasas, khanqas*) for the propagation of *Sunni* Islam, mausoleums and welfare projects, as well as awesome fortifications pertaining to the military conflict with the Crusaders. The Citadel of Aleppo in Syria is a remarkable example of their military architecture.

The Mamluks (648/1250-923/1517) successors of the Ayyubids, successfully resisted the Crusades and the Mongols, achieved the unity of Syria and Egypt and created a formidable empire. The wealth and luxury of the Mamluk Sultan's court in Cairo motivated artists and architects to achieve an extraordinarily elegant style of

architecture. For the world of Islam, the Mamluk period marked a rebirth and renaissance. The enthusiasm for establishing religious foundations and reconstructing existing ones place the Mamluks among the greatest patrons of art and architecture in the history of Islam. The Mosque of Hassan (757/1356), a funerary mosque built with a cruciform plan in which the four arms of the cross were formed by four *iwans* of the building around a central courtyard, was typical of the era.

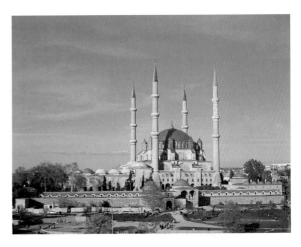

Selimiye Mosque, general view, Edirne, Turkey.

Anatolia was the birthplace of two great Islamic dynasties: the Seljuqs (571/1075-718/1318), who introduced Islam to the region; and the Ottomans (699/1299-1340/1922), who brought about the end of the Byzantine Empire upon capturing Constantinople, and asserted their hegemony throughout the region.

A distinctive style of Seljuq art and architecture flourished with influences from Central Asia, Iran, Mesopotamia and Syria, which merged with elements deriving from Anatolian Christian and antiquity heritage. Konya, the new capital in Central Anatolia, as well as other cities, were enriched with buildings in the newly developed Seljuq style. Numerous mosques, *madrasas*, *turbes* and *caravanserais*, which were richly decorated by stucco and tiling with diverse figural representations, have survived to our day.

Tile of Kubadabad Palace, Karatay Museum, Konya, Turkey.

As the Seljuq Emirates disintegrated and Byzantium declined, the Ottomans expanded their territory swiftly changing their capital from Iznik to Bursa and then again to Edirne. The conquest of Constantinople in 858/1453 by Sultan Mehmet II provided the necessary impetus for the transition of an emerging state into a great empire. A superpower that extended its boundaries to Vienna including the Balkans in the West and to Iran in the East, as well

Great Mosque of Cordoba, mihrab, Spain.

Madinat al-Zahra', Dar al-Yund, Spain.

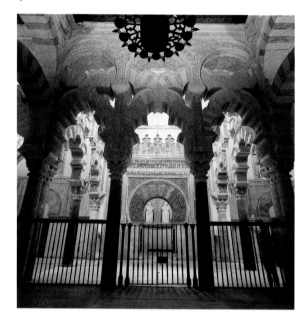

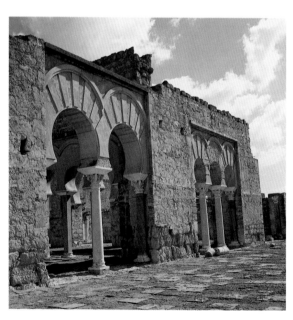

as North Africa from Egypt to Algeria, turning the Eastern Mediterranean into an Ottoman sea. The race to surpass the grandeur of the inherited Byzantine churches, exemplified by the Hagia Sophia, culminated in the construction of great mosques in Istanbul. The most significant one is the Mosque of Süleymaniye, built in the 10th/16th century by the famous Ottoman architect Sinan, it epitomises the climax in architectural harmony in domed buildings. Most major Ottoman mosques were part of a large building complex called *kulliye* that also consisted several *madrasas*, a *Qur'an* school, a library, a hospital (*darussifa*), a hostel (*tabhane*), a public kitchen, a *caravanserai* and mausoleums (*turbes*). From the beginning of the 12th/18th century, during the so-called Tulip Period, Ottoman architecture and decorative style reflected the influence of French Baroque and Rococo, heralding the Westernisation period in arts and architecture.

Al-Andalus at the western part of the Islamic world became the cradle of a brilliant artistic and cultural expression. 'Abd al-Rahman I established an independent Umayyad caliphate (138/750-422/1031) with Cordoba as its capital. The Great Mosque of Cordoba would pioneer innovative artistic tendencies such as the double-tiered arches with two alternating

colours and panels with vegetal orna-
mentation which would become part
of the repertoire of al-Andalus artistic
forms.

In the 5th/11th century, the caliphate
of Cordoba broke up into a score of
principalities incapable of preventing
the progressive advance of the recon-
quest initiated by the Christian states
of the Northwestern Iberian Peninsula.
These petty kings, or Taifa Kings, sum-
moned the Almoravids in 479/1086
and the Almohads in 540/1145 in or-

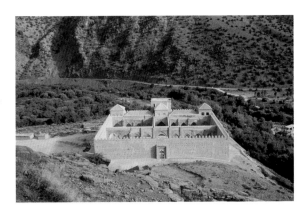

*Tinmal Mosque, aerial
view, Morocco.*

der to repel the Christians and re-established partial unity in al-Andalus.
Through their intervention in the Iberian Peninsula, the Almoravids (427/1036-
541/1147) came into contact with a new civilisations and were captivated
quickly by the refinement of al-Andalus art as reflected in their capital,
Marrakesh, where they built a grand mosque and palaces. The influence of the
architecture of Cordoba and other capitals such as Seville would be felt in all
of the Almoravid monuments from Tlemcen, Algiers to Fez.

Under the rule of the Almohads (515/1121-667/1269), who expanded their
hegemony as far as Tunisia, Western Islamic art reached its climax. During
this period, artistic creativity that originated with the Almoravid rulers was
renewed and masterpieces of Islamic art were created. The Great Mosque of

*Ladies Tower and
Gardens, Alhambra,
Granada, Spain.*

Seville with its minaret the Giralda,
the Kutubiya in Marrakesh, the
Mosque of Hassan in Rabat and the
Mosque of Tinmal high in the Atlas
Mountains in Morocco are notable
examples.

Upon the dissolution of the Almohad
Empire, the Nasrid Dynasty
(629/1232-897/1492) installed it-
self in Granada and was to experi-
ence a period of splendour in the
8th/14th century. The civilisation of
Granada would become a cultural

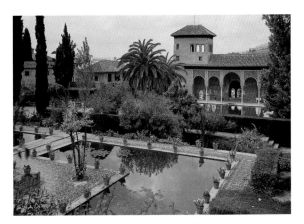

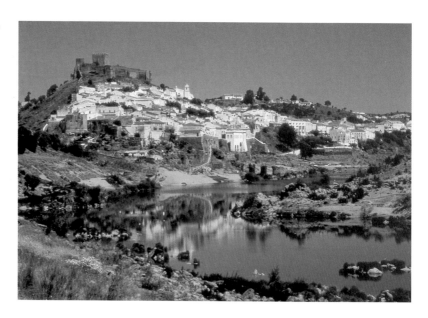

Mertola, general view, Portugal.

model in future centuries in Spain (Mudejar Art) and particularly in Morocco, where this artistic tradition enjoyed great popularity and would be preserved until the present day in the areas of architecture and decoration, music and cuisine. The famous palace and fort of *al-Hamra'* (the Alhambra) in Granada marks the crowning achievement of al-Andalus art, with all features of its artistic repertoire.

Decoration detail, Abu Inan Madrasa, Meknes, Morocco.

At the same time in Morocco, the Merinids (641/1243-876/1471) replaced the Almohads, while in Algeria the 'Abd al-Wadid's reigned (633/1235-922/1516), as did the Hafsids (625/1228-941/1534) in Tunisia. The Merinids perpetuated al-Andalus art, enriching it with new features. They embellished their capital Fez with an abundance of mosques, palaces and *madrasas*, with their clay mosaic and *zellij* panelling in the wall decorations, considered

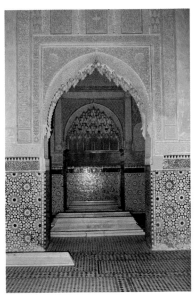

Qal'a of the Bani Hammad, minaret, Algeria.

Sa'adian Tomb Marrakesh, Morocco.

to be the most perfect works of Islamic art. The later Moroccan dynasties, the Sa'adians (933/1527-1070/1659) and the 'Alawite (1077/1659 – until the present day), carried on the artistic tradition of al-Andalus that was exiled from its native soil in 897/1492. They continued to build and decorate their monuments using the same formulas and the same decorative themes as had the preceding dynasties, adding innovative touches characteristic of their creative genius. In the early 11th/17th century, emigrants from al-Andalus (the *Moriscos*), who took up residence in the northern cities of Morocco, introduced numerous features of al-Andalus art. Today, Morocco is one of the few countries that has kept traditions of al-Andalus alive in its architecture and furniture, at the same time modernising them as they incorporated the architectural techniques and styles of the 15th/20th century.

ARCHITECTURAL SUMMARY

In general terms, Islamic architecture can be classified into two categories: religious, such as mosques, *madrasas*, mausoleums, and secular, such as palaces, *caravanserais*, fortifications, etc.

Religious Architecture

Mosques

The mosque for obvious reasons lies at the very heart of Islamic architecture. It is an apt symbol of the faith that it serves. That symbolic role was understood by Muslims at a very early stage, and played an important part in the creation of suitable visual markers for the building: minaret, dome, *mihrab*, *minbar*, etc.

The first mosque in Islam was the courtyard of the Prophet's house in Medina, with no architectural refinements. Early mosques built by the Muslims as their empire was expanding were simple. From these buildings developed the congregational or Friday mosque (*jami*'), essential features of which remain today unchanged for nearly 1400 years. The general plan consists of a large courtyard surrounded by arched porticoes, with more aisles or arcades on the side facing Mecca (*qibla*) than the other sides. The Great Umayyad Mosque in Damascus, which followed the plan of the Prophet's Mosque, became the prototype for many mosques built in various parts of the Islamic world.

Umayyad Mosque of Damascus, Syria.

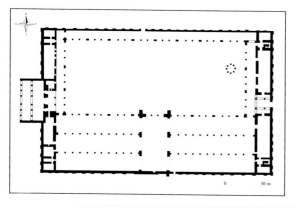

Two other types of mosques developed in Anatolia and afterwards in the Ottoman domains: the basilical and the dome types. The first type is a simple pillared hall or basilica that follows late Roman and Byzantine Syrian traditions, introduced with some modifications in the 5th/11th century. The second type, which developed during the Ottoman period, has its organisation of interior space under a single dome. The Ottoman

architects in great imperial mosques created a new style of domed construction by merging the Islamic mosque tradition with that of dome building in Anatolia. The main dome rests on a hexagonal support system, while lateral bays are covered by smaller domes. This emphasis on an interior space dominated by a single dome became the starting point of a style that was to be introduced in the 10th/16th century. During this period, mosques became multipurpose social com-

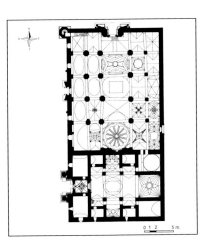

Great Mosque, Divriği, Turkey.

plexes consisting of a *zawiya*, a *madrasa*, a public kitchen, a bath, a *caravanserai* and a mausoleum of the founder. The supreme monument of this style is the Sülaymeniye Mosque in Istanbul built in 965/1557 by the great architect Sinan.

The minaret from the top of which the *muezzin* calls Muslims to prayer, is the most prominent marker of the mosque. In Syria the traditional minaret consists of a square-plan tower built of stone. In Mamluk Egypt minarets are each divided into three distinct zones: a square section at the bottom, an octagonal middle section and a circular section with a small dome on the top. Its shaft is

richly decorated and the transition between each section is covered with a band of *muqarnas* decoration. Minarets in North Africa and Spain, that share the square-tower form with Syria, are decorated with panels of motifs around paired sets of windows. During the Ottoman period the octagonal or cylindrical minarets replaced the square tower. Often these are tall pointed minarets and although mosques generally have only one minaret, in major cities there are two, four or even six minarets.

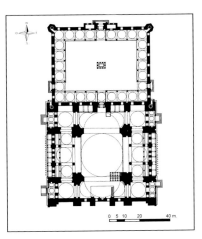

Sülaymeniye Mosque, Istanbul, Turkey.

27

Typology of minarets.

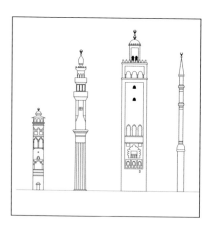

Madrasas

It seems likely that the Seljuqs built the first *madrasas* in Persia in the early 5th/11th century when they were small structures with a domed courtyard and two lateral *iwans*. A later type developed that has an open courtyard with a central *iwan* and which is surrounded by arcades. During the 6th/12th century in Anatolia, the *madrasa* became multifunctional and was intended to serve as a medical school, mental hospital, a hospice with a public kitchen (*imaret*) and a mausoleum. The promotion of *Sunni* (Orthodox) Islam reached a new zenith in Syria and Egypt under the Zengids and the Ayyubids (6th/12th–early 7th/13th centuries). This era witnessed the introduction of the *madrasa* established by a civic or political leader for the advancement of Islamic jurisprudence. The foundation was funded by an endowment in perpetuity (*waqf*), usually the revenues of land or property in the form of an orchard, shops in a market (*suq*), or a bathhouse (*hammam*). The *madrasa* traditionally followed a cruciform plan with a central court surrounded by four *iwans*. Soon the *madrasa* became a dominant architectural form with mosques adopting a four-*iwan* plan. The *madrasa* gradually lost its sole religious and political function as a propaganda tool and tended to have a broader civic function, serving as a congregational mosque and a mausoleum for the benefactor.

The construction of *madrasas* in Egypt, and particularly in Cairo, gathered new momentum with the arrival of the Mamluks. The typical

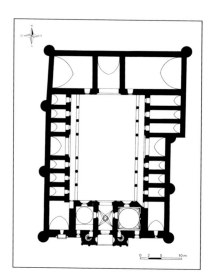

Sivas Gök Madrasa, Turkey.

Cairene *madrasa* of this era was a multifunctional gigantic four-*iwan* structure with a stalactite (*muqarnas*) portal and splendid façades. With the advent of the Ottomans in the 10th/16th century, the joint foundation, typically a mosque-*madrasa*, became a widespread, large complex that enjoyed imperial patronage. The *iwan* disappeared gradually and was replaced by a dominant dome chamber. A substantial increase in the number of domed cells used by students is a characteristic of Ottoman *madrasas*.

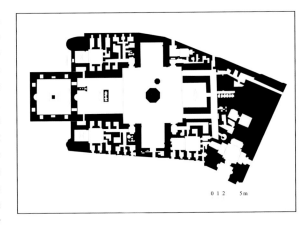

Mosque and Madrasa Sultan Hassan, Cairo, Egypt.

One of the various building types that by virtue of their function and of their form can be related to the *madrasa* is the *khanqa*. The term indicates an institution, rather than a particular kind of building, that houses members of a Muslim mystical (*sufi*) order. Several other words used by Muslim historians as synonyms for *khanqa* include: in the Maghrib, *zawiya*; in Ottoman domain, *tekke*; and in general, *ribat*. Sufism permanently dominated the *khanqa*, which originated in eastern Persia during the 4th/10th century. In its simplest form the *khanqa* was a house where a group of pupils gathered around a master (*shaykh*), and it had the facilities for assembly, prayer and communal living. The establishment of *khanqas* flourished under the Seljuqs during the 5th/11th and the 6th/12th centuries and benefited from the close association between *Sufism* and the *Shafiʿi madhhab* (doctrine) favoured by the ruling elite.

Mausoleums

The terminology of the building type of the mausoleum used in Islamic sources is varied. The standard descriptive term *turbe* refers to the function of the building as for burial. Another term is *qubba* that refers to the most identifiable, the dome, and often marks a structure commemorating Biblical prophets, companions of the Prophet Muhammad and religious or military notables. The function of mausoleums is not limited simply to a place of burial

29

*Qasr al-Khayr
al-Sharqi, Syria.*

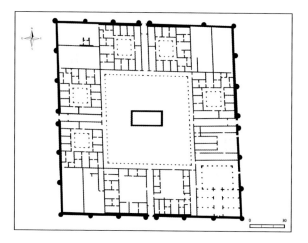

and commemoration, but also plays an important role in "popular" religion. They are venerated as tombs of local saints and became places of pilgrimage. Often the structure of a mausoleum is embellished with Qur'anic quotations and contains a *mihrab* within it to render it a place of prayer. In some cases the mausoleum became part of a joint foundation. Forms of medieval Islamic mausoleums are varied, but the traditional one has a domed square plan.

Secular Architecture

Palaces

The Umayyad period is characterised by sumptuous palaces and bathhouses in remote desert regions. Their basic plan is largely derived from Roman military models. Although the decoration of these structures is eclectic, they constitute the best examples of the budding Islamic decorative style.

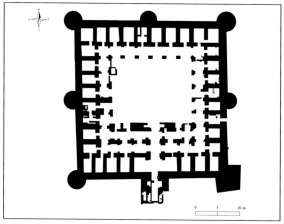

*Ribat of Sousse,
Tunisia.*

Mosaics, mural paintings, stone or stucco sculpture were used for a remarkable variety of decorations and themes. Abbasid palaces in Iraq, such as those at Samarra and Ukhaidir, follow the same plan as their Umayyad forerunners, but are marked by an increase in size, the use of the great *iwan*, dome and courtyard, and the extensive use of stucco decorations. Palaces in the later Islamic period developed a distinctive style that was more decorative and less monumental. The most remarkable example of royal or princely palaces is the Alhambra. The vast area of the palace is broken up into a series of separate units: gardens, pavilions

and courts. The most striking
feature of Alhambra, however, is
the decoration that provides an
extraordinary effect in the interior
of the building.

*Aksaray Sultan Khan,
Turkey.*

Caravanserais

A *caravanserai* generally refers to a
large structure that provides a lodg-
ing place for travellers and mer-
chants. Normally, it has a square or
rectangular floor plan, with a sin-
gle projecting monumental entrance
and towers in the exterior walls. A central courtyard is surrounded by por-
ticoes and rooms for lodging travellers, storing merchandise and for the
stabling of animals.

The characteristic type of building has a wide range of functions since it has
been described as *khan, han, funduq, ribat*. These terms may imply no more
than differences in regional vocabularies rather than being distinctive func-
tions or types. The architectural sources of the various types of *caravanserais*
are difficult to identify. Some are perhaps derived from the Roman *castrum*
or military camp to which the Umayyad desert palaces are related. Other types,
in Mesopotamia and Persia, are associated with domestic architecture.

Urban Organisation

From about the 3rd/10th century every town of any significance acquired fortified
walls and towers, elaborate gates and a mighty citadel (*qal'a* or *qasba*) as the seat
of power. These are massive constructions built in materials characteristic of
the region in which they are found; stone in Syria, Palestine and Egypt, or
brick, stone and rammed earth in the Iberian Peninsula and North Africa. A
unique example of military architecture is the *ribat*. Technically, this is a fortified
palace designated for the temporary or permanent warriors of Islam who
committed themselves to the defence of frontiers. The *ribat* of Sousse in Tunisia

bears a resemblance to early Islamic palaces, but with a different interior arrangement of large halls, mosque and a minaret.

The division of the majority of Islamic cities into neighbourhoods is based on ethnic and religious affinity and it is also a system of urban organisation that facilitates the administration of the population. In the neighbourhood there is always a mosque. A bathhouse, a fountain, an oven and a group of stores are located either within or nearby. Its structure is formed by a network of streets, alleys and a collection of houses. Depending on the region and era, the home takes on diverse features governed by the historical and cultural traditions, climate and construction materials available.

The market (*suq*), which functions as the nerve-centre for local businesses, would be the most relevant characteristic of Islamic cities. Its distance from the mosque determines the spatial organisation of the markets by specialised guilds. For instance, the professions considered clean and honourable (bookmakers, perfume makers, tailors) are located in the mosque's immediate environs, and the noisy and foul-smelling crafts (blacksmiths, tanning, cloth dying) are situated progressively further from it. This geographic distribution responds to imperatives that rank on strictly technical grounds.

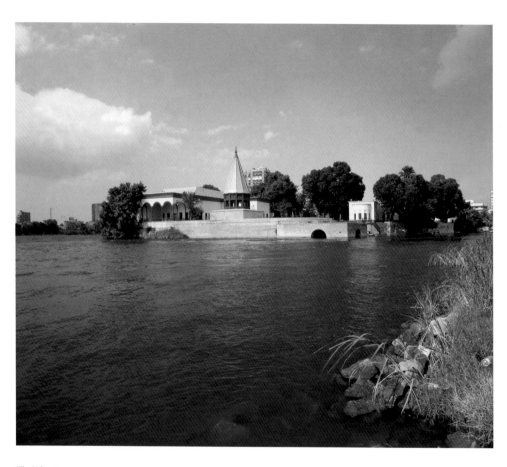

*The Nilometer on
Roda Island, view from
the south, Cairo.*

INTRODUCTION: THE HISTORICAL BACKGROUND

Salah El-Bahnasi, Mohamed Hossam El-Din, Mohamed Abd El-Aziz

The classical historian Herodotus described Egypt as "the gift of The Nile", for without the irrigation provided by the waters of Africa's greatest river, Egypt would have no agriculture. The Nile has its source in Lake Victoria, and on flowing northwards, through the low swamplands of southern Sudan, takes the name of the White Nile (*al-Bahr al-Abyad*) until it empties into the Mediterranean Sea. On reaching Cairo, the river forms the Nile Delta, the most populous and representative of her regions. As such, the Delta has always been closely associated with the countries of the Mediterranean, and Egypt, in turn, has maintained unbroken contact with her neighbours.

Since the unification of Egypt under the Pharaoh Menes in 3200 BC, the State of Egypt and its civilisations among the most ancient in the world, have successfully maintained their national and historical identity. With her unification came the first of the three great eras of the pharaohs: the Old Kingdom, time of the building of the pyramids of Giza; the Middle Kingdom, famous for agricultural growth, dams and other great engineering works; and the New Kingdom, which has left us the spectacular monuments of Luxor and Abu Simbel.

With her conquest by Alexander the Great, founder of Alexandria (AD 332), a new phase in Egypt's history began. Alexander's successor, Ptolemy I, son of Lagos, brought together the civilisations of Greece and Egypt in the Ptolemaic State he founded, transforming the city of Alexandria and opening its famous Library and Alexandrian Museum, principal seat of Greek learning. One of the dynasty's most famous sons, Ptolemy II, commissioned the building of the Lighthouse of Alexandria. Under the Ptolemies, Alexandria became the hub of artistic and literary life of the East and one of the greatest focal points for Hellenistic civilisation.

Egypt went on to become a province of the Roman Empire with her conquest by Rome in AD 30. The second century saw the spread of Christianity in Egypt, and the persecution its followers suffered would lead to the creation of Egypt's monasteries and her monastic tradition. With the official recognition of Christianity by the Roman emperor Constantine I in the fourth century came the beginning of the Byzantine era.

Egypt has long been considered the cradle of divine revelation. Home to patriarchs and prophets, such as Abraham, Joseph, Enoch and Job, Egypt was the site of the revelation of the Ten Commandments to Moses on Mount Sinai. Egypt has special significance for Christians and Muslims; Christ spent part of his childhood there following the Holy Family's flight from persecution at the hands of King Herod (the cave where the Family took refuge can be found in the church of Saint Sergius in Old Cairo), and the prophet Mohammad married Maria the Copt, from Upper Egypt.

Following her conquest by 'Amr Ibn al-'As in 20/640, Egypt ceased to be part of the Eastern Empire and would find her identity within the greater Islamic State. With the exception of the times in which she achieved independence, such as under the Tulunids (254/868-323/934) and the Ikhshidids (323/934-358/969), Egypt was to remain a dependent province of the Caliphates of Medina, Damascus and Baghdad. Later, in the time of the Fatimid dynasty (358/969-565/1169) Egypt would herself become the seat of the Caliphate. It was in this period that Egypt's sealed her identity as a fully independent

state, bringing territories as far as Syria, *al-Hijaz* and Yemen under her rule. In the Ayyubid era (565/1169-48/1250) the Sultan al-Malik al-Salih began the acquisition of young Turkish slaves destined to form the elite personal guard of the sultans. These were the soldier-slaves (*mamalik*, in its singular form, *mamluk*, meaning that which is owned), who would bring down the Ayyubid dynasty. During the reign of Mamluk sultans (648/1250-922/1517), Egypt was to become a great power. With frontiers extending as far as the outer reaches of the Ottoman Empire, she would even invade and impose vassalage on the Island of Cyprus. Weakened by the collapse of her economy, she would prove an easy conquest for the Ottomans (922/1517-1213/1798). The brief Napoleonic occupation of 1798-1801 would open Egypt to the influences of western culture, which would, in turn, stimulate her political and spiritual renaissance. Once again under Ottoman domination (1216/1801-1299/1882), Egypt was to enjoy a degree of independence under the rule of Muhammad Ali (1220/1805-1265/1849), the founder of modern Egypt.

M. A. A.

Islamic Egypt

"He who has not seen Cairo, has not seen the magnitude of Islam, for she is the capital of the world, the garden of the universe, the assembly of nations, the beginning of the Earth, the origin of Man, the *iwan* of Islam and the seat of Kingship." This description by the Arab historian, Ibn Khaldun (732/1332-808/1406) encapsulates Egypt's pivotal role as the axis around which great historical events would unfold.

As Ibn Khaldun's description demonstrates, the Arabs were just as aware of Egypt's political and economic importance as a centre for international trade as other nations had been before them. Indeed this fact was to prove the spur for general 'Amr Ibn al-'As to secure the authorisation of the Caliph 'Umar Ibn al-Khattab for an Egyptian campaign. In the year 18/639, 'Amr's forces, en route from Palestine, advanced on Egypt, taking al-'Arish, al-Farama' (near Port Said) and Bilbays, later subjecting the Fort of Babylon to the south of Cairo to a protracted six-month siege. It ended when Cyrus, the Melkite patriarch and governor of Egypt agreed to negotiate with the Muslims, who swept, victorious, into the fort.

With the fall of the city of Alexandria, formerly the capital, 'Amr Ibn al-'As went on to found the city of Fustat in the year 21/641. This was to be the first Islamic capital of Africa and would remain so until the founding of al-'Askar by the Abbasids. The new capital was built on the site of the Roman fort of Babylon. Lying between Upper and Lower Egypt and on the Red Sea Route, its strategic geographic position made it a much better location than Alexandria. It is interesting to note the degree of internal support 'Amr's campaign enjoyed. Not only did his army encounter no resistance from a people who had already suffered the tyranny of the Byzantines and the Persians, but also his Muslim forces even enjoyed active support in the form of help solicited by the Patriarch Benjamin I (622-661) from his compatriots for the campaign. As the historian Thomas Arnold points out, the Islamic conquest

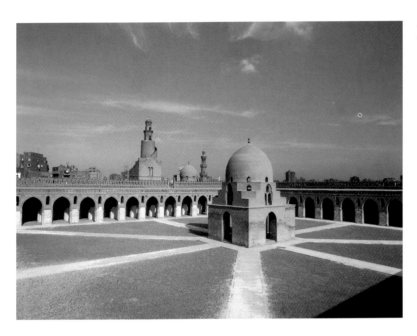

Mosque of Ibn Tulun, court, Cairo.

of Egypt brought its people a degree of religious freedom that they had not enjoyed for more than a century. Whilst conversions to Islam were initially slow, the reduction of taxes for new converts encouraged the Egyptians to abandon their religion and traditions and soon a large number embraced Islam.

Defining herself as part of the broader Islamic State, Egypt was to remain a dependent province of the Caliphates in Medina and the Umayyads and Abbasids (with their seats in Damascus and Baghdad respectively), until Ahmad Ibn Tulun proclaimed the independence of Egypt and founded the Tulunid State. His reign (254/868-270/884) was, on balance, a period of peace and prosperity.

To secure his authority, Ibn Tulun recruited a new army, composed predominantly of Greeks and black slaves, and in 256/870 founded a new city to the north of the Old City of Fustat, al-Qata'i'. Equipped with its congregational mosque, which survives to this day under the name of the Mosque of Ibn Tulun, and a government palace, al-Qata'i' became the capital of the Tulunid State. Having firmly established himself in power, Ibn Tulun freed the Abbasid Caliphs from responsibility for the regime's defence, a move that served to further consolidate its legitimacy and prestige. While the regime depended on the Abbasids to recognise both its constitutional legitimacy and its authority to operate on the frontiers of Egypt, (defined by the natural boundaries of the Taurus Mountains and the Euphrates, in addition to Aleppo, Antioch and all of northern Syria), the Tulunid State enjoyed political and financial independence. Although in 323/934

37

The newly founded city of Cairo was built on a square area of sides 1,200 m. in length lying either side of a main north-south axis. For the first time, it quickly took on the appearance of a fortified city; to the west, an adobe wall ran the length of the al-Khalig, which served as canal and moat, and the city had eight gates, two on each flank. There were two mosques; the al-Hakim Mosque to the north and the Mosque of al-Azhar to the south, living quarters, the residences of the princes and the ruling class and all the necessary religious and civil institutions. Some of these buildings can still be seen today and testify to the advanced state of development of the architecture and decorative arts of the era.

Among the most notable Fatimid monuments which can still be seen today are the congregational Mosque of al-Azhar, the Mosque of al-Hakim bi-Amr Allah, the tombs of al-Sab'a Banat, the sanctuary of al-Juyushi, the Mosque of al-Aqmar, the sanctuary of al-Sayyida Ruqayya and the Mosque of Salih Tala'i' Ibn Ruzayq. Nor should we forget the many Fatimid works of art, the fruit of enthusiastic collecting by European pilgrims to Jerusalem, which are scattered throughout the museums of the world. The frescos can still be seen on the ceiling of the Palatine Chapel of Roger II in Palermo, Sicily (the latter also fell under Fatimid power). They show close parallels with those in the Fatimid baths in the area of Abu al-Su'ud (Fustat), now on display in the Museum of Islamic Art in Cairo, demonstrating just how far the Fatimids exerted their artistic influence on the island.

Al-Mu'izz's ambitions for universal sovereignty were soon to come up against the international political realities of the day.

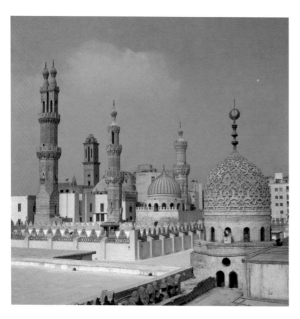

Mosque of al-Azhar, minarets and domes, Cairo.

Muhammad Ibn Taghg would proclaim the independence of the State, thereby founding the Ikhshidid dynasty, the political ambitions of this new leader were confined to governing Palestine and Damascus and maintaining good relations with northern Syrian rulers.

In the year 358/969, after various failed campaigns and the eventual invasion and conquest of the country by Gawhar al-Siqilli (the Sicilian), general of the Caliph al-Mu'izz li-Din Allah, Egypt became the seat of the Fatimid Caliphate. Immediately upon securing the victory and by order of the Caliph, Gawhar al-Siqilli founded the capital of the Fatimids, *al-Qahira* (Cairo) "the victorious". With this name, al-Mu'izz sought to set the city's unique status and splendour against that of the capitals of Islamic Egypt which had preceded it (Fustat, al-'Askar and al-Qata'i').

Fatimid power proved too weak either to bring about the fall of the Abbasid Caliphate of Baghdad, or to maintain its hold on North Africa and Sicily. The signs of weakness the State revealed only served to feed the ambitions of its enemies; the governors of Tyre and Tripoli proclaimed their independence and the Seljuqs broke Fatimid hold in Syria. The governor of the Maghrib withdrew his loyalty to the Fatimids, transferring his allegiance to the Abbasids. Nor were Christian forces slow to react to the situation; the Norman King, Roger II invaded Sicily, overthrowing Fatimid rule in 484/1091 and the Byzantine Empire felt the situation sufficiently opportune to pact with the Crusaders. This accord would lead to the first Crusade against Egypt and Syria in 490/1097. As a result the Crusaders would capture most of the cities of Palestine, the ports and cities of southern Syria, reaching as far as the city of Tanis to the south of Lake Manzala (Egypt). Henceforth, Egypt and Syria were to constitute the battlefield of the Islamic forces and the Fatimid State would decline, its downfall sealed when the Islamic emirates of Syria became Christian kingdoms.

In the midst of this disarray emerged the Ayyubid dynasty in Egypt. It was found-ed by the general Salah al-Din al-Ayyubi (Saladin), he who had rallied his armies under the banner of the anti-Crusader cause. His forces succeeded in defeating the Crusaders in numerous battles, and achieved an overwhelming victory at Hattin (Palestine) in the year 583/1187, routing the largest Crusader army of the time. He then went on to take Jerusalem after 90 years in Crusader hands. Salah al-Din's campaign was, nevertheless, primarily defensive in nature; Arnold the Crusader had violated the treaties which he had underwritten, constantly attacking the Muslim trade caravans constituting a threat to the two holy sites of Mecca and Medina. There were to be repeated battles between Muslims and Crusaders, with territories constantly changing hands, until al-Malik al-Salih Najm al-Din Ayyub achieved what the Ayyubids had long been striving for, recovering Jerusalem in the Battle of Gaza. Such was the magnitude of the Muslim victory, that historians have described this battle as "the second Hattin". In the same way al-Malik al-Salih was to meet the seventh Crusade, only to die before the end of the battle, as did Amir Fakhr al-Din, general of the Ayyubid army. Baybars I al-Bunduqdari then assumed command of

Palatine Chapel of Roger II, detail of ceiling frescoes, Palermo.

39

the army and inflicted a crushing defeat upon the Crusaders in al-Mansura (Egypt), in a battle that has been described as "the graveyard of the Crusaders" as a result of the Arab victory. Immediately upon his arrival from Syria, al-Malik al-Salih's son, Turan Shah, took the throne. The entire Crusader army lay dead or had been taken captive in Faraskur; its king, Louis IX of France (Saint Louis) had been captured and imprisoned in the house of Ibn Luqman, in al-Mansura. Turan Shah's determination to pursue the war against the Crusades was cut short by his assassination in 648/1250, the year which marked the end of the Ayyubid State. Although it had lasted no more than 80 years, Ayyubid rule stands out as one of the most brilliant periods in the history of Islamic Egypt.

It was during this period that conditions were to coalesce that would bring about the establishment of the Mamluk State. The division and the weakness of the Ayyubid dynasty following the death of Salah al-Din and the increasing pressure exerted by the Crusaders over their possessions in Syria convinced the Ayyubids of the need to form a powerful army to counter the attacks to which they were being subjected. In creating this force they bought a large number of slaves, who were not only to exert a quite unexpected influence on the course of later events, but would even be the direct cause of the overthrow of al-Malik al-'Adil, the last Ayyubid ruler. Based on Roda Island to the south of Cairo, these slaves were to seize the reins of power, ruling Egypt and achieving spectacular victories against the Mongols and Crusaders.

S. B. and M. H. D.

The Mamluks: From Slaves to Sultans

As their name indicates, the Mamluks were slaves that had been purchased, received as gifts or taken as prisoners of war; a practice that had existed since early times in Islamic society. Initially forming the personal guard of the Abbasid Caliphs, Mamluk numbers grew through Muslim conquests and trade. Their ranks included Turks, Sicilians and Greeks, in addition to blacks from East Africa who had settled in the south of Iraq or Egypt such as the Ikhshidids.

In the aftermath of the political anarchy that followed the death of the Sultan al-Nasir Salih al-Din al-Ayyubi, the Mamluks became increasingly involved in military operations at the request of Ayyubid rulers engaged in power struggles amongst themselves in Egypt and Syria. Mamluk numbers grew as a result, as did the influence they exerted on the political life of the period within Egyptian and Syrian power circles.

The Sultan al-Malik al-Salih Najm al-Din Ayyub (637/1240-647/1249) is credited as instrumental in bringing about the growth of Mamluk power. Records show that he acquired a greater number of slaves than his predecessors and installed them in his barracks on Roda Island, on the Nile (*al-bahr*, the sea). The majority of these Mamluks, known as *Bahris*, were Turkish peoples from the south of Russia and such was the influence they wielded that they were to take power after the events which followed the death of Najm al-Din Ayyub.

Throughout the reign of the Mamluk sultans (648/1250-922/1517) successive rulers depended upon the military power of their slaves, a fact which led to ever

greater increases in their numbers. Mam-
luks were purchased on behalf of the gov-
ernment by a senior civil servant, the
trader of Mamluks (*taguir al-mamalik*).

In view of the military and political
importance granted to the Mamluks, new
slaves acquired by the sultan were subject
to a medical examination and once pro-
nounced fit for service, were distributed
among the garrisons of the Citadel of
Cairo (Itinerary I), according to their
respective origins. They were educated in
the school of the Mamluks at the Citadel
where they were taught by *al-faqih*
charged with imparting the principles of
Islam and the rudiments of Arabic. They
received further training in the corps of
pages, where they learned such skills as
riding, mace-bearing, serving their mas-
ters at table as cup-bearers (*saqi*) and
carvers, serving at polo matches, and
were finally selected on an individual basis
for the service of the *amirs* or sultan. The
Mamluks of this second dynastic line were
predominantly Circassian from the Cau-
casus. Their training in the towers or *burg*
of the city led to their becoming known
as *Burguis* (784/1382-922/1517).

Upon reaching adulthood and finishing his
training, the Mamluk went on to swell the
ranks of the cavalry. He received a feudal
title to cultivable land on Sultan's Great
Procession (Itinerary II), at the end of
which he received the title of knight and
swore an oath of allegiance to his lord.
Since the Mamluks assumed responsibili-
ty both for the defence of the territory
against external aggression and the throne
of the sultan against internal intrigues,
only those who achieved this rank were
empowered to govern in Egypt and Syria.
It was for this reason that the highest
posts were reserved for administration
and the army. The latter comprised the

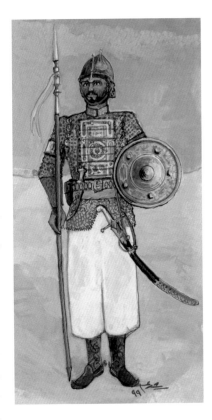

*Mamluk Soldier
(painting by
Mohammed Rushdy).*

sultan's personal guard, its troops
(recruited and paid in cash or in the form
of produce given under feudal title), and
the guard of the great *amirs* and of earlier
sultans.

S. B. and M. H. D.

The *Bahri* Mamluks
(648/1250-783/1381)

The *Bahri* Mamluk State came into being
when Shajar al-Durr, widow of al-Malik
al-Salih Najm al-Din Ayyub was pro-

41

Lion sculpted in marble, Arms of Sultan Baybars I al-Bunduqdari, Museum of Islamic Art (reg. no. 3796), Cairo.

claimed the successor to her husband and sultana of the territories. Such was the indignation which this move provoked in the Abbasid Caliph that she was compelled to contract marriage with the Mamluk Amir al-Mu'izz 'Izz al-Din Aybak, abdicating in his favour in the lunar month of *Rabi' II* of 648/July 1250 after a reign of only 80 days. Aybak was the founder of the dynasty and his later moves to strengthen his position in the government by contracting marriage with the daughter of the governor of Mosul, led to his fall from favour with Shajar al-Durr. It was she who conspired to have him brutally murdered in the royal baths; a fate which she too later met.

The *Bahri* rulers were chosen by the Mamluks from among the descendants of the sultan. Baybars I al-Bunduqdari was succeeded by two of his sons, who in turn were succeeded by Qalawun, his sons, grandsons and great-grandsons. When a sultan died one of his sons remained in charge of the affairs of state until stability was restored and the strongest of the *amirs* assumed the sultanate. This occurred in the case of the son of Sultan Aybak, and was to be repeated with the

sons of the Sultan Baybars I. As the sons of sultans, they were freeborn Muslims, and were excluded from the Mamluk army. As a result, they could not inherit the political rank of their fathers. It was only after the sons of Qalawun assumed power that the principle of hereditary succession was applied. They ruled until the end of the *Bahri* Mamluk State in 783/1381.

Sayf al-Din Qutuz made use of the threat posed to the territory by Crusaders and Mongols to depose Aybak's son and seize power. These events led to the creation of the Mamluk State, whose sultans were to assume responsibility for liberating the Arab nation from the Crusaders. In 656/1258 Iraq was invaded, Baghdad seized by the Mongols and the Abbasid Caliph assassinated, an event which would have grave consequences for the Islamic world. Egypt was ready to meet Mongol aggression; in 658/1260 her army, commanded by Sayf al-Din Qutuz inflicted a crushing defeat on the Mongols at 'Ayn Jalut, near Nazareth in Palestine. This would be the first defeat suffered by the Mongols since the days of Genghis Khan. It is thanks to Qutuz's victory over the Mongols that the Islamic world and Europe were spared invasion. With the exception of the principality of al-Karak, the whole of Syria fell within the sovereignty of the sultanate, whose prestige grew considerably both within and beyond its borders. Sadly, Qutuz was not to enjoy the fruits of his victory; he was conspired against and on his return from 'Ayn Jalut assassinated by his friend Baybars I al-Bunduqdari. Swiftly installed in the Citadel of Cairo, Baybars usurped the sultan's throne.

With Baybars installed in the Citadel on 15th *Dhu al-qa'da* 658/22th October 1260,

a new page in the history of Egypt began. Such was the scale of the governmental reforms and military campaigns he undertook that Baybars is considered the true founder of the Mamluk State. During his 17-year administration, he contained the Mongol and Crusader threat. At home, he put down insurrections, lowered taxes and ordered the renovation of the fleet. He commissioned the building of roads and repair of bridges, the strengthening of forts, which were to provide a base for the Mamluks, and the fortification of the north coast. He also ordered the dredging and cleaning of the Nile estuaries in Damietta and Rosetta. In addition to all this, Baybars, the future al-Malik al-Zahir, brokered treaties and maintained friendly relations with the rulers of neighbouring States, such as the Byzantine Emperor, the King of Sicily Frederick II and the successor of Barakat Khan, grandson of Genghis Khan. Among the monuments of this era still to be found in Cairo in the district of al-Zahir, is the mosque, which bears his name.

After Baybars, Qalawun is considered to have done most to establish the *Bahri* Mamluk State. He came to the throne in 678/1279 and the throne was to remain in the hands of his descendants for almost a century. The dynasty's successful handling of Mongol and Crusader aggression was to have significant consequences in diverse areas of the social and economic life of the State. The *Bahri* era is thus considered highly significant both to Egyptian history and civilisation as a whole and to the Mamluk era in particular. Sultan al-Ashraf Khalil (689/1290-693/1294) was able to complete the task started by his father, Qalawun in wresting Acre from the Crusaders in 690/1291, thereby bringing to an end the Christian presence

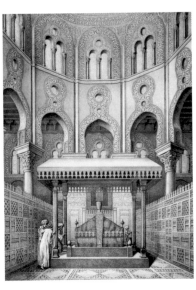

Interior of the Mausoleum of Sultan Qalawun, Cairo (Prisse d'Avennes, 1999, courtesy of the American University of Cairo).

in Syria. Al-Nasir Muhammad, the youngest son of Qalawun, also achieved an important victory over the Mongols in Syria, in the Battle of Shakhab, to the south of Damascus.

These victories had positive consequences both abroad and at home, where building work and the arts were stimulated. The buildings of the Qalawun family are still considered the culmination of this civilisation's artistic life. Among the most significant of these are the *qubba*, the *madrasa* and the hospital of Sultan Qalawun (Itinerary III), the Madrasa of al-Nasir Muhammad Ibn Qalawun and the buildings in the Citadel of Cairo, such as the al-Ablaq Palace and Mosque (Itinerary I). Among Al-Nasir Muhammad's greatest achievements was the restoration of the Lighthouse of Alexandria, destroyed by an earthquake in 702/1310 and the re-excavation, long after water had ceased to flow through it, of the Alexandrian Canal in 710/1310, there-

The Citadel, general view, Cairo.

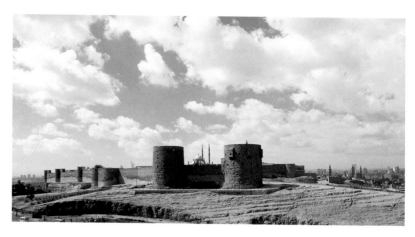

by improving communication with the interior and transforming the city of Fuwa (Itinerary VIII), which became a major centre for trade.

The Mamluk sultans were not the only ones to undertake major building projects; so too did *amirs* such as Salar al-Gawli, al-Tunbugha al-Maridani, Qusun al-Saqi, Bashtak, Shaykhu al-'Umari and Sarghatmish. The Egyptian people reaped the benefits of this commercial and political prosperity, as seen in the ostentatious displays of luxury and opulence commonplace in the Egyptian society of the time.

The factors to have the greatest bearing in the history of the *Bahri* Mamluk sultans can be summarised as the following; the restoration of the caliphate in Egypt by Baybars, the containment of the Mongol threat which had devastated Asia, and the subsequent re-establishment of trade routes. The latter would allow Egypt to recover her former splendour, as reflected in the building of numerous commercial establishments of the time.

S. B. and M. H. D.

The *Burgui* or Circassian Mamluks (784/1382-923/1517)

The second Mamluk State was in cultural, economic and administrative terms an extension of the first. In 784/1382 al-Zahir Sayf al-Din Barquq overthrew the last descendant of the Qalawun family, thereby establishing the *Burgui* or Circassian Mamluk State. The corps of bodyguards garrisoned in the towers (*burg*) of the Citadel of Cairo had been founded by Qalawun. Although the line of succession in the second Mamluk State was based on tutelage (most of Barquq's successors were his Mamluks or Mamluks of his Mamluks), Barquq however successfully installed his son as his direct successor. A second son also acceded to the throne, though retaining it for barely a year. With the exception of al-Nasir Muhammad, son of Qaytbay, who retained the throne for almost two years, no son of a sultan proclaimed heir to the throne would reign for more than a few months, and henceforth the Mamluks abandoned the principle of hereditary succession.

The second Mamluk State, like its predecessors, had to contend with Mongol aggression in the form of the Timurids. Barquq responded to their threats by having their emissaries murdered and preparing to engage the enemy. To win the support of his people he reduced taxes, reference to which can be found in inscriptions to the left of the entrance to the Mosque of al-Qina'i in the city of Fuwa (Itinerary VIII), where the abolition of certain levies is mentioned.

The reign of Barsbay, who assumed power in 825/1422, was a period of stability in which Egypt was to extend her sovereignty to much of the Mediterranean and even as far as the ports of Jedda and the Red Sea. In 830/1426 Barsbay' forces captured Cyprus and brought its king, Janus as prisoner to Cairo. In his determination to monopolise trade both at home and abroad, the sultan had the Alexandria Canal redug, thereby facilitating navigation and improving communications between cities. Although the sultan's desire to maintain personal control over all trade prejudiced the interests of his subjects, it provided him with ample resources with which to pay his Mamluks, forestall insurrections and defend the realm.

Sultan Jaqmaq, who took the throne in 842/1438, pursued Barsbay's policy of the harrying of pirates as a means of safeguarding trade in the Mediterranean. Although he failed to capture the Island of Rhodes, seat of the Knights Templar (the Order of Saint John of Jerusalem), he succeeded in brokering a truce and negotiating a treaty with them.

Sultan Inal (857/1453-865/1461) was to achieve great political victory in reaching a truce with the Ottoman Sultan Muhammad al-Fatih, despatching a delegation to congratulate him on the capture of Constantinople in 856/1452. Inal's successor, Khushqadam al-Ahmadi, was Greek, unlike the other sultans who were of Circassian origin, and his reign saw grave deterioration in Mamluk – Ottoman relations.

With the accession of Qaytbay to the throne in 872/1468, the sultanate was to recover the authority which political turbulence had undermined. A now stable economy allowed Egypt to enjoy a period of supremacy. The sultan's military triumphs made Egypt a force to be feared and monarchs throughout the world sought to enter into agreements with her. The widespread stability the country enjoyed found its creative expression in the architecture the sultan and his *amirs* have bequeathed to us. Among the most significant of these are the fortifications of the Egyptian coast, such as the Fort of Alexandria (Itinerary VI), The Rosetta Tower (Itinerary VII), in addition to numerous commercial establishments such as the *wikala* near Bab al-Nasr in Cairo (Itinerary II), and the one behind the Al-Azhar Mosque. He also commissioned mosques such as that of the Cemetery of the Mamluks in Cairo and founded charitable establishments such as the *sabil* and the *kuttab* of al-Saliba Street, also in Cairo (Itinerary IV), all this in addition to his works in Syria. The buildings of his

Madrasa and Mosque of Sultan Qaytbay, mausoleum dome, detail of Sultan's Arms sculpted on the dome drum, Cairo.

45

Madrasa of Sultan al-Ghuri, detail of the main door decoration with the Sultan's Arms, Cairo.

on Egypt. Having reached India, Portuguese ambitions turned towards the East, as did those of the Ottomans who also perceived their commercial interests to lie there. In 922/1516, the Mamluks were routed in the battle of Marj Dabiq and their position was irreparably weakened on the death of al-Ghuri by treason at the hands of Khayr Bek, governor of Aleppo. Tumanbay sought to follow in al-Ghuri's footsteps, only to be betrayed and captured by the Ottomans, who hanged him on Bab Zuwayla, one of the gates of the city of Cairo. His death marked the end of the Mamluk State in Egypt and Syria.

S. B. and M. H. D.

The Supremacy of the Mamluk State

28-year reign are renowned more for their elegance and harmony of style than for their dimensions.

Despite the period of instability following the death of Qaytbay, continuity was to return to Egypt upon the accession of the Sultan al-Ghuri in 906/1501. Al-Ghuri followed the course undertaken by his predecessor, fortifying coastal areas, restoring the Citadel of Qaytbay in Alexandria and the city walls of Rosetta. He undertook extensive building work and some of the most important structures of this period are the mosque, the *madrasa*, the *sabil*, the *khanqa,* the house and the *wikala* of al-Ghuri (Itinerary V) to be found in the district of Cairo bearing his name.

The discovery of the sea passage round the Cape of Good Hope was to have a profound political and economic impact

The Mamluk State of Egypt and Syria was one of the great Islamic powers of the Middle Ages. Its sultans dealt successfully with external threats to Islamic territories, pursuing and defeating those who posed the greatest danger, the Mongols and Crusaders. The first task of the sultans had been to consolidate the empire. Their most feared adversaries, the Mongols were defeated in 658/1260 at 'Ayn Jalut (Palestine) and the Crusaders crushed by Sultans Baybars, Qalawun and Khalil. The Ayyubids, who had managed to hold on to small sovereign territories, were eventually to contribute to the stability and legitimacy of the Mamluk throne. Following the assassination by the Mongols of the Abbasid Caliph of Baghdad, Baybars welcomed his heir to Cairo, re-establishing the Caliphate in 659/1261. The Caliph subsequently

appointed Baybars member of government (*qasim al-dawla*), eventually awarding him the powers of Caliph. In this way the Mamluk State was to become one of the major Islamic forces of the Middle Ages, with all that it implied for its relations with other Islamic States and the Christian world. These factors all served to cement Egypt's foreign relations with other Islamic States, as did the removal of the seat of the Abbasid Caliphate to Egypt after the fall of Baghdad in 656/1258. Henceforth, rulers of Islamic States would look to Egypt for recognition of their legitimacy. Indeed, towards the end of Mamluk power, the Caliph would even render vassalage to the Sultan during the celebration of his accession. Thus, the Caliph was to lose all authority; divested of power, fortune and all influence, he was reduced to a shadow of a sovereign. He received occasional invitations to participate in the investitures of Hindu sovereigns such as the Sultan Muhammad Ibn Taghliq, Amir of the Kingdom of Hindustan, who requested such a delegation from the Abbasid Caliph in Egypt during the reign of al-Nasir Muhammad, son of Qalawun.

In her relations with Christian States, Egypt was also to play a dominant role. The fact that the Ethiopian church was subordinate to the church of Alexandria (founded by Saint Mark), and that its archbishops were Egyptian and appointed by the Egyptian Church, Ethiopia was obliged to cultivate good relations with Egypt. As Egypt lay on the pilgrim route used by Christians travelling from Ethiopia and Spain to Jerusalem, their rulers also saw the benefit of remaining on good terms with the Mamluks to whom they dispatched gifts and delegations to guarantee the safe passage of their subjects. King Jaime II "The Just" of Aragon, Spain (r. 1291-327) sent such presents to al-Nasir Muhammad Ibn Qalawun, requesting safe passage for pilgrims on their way to Jerusalem.

Political factors played an important role in the expansion of Egyptian foreign relations. Baybars I al-Bunduqdari, who assumed power in 568/1260, allied himself with the Seljuqs against the threat posed by the Ilkhanids of Persia, who at the same time were seeking to enter into alliance with the Mongols and Crusaders against the Mamluks. This move would affect the signing of a treaty between Baybars and the Mongol chief Barakat Khan. The Mamluk State would later consolidate its position in 678/1279 as a result of new treaties entered into by Sultan Qalawun (678/1279-689/1290) with the Byzantines, France, Castile, Sicily, the Republics of Genoa and Venice.

Later, in 693/1293, his son, al-Nasir Muhammad, would ally himself with the Byzantines both as protection against the Ottomans and to ensure their neutrality in his campaign against the Crusaders. To this end he signed a treaty with King Manfred, son of Frederick II, Emperor of the Holy Roman Empire, Sicily and Naples. He also maintained good relations with Alfonso X, King of Castile. We have no greater proof of the diversity of Egypt's foreign relations during Mamluk rule than the sheer volume of correspondence sent and received by the Chancery of Cairo, the Ministry of Foreign Affairs of the period.

Thanks to its privileged location at the heart of the trade routes, particularly those of eastern Asia, from China and India, the Mamluk State dominated the sea borne and overland trade of the world. Such was the dominant position it

enjoyed that the Red Sea became Islamic territory to which only those vessels sailing under Muslim flags were permitted. In the same way the Mamluk Sultans protected trade in the Red Sea against pirate attacks.

When the Abbasid Caliphate moved to Egypt in the reign of Baybars in 659/1261, the cultural centre of Islam shifted from Baghdad to Cairo. In the wake of the desolation wrought by the Mongols on the once prosperous Abbasids, the Mamluk capital became the centre of gravity for Arab-Islamic civilisation, where it found patrons and protection. Artisans, politicians, Arab and Muslim sages from throughout the world flocked to Cairo in search of the security and stability it offered. It is for this reason that Egypt's cultural, scientific and artistic life enjoyed moments of great dynamism, as did those cities dependent on Cairo, such as Damascus and Jerusalem.

S. B. and M. H. D.

MAMLUK ART: THE SPLENDOUR AND MAGIC OF THE SULTANS

Salah El-Bahnasi, Tarek Torky

Islamic art in Egypt reached its peak during the era of the Mamluk Sultans. Their great victories on the battlefield against the attacks of Crusaders and Mongols were to find their parallel in the art forms they evolved. They took advantage of Egypt's enormous cultural legacy in order to develop their arts. Consequently, highly skilled Mamluk artisans and artists adopted all that was unique to Egypt's own heritage and worked masterfully with the abundant materials available to them.

They were to find inspiration for their craftsmanship in artistic themes from different cultures, above all from their own Mamluk homelands. During this period their perfectly constructed buildings brought together harmony of theme in delicately finished works of art of unprecedented quality.

They drew on many ideas from Seljuq art, such as the *madrasa* with its layout of four *iwans* surrounding a large courtyard. The first structure to receive the name of "*madrasa*" was built in Nisapur, Iran in 438/1046 and its layout was to provide the model for numerous later examples. The entrances in the façades of the Madrasas of Sultan Hassan and Umm al-Sultan Sha'ban (see Itinerary I and Itinerary II respectively) clearly find their inspiration in the style of raised entrances of the Seljuqs of Anatolia (modern day Turkey). Their arches, framed by a rectangular surround, resemble a shallow *iwan*.

Among other architectural features employed we encounter the *iwan* with *sabil*, as seen in the hospital (*bimaristan* or *maristan*) of Sultan Qalawun (Itinerary III); high, drum domes and pointed arches with three- or four-arch centres, an example being the Madrasa of Amir

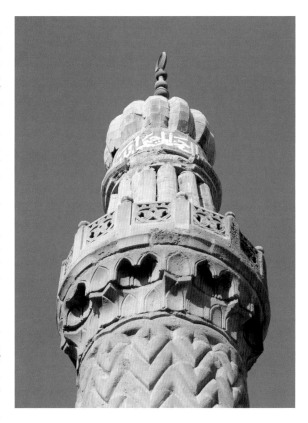

Mosque of Sultan al-Nasir Muhammad, minaret, detail of ceramic tiling, Cairo.

Sarghatmish (Itinerary IV), and the dome structure rising above the three aisles leading to the *mihrab*, as observed in the Mosque of al-Nasir Muhammad (I.1.e). Tile and ceramic wall decoration can be seen in both the minaret of the Mosque of al-Nasir Muhammad and the *mihrab* in the Mosque of Ibn Tulun (Itinerary IV), the renovation of which was carried out by Sultan Husam al-Din Lajin.

The Mongol invasion of countries such as Iran, Iraq and Syria forced many artisans to emigrate to Egypt, and with them, they brought a combination of new art forms. The use of openings over the

49

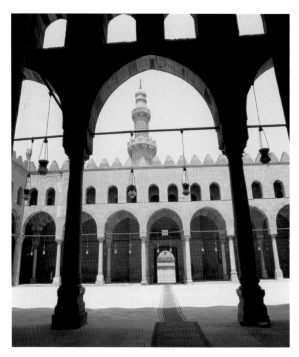

Mosque of Sultan al-Nasir Muhammad, openings in upper sections of arches overlooking the courtyard, Cairo.

Complex of Sultan Qalawun, mausoleum, alternating column and pillar dome supports, Cairo.

upper sections of arcades overlooking the courtyard in al-Nasir Muhammad Ibn Qalawun Mosque (Itinerary I) is similar to that of the Umayyad Mosque in Damascus. The support system of alternating columns and pillars on which the dome rests over the mausoleum of Sultan Qalawun (Itinerary III) finds its parallel in monuments typical of the Syrian tradition. The hospital within the same complex (III.1.c) was built according to the al-Nuri model, also in Damascus. The mosaics found in the ruins of the al-Ablaq Palace (Itinerary I), are very similar to those seen on the façade of the palace of the same name built by Baybars in Marja, Damascus.

The Mamluk's artistic sensibility found inspiration in and absorbed art forms from the people with whom they cultivated political or commercial relations. Eastern designs and motifs found their way into the local artistic language as evidenced by the square *Kufic* inscriptions on the marble sides of the walls of Sultan Qalawun *qubba* (Itinerary III) and which resemble square Chinese stamps. The mythical bird, dragon, clouds and peonies on the *dikkat al-muballigh*, or recitation platform, of the *khanqa* of Amir Shaykhu (Itinerary IV) are only a few of the decorative themes of Chinese origin found on works of art from the Mamluk era. Others are seen in the hardened and lacquered leaves of *kadahi* or paper maché which were used to make utensils previously made out of metal such as pen holders, ink wells, and so on.

The appearance of certain elements of Maghrebi influence is also noted on buildings of the Mamluk period: the style of the square-based minaret found at the Qalawun architectural complex and in the mausoleum and *khanqa* of Salar and Sin-

50

gar al-Gawli (Itinerary IV); the minaret of Ibn Tulun Mosque, restored by Husam al-Din Lajin, bears a double-arched window with horseshoe arches also used on the minaret of the Qalawun complex.

As ties between the Mamluks and Mongols grew closer during the reign of al-Nasir Muhammad, so Persian techniques and motifs became more widely accessible. This fact is reflected in the ribbed finials of the two minarets of the al-Nasir Muhammad Mosque (Itinerary I) bearing influences of the Ilkhanids, Persian Mongols. Certain historical sources, such

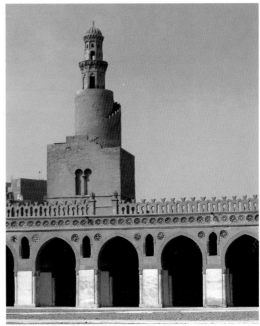

Mosque of Ibn Tulun, minaret, double window with horseshoe arches, Cairo.

as al-Maqrizi, refer to the architect al-Tabrizi (a native of the city of Tabriz, North-west Iran), who came to Egypt in 735/1335 with a Mamluk delegation on his return from visiting the Abu Sa'id *khan*. This date coincides with the second restoration of the Mosque of al-Nasir. Artists of the era created a magnificent artistic legacy, which mirrored the varied circumstances in which the Egyptian people of the period lived. The number of *madrasa*s scattered throughout the city of Cairo demonstrates the importance Mamluks placed on providing education. Likewise, the fortresses along the Egyptian coasts are evidence of the way these people prioritised guarding the shores from the constant attacks from outsiders. The desire of the sultans and *amirs* to serve God more closely and the deeply

Complex of Sultan Qalawun, mausoleum, square Kufic inscription on marble panelled walls, Cairo.

51

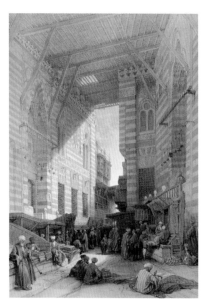

Suq of al-Haririyin and Sultan al-Ghuri Complex, Cairo (D. Roberts, 1996, courtesy of the American University of Cairo).

religious sentiments of the people, are reflected in the construction of a variety of buildings. Such buildings included mosques, whose minarets rise majestically above the city; *khanqas*, whose numbers grew as the practice of Sufism became more widespread during the Mamluk period; *sabils*, which became popular in the streets to quench thirst in the hot Egyptian summer; *kuttabs*, located above the *sabils*, to educate orphans, and also water troughs for animals. The diversity of religious, educational and charitable buildings shows how compassion, solidarity and the desire to carry out good works reigned among the inhabitants of Cairo. *Hammams* were to be found on every street, a feature reflecting not only the Egyptian love of cleanliness but also the advanced state of their civilisation. The *suqs*, *wikalas* and the bustling commercial activity bear witness to the

economic vitality of the period. These establishments were created as *waqfs*, or pious foundations, to defray the expenses of the religious buildings. A "market inspector" *muhtasib* was appointed to oversee the running of commercial exchange.

The architectural style and decorative elements of palaces and houses evoke the different aspects of life in Mamluk society. As such, utensils for day-to-day use found in them are now the pride of many museums around the world. Artefacts in museums are of great value and provide irrefutable proof of the excellence of artistic development, the expertise of the artists and of the degree of evolution of artistic sensibilities in this period. Egypt maintained her outstanding position in the world of arts until the end of Mamluk rule. Following the fall of the Egyptian sultans in 923/1517, the Ottoman Sultan, Salim I transferred the artistic treasures of the country over land and sea to Istanbul and with them, he took many of the best artisans. The historian Ibn Iyas recounts how this event was to lead to the disappearance of some 50 crafts in Egypt.

S. B.

Mamluk Architectural Creativity

The Mamluk era contributed many and varied creative themes to the already diverse branches of Islamic architecture. The Mamluks held onto certain characteristics of earlier traditional models as evidenced by constructions such as the hypostyle mosque plan, the congregational Mosque of Baybars I al-Bunduqdari, the congregational Mosque of al-Nasir Muhammad in the Citadel, Cairo, or in

the congregational Mosque of al-Tunbugha al-Maridani to name but a few. Nevertheless, the desire to innovate was to be the characteristic feature of this period and it was then that Mamluk architectural expression underwent its most significant changes and consequently its most representative achievements.

Buildings designed for a variety of purposes (religious, educational or charitable) are grouped together in large impressive complexes. The tomb of the founder of a complex was often housed there so as to glorify the memory of its benefactor. The complex of Sultan Qalawun in the al-Nahhasin quarter, brings together a *madrasa*, a mausoleum and a hospital, thought to be the oldest and largest of this new style of Mamluk architecture and which was to survive almost unchanged to our day. As the urban area became increasingly saturated throughout the Mamluk period, so these complexes, which wherever possible were located on main streets, were built on gradually smaller and more irregular plots of land. As a result of this shortage of land, buildings grew taller in relation to the surface area they occupied. The floor layout varied and became increasingly diverse, creating a surprising variety of ingenious solutions. This became one of the most characteristic features of Mamluk architecture. Furthermore, a greater number of buildings were constructed for public use, such as the *sabils*, *kuttabs*, hospitals and *hammams* among others.

The oldest example of the addition of a *sabil* to a *madrasa* is one that in 726/1326 al-Nasir Muhammad had added to the east façade of the *madrasa* built by his father, Sultan Qalawun.

The merging of the two types of mosque and *madrasa* layouts resulted in the *iwan* being separated from the *qibla* into aisles divided by arcades. The Qalawun Madrasa in al-Nahhasin constitutes the first example of this new layout.

The carefully planned distribution of space in the *madrasas* is reflected in the structure whereby the building with its *iwans* took on a cruciform plan; in general an open central courtyard, flanked by four *iwans*, the largest of which belonged to the *qibla*. The oldest example is the al-Zahir Baybars Madrasa, located in al-Mu'izz Street, dating from 662/1263. Nevertheless, the most representative model is arguably the Madrasa of Sultan Hassan.

In the Small Cemetery, Cairo, on the *qubba* of al-Manufi dating back to the 7th/13th century we find the first example of a *gawsaq* (or kiosk). The first *gawsaq* resting on columns, however, is to be found on the minaret of al-Tunbugha al-Maridani from 739/1340.

Qubba of al-Manufi, gawsaq, Cairo.

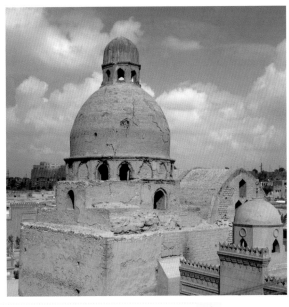

Mosque of Sultan Qaytbay, minaret, ensemble and details, Cairo (Prisse d'Avennes, 1999, courtesy of the American University of Cairo).

Mosque of Qanibay Amir Akhur, twin finial on the minaret, Cairo (Prisse d'Avennes, 1999, courtesy of the American University of Cairo).

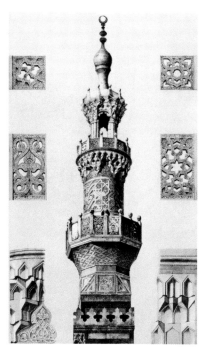

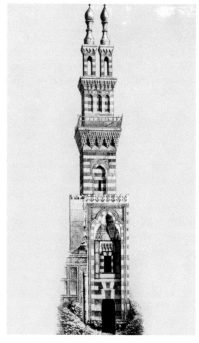

A new style of minaret would also appear, characterised by its different storeys. Beginning with a square-based lower section, then an octagonal middle section, the minaret was crowned with a circular upper section. It was also recognised for the exquisite decoration of the shaft. These minarets are not only remarkable for their physical height, but also because they represent the apogee of their own artistic and architectural values. In the 8th/14th century, new styles and changes were made to the circular sections crowning Egyptian minarets. The bulb shape, which was finally settled on, distinguishes it from other minarets in the Islamic world. At the end of the Mamluk period, the double- or twin-topped minaret was to appear. This style can be seen in al-Ghuri's Mosque minaret, in the minaret the same Sultan had built in the congregational Mosque of al-Azhar, and in the Qanibay Amir Akhur minaret situated in Salah al-Din Square, (the Citadel Square).

In Fatimid times, domes had only covered the section in front of the *mihrab*. The *mihrab* of the Mosque of al-Hakim bi-Amr Allah is the most representative model of those still standing. In Mamluk times, however, domes became wider, covering the three sections opposite the *mihrab*. Examples illustrating this design are in this mosque, in the Mosque of al-Nasir Muhammad in the Citadel and in the Mosque of al-Tunbugha al-Maridani in al-Tabbana Street.

Particular attention was paid to the stone and plaster decoration of façades, which

54

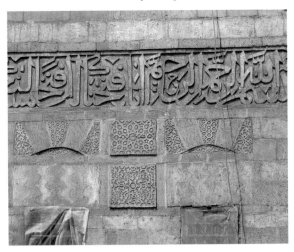

Madrasa of Sultan al-Ghuri, main façade with bi-coloured masonry, detail of the decoration and part of the inscription band, Cairo.

ranged from floral and geometric motifs to inscription bands and various patterns on arches and walls, such as the *al-ablaq* and *al-mushahhar* (both forms of black-and-white or white-and-red striped masonry). It was during this period that the first entrance portals with *muqarnas*, or stalactite vaults, appeared in Islamic architecture in Egypt, namely in the portal of the Madrasa of Baybars I al-Bunduqdari in the al-Gamaliyya Quarter. *Muqarnas* also appeared on pendentives filling the transition zone to domes and even on an earlier construction on the arches of Tankizbugha *qubba* (7th/14th century), in the Small Cemetery. During the era of the Circassian Mamluks, command of the *muqarnas* technique evolved such that it would be recognised as an art form of the highest craftsmanship. Designs became more complicated with the number of rows varying between eight and thirteen.

Otherwise, materials available in the surrounding area were used in response to the local climactic conditions. Thus, stone was used for the outer walls, lower floors, domes and vaults while lavatories in various buildings, cisterns for the *sabils* and the "caldarium" of the *hammams* were constructed of burnt brick. Walls, floors, *sabils* and columns were covered by marble, and wood was used for ceilings, *mashrabiyyas*, lantern towers or skylights, doors, windows, *minbars* and the *dikkat al-muballigh*, or recitation platforms, all of these techniques characteristic of the Mamluk period.

Outside Cairo, the focal point of Mamluk artistic patronage, regional styles also developed in other cities to which a smaller number of Mamluk *amirs* had been assigned. In the majority of cities on the Nile Delta, the most important being

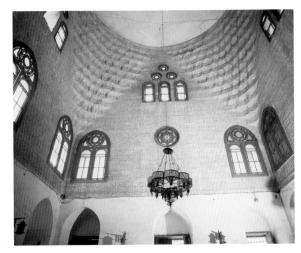

Madrasa of Sultan al-Ghuri, mausoleum dome with stalectites, Cairo.

Rosetta and Fuwa (Itinerary VII and Itinerary VIII respectively), a local decorative style of architecture called *al-mangur* was used. This consisted of alternating courses of red and black brick, where the half-burnt red brick is baked a second time to obtain the black colour. White mortar was used left protruding between the

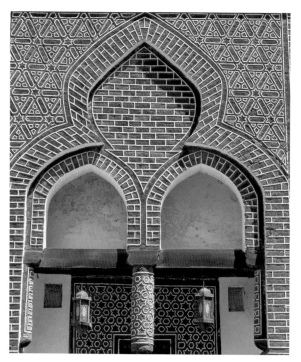

Mosque of Abu al-Makarim, detail of the entrance with bi-colour masonry, Fuwa.

buildings constructed under the reign of Qaytbay. Towards the end of the Mamluk era, the architect Inal would also be recognised for his skills in supervising the construction of the Mosque of Sultan al-Ghuri.

In general terms Mamluk architects came up against three major stumbling blocks. First the location of the buildings on main streets and their positioning on irregular plots of land. Second the orientation towards Mecca of any area reserved for prayer, and finally, the fact that the patrons of such buildings wished them to be visible from as many locations in the city as possible.

All architects throughout the period were particularly noted for adhering to these criteria, as illustrated by the Mosques of al-Tunbugha al-Maridani and Qujmas al-Ishaqi.

S. B.

bricks, giving the construction its characteristic decorative appearance.

In both documents of the period and inscriptions on buildings, names appear of the architects who created these great monuments. Among the names Ibn al-Suyufi is mentioned, the most important architect of the al-Nasir Muhammad Ibn Qalawun Sultanate. His most emblematic works include the Madrasa of al-Aqbughawiyya, added to the Mosque of al-Azhar by Amir Aqbugha 'Abd al-Wahid in 740/1339, and the Mosque of al-Tunbugha al-Maridani. Particularly noted among architects of the second Mamluk period are the Tulunid family. They are renowned for constructions such as the Madrasa of Sultan Barquq, first of the Circassian Sultans, and for

Achievements in the Crafts of the Mamluk Era

Throughout the Mamluk era the arts underwent a revival. The artist's role was no longer limited to the inspiration and development of decorative motifs from the diverse ethnic origins of the Mamluks, nor from the extended area of the States of the Islamic and European world with whom they fostered political and commercial relations. Artists were concerned with developing decorative arts and reproducing works of art that would enjoy great popularity among their citizens. Consequently, they copied the styles of Chinese ceramics such as porcelain and celadon glazes, and other Iranian models, namely Sultanabad ceramic wares.

Among the major art forms that experienced considerable growth during the period, most notable is the development of the woodcarving and turning trade. Used in the making of *mashrabiyyas*, it soon became a distinctive feature of secular buildings in the Mamluk era, particularly in palaces, houses and *wikalas*. Mamluk artists demonstrated great mastery when assembling the delicate pieces of wood to create a diversity of decorative designs with geometric and floral patterns, architectural shapes or inscriptions. Ceramic tiles had not previously been used in Egypt to decorate buildings. They were first used in Islamic Egyptian architecture to cover parts of the buildings in the al-Nasir Muhammad *sabil*, annexed to the *madrasa* built by his father Qalawun. Tiles were also used on the finials of the minarets of the Mosque of al-Nasir Muhammad in the Citadel, and on the drum domes such as in the Tushtumur *qubba* and the Mosque of al-Ghuri.

One of the most representative products of the last Mamluk patrons of the arts were the knotted rugs; there are several dozen which have survived to our day and are commonly known as "Mamluk" rugs for their characteristic structure, technique and pattern. One collection is unique to the Islamic world, due to its warp, weft and pile being of silk. Occasionally the warp and weft were made of linen or cotton, and the pile of silk. Glassware manufacturing techniques were to reach their height of perfection in objects designed for both domestic use and exportation. Practically any shape or form could be created including glasses, bottles, jars, jugs, ewers and bowls with feet. Mamluk glassware, however, was most famed for its lamps. A unique sample of enamelled glass lamps with geometric, floral and calligraphic designs, unparalleled either by earlier or later designs is on display in the Museum of Islamic Art in Cairo. Lamp decoration during the reign of Sultan Hassan Ibn al-Nasir Muhammad Ibn Qalawun (in the second half of the 7th/14th century) bears witness to the broad repertoire of motifs fashioned by the Mamluk artists. Among the most important collections of this genre is one comprising 19 lamps bearing the Sultan's name and another collection belonging to Sultan al-Ashraf Sha'ban, both of which are preserved in the Museum of Islamic Art in Cairo.

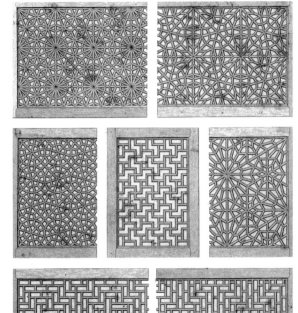

Wooden screeens, ensembles and details, Cairo (Prisse d'Avennes, 1999, courtesy of the American University of Cairo).

Glass lamp bearing the name of Sultan Hassan Ibn al-Nasir Muhammad, Museum of Islamic Art (reg. no. 319), Cairo.

The art of damascene, ornamental metalworking, particularly with gold and silver inlaid on other metals, would reach its zenith of precision and perfection providing enormous decorative variety. Sultan al-Nasir Muhammad's private dining table, *kursi al-'asha'* made of bronze and encrusted with gold and silver is exemplary. This artefact is also kept in the Museum of Islamic Art in Cairo. The metalwork production in the Court of al-Nasir Muhammad was notably prolific. Pieces which have been preserved and can be attributed to the patronage of the sultan or of his *amirs*, are characterised by their dazzling finishes of outstanding excellence, a greater preference for epigraphs over figural decoration, and the inclusion of emblems in the ornamental language. With the exception of objects used in court ceremonials, splendid doors, window bars, decorative lamps and boxes for storing Qur'anic manuscripts were also made.

Decorative arts evolved as much in architecture, through their use on the outsides of buildings, as in other arts and crafts. Where in the Fatimid and Ayyubid periods decoration was carried out almost exclusively in plaster or plaster dressing coat, the Mamluks used stone. The finest examples of domes covered with floral and geometric designs are found in the al-Gawhariyya Madrasa of the Mosque of al-Azhar, in the *qubba* of Sultan Qansuh Abu Sa'id and in the Madrasa of Amir Qurqumas.

In addition to this, the diversification of calligraphic styles ranged from *thuluth* script, used in the decoration of buildings and in other arts and crafts, to square *Kufic* script, used from the beginning of the Mamluk period. Examples can be seen in the inscriptions around the frame

Kursi al-'Asha' of Sultan al-Nasir Muhammad, Museum of Islamic Art (reg. no. 139), Cairo.

58

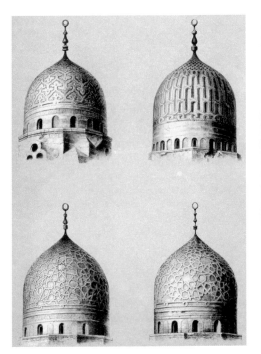

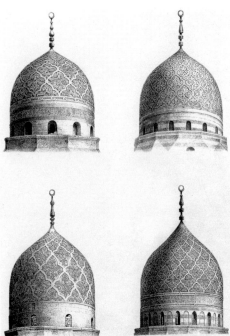

of the marble-based tomb of Zayn al-Din Yusuf in the al-Qadiriyya Quarter of Cairo. Later on, Muhammad Ibn Sunqur would create a technique based on the infinite reproduction of *Kufic* characters in exquisite units, of which al-Nasir Muhammad's *kursi al-'asha'* (dining table) is an example. This technique was later applied to works of art in the Mamluk era.

Only one example of the use of glass-encrusted plaster decoration has survived to our day; it is the upper part of the *mihrab* of the Ahmad Ibn Sulayman al-Rifa'i *qubba*, dated 691/1291.

Works of art of the period, in particular the ceramics, would bring great acclaim to a large number of artists such as Ghaybi Ibn al-Tawrizi, Ghuzeil, Abu al-'Izz and Sharaf al-Atwani. Unusually, the first name from this era to come to our attention belongs to a woman ceramic worker. Archaeological explorations carried out in al-Fustat, uncovered a vessel bearing the inscription "work of Khadija" on its base. This example confirms that women took part in the different tasks, one of which was in the manufacture of ceramics.

In illustrated manuscripts, Egypt held on to the traditional Arabic school of thought until as late as the 10th/16th century. Until then, a single artist carried out all such work. In Iran and Iraq, however, this had disappeared as a consequence of the Mongol invasion in the 7th/13th century and the production of illustrated manuscripts was shared between a scribe and an illus-

Variety of dome designs, Cairo (Prisse d'Avennes, 1999, courtesy of the American University of Cairo).

Scenes from the Maqamat (Assemblies) by al-Hariri (Prisse d'Avennes, 1999, courtesy of the American University of Cairo).

trator. The majority of Mamluk manuscripts were produced between the end of the 6th/13th century and the first half of the 7th/14th century. Literary works and scientific treatises, such as the *Maqamat* (Assemblies) by al-Hariri, the animal fables *Kalila wa-Dimna*, *al-Hiyal al-mikanikiyya* (the Automata) by al-Jazari, *al-Tanjim* (Astronomy) and *al-Furusiyya wa-funun al-mubaraza* (The Arts of Horse-riding and Chivalry) had enjoyed tremendous popularity in earlier times, although illustrated copies continued to be made using traditional methods and styles. A two-vol-

ume translation from Persian into Turkish of *al-Shahnama* was made for Qansuh al-Ghuri. With its 62 colour illustrations, it is the only illustrated manuscript known to have been commissioned by a Mamluk sultan.

Mamluk art would also greatly influence the art of other cultures. Damascene techniques passed from Egyptian to Italian cities and in particular to Venice in the 9th/15th century, via the Crusaders and merchants making pilgrimages to Jerusalem. A bronze dish, encrusted with silver made in the city of Venice bears the arms of the Occhidicane family, governors of Legnago (1256) or of Campagna (1404), small towns near Verona (Italy). Small decorative copper pieces with enamel encrustation were made in France during the second half of the 7th/13th century. The city of Limoges specialised in the manufacture of damascene pieces, known as "twins", due to the fact that they were made in matching pairs. They bear ornamentation of a clearly Islamic influence.

There is evidence of a Mamluk-period basin having been used for religious purposes in France in the 13th/17th century. The so-called "Baptismal Font of Saint Louis", is nowadays preserved in the Louvre in Paris and the basin bears neither the date nor identification of its patron. Given its outstanding production, the striking quality of its craftsmanship and the precision of its fine detail, it is highly improbable that it was made for the commercial market. These artefacts were used for ceremonial hand washing and formed part of a set of matching ewers.

Mamluk influence on European arts can also be seen in the use of *thuluth* script to decorate works such as the statue of David completed by Verrocchio in 1476.

On display in the Bargello Museum (Florence), the *thuluth* calligraphy around the edge of the garment is an imitation of Arabic letters. Likewise Islamic influence is evident in an altarpiece by Gentile da Fabriano *The Adoration of the Magi* which is displayed in The Uffizi Museum in Florence. Finished in 1423, it reflects the artistic influence related to the trade agreements set up between Florence and Egypt in 1421-1422 through the pseudo-*Kufic* script that is represented. The Mamluk art of rug making would strongly influence Ottoman production, in both the method and style of decoration used. We find examples of Mamluk rugs in the new al-Walida Mosque in Istanbul built by the Ottoman Sultan Murad III (r. 981/1574-1106/1595). Mamluk-style rugs are also encountered illustrated in European works of art. In particular the paintings of Carpaccio. Mamluk minaret design is said to have influenced bell-tower construction at the end of the Renaissance, as adopted by the English architect Christopher Wren in the design for the structure of his towers. Likewise, Cairene Mamluk architecture is also believed to have prompted the use of *al-ablaq* (striped forms created by the use of alternating courses of dark and light stone), observed in many Italian cities.

These essential elements of the impressive artistic and architectural legacy of the Mamluk era bear witness to the skill and creativity of their artists. While all cultures have their own art forms with which they identify, Egyptian artists and architects showed an enormous capacity to absorb art forms from other peoples and to adapt them, recreating them and investing them with their own innovations. In this appropriation of contributions from other cultures the Mamluk-era

artists were following the traditions of artists from ancient civilisations dedicated to fine arts. The greatest proof of the genius of the Mamluk period was their reflective creativity.

S. B.

The Itineraries

Of the eight itineraries selected to offer the visitor a broad view of the culture and art that flourished in Egypt throughout the Mamluk era (648/1250-923/1517) the first five are centred on the city of Cairo, focal point of the artistic patronage of sultans and *amirs*.

Itinerary I begins with a visit to the Museum of Islamic Art, our gateway to Mamluk art. Among the masterpieces preserved in the Museum, a representative selection has been chosen, which demonstrates the productivity and skill of Egyptian artists of the

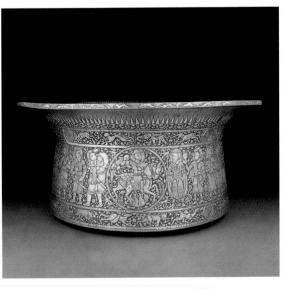

Basin, "Baptismal Font of Saint Louis", Louvre (reg. no. 93CE2182), Paris.

period in their different crafts (wood, ceramics, ornamental metalwork, glassware and rugs). From there we proceed to the Citadel, seat of the government and residence of the sultan of Egypt and Syria. There we discover the towers of the military fortifications where the *Burgui* or Circassian Mamluks were trained. Among other religious and secular buildings, we visit what remains of the Palace of al-Nasir Muhammad Ibn Qalawun, known as Qasr al-Ablaq, *al-ablaq* being the alternating black-and-white striped masonry walls. Outside the Citadel, we visit *amir*s' palaces and important religious complexes including mosques and *madrasa*s.

Itinerary II, a two-day route, follows the sultan's procession, one of the most important of the Mamluk period. The significance of such an event is the main reason why the sultans, *amir*s and important members of State commissioned their buildings along the streets this luxurious procession followed.

We begin by visiting the North Cemetery (also known as the "Mamluk Cemetery"), where Farag Ibn Barquq began the tradition of magnificent funerary complexes. Following the route of the procession through the residential and business streets, we proceed to visit the sumptuous monuments that reveal to us the subtle architectural and ornamental finery of the *Bahri*s and the *Burgui*s.

Itinerary III helps us to appreciate the flourishing cultural activity of the city of Cairo, which greatly influenced the spread of educational institutions. By visiting the most outstanding buildings such as *madrasa*s, mosques, *khanqa*s and hospitals particular importance is placed on the different sciences studied as well as on the mechanisms used to finance and maintain these establishments via the *waqf* system.

The main theme of Itinerary IV is the River Nile, life source of Egypt since time immemorial. On this route, we understand the enormous significance given to the installation of nilometers along its length to measure water level and also to warn of flood danger. By following the same path as the sultan took during the celebration of the rising of the Nile, that is to a level sufficient to guarantee water for both domestic use and irrigation, we visit different hydraulic works such as nilometers, aqueducts and *sabil*s, as well as the buildings that the great *amir*s had constructed along its length.

Itinerary V concentrates on a single theme, that of commercial wealth, gained through the success of the sultans in the face of Mongol attacks and Frankish invasions. The guarantee of a stable market allowed the revival of the bazaars and the sultans concentrated their attentions on the construction of commercial establishments. The itinerary includes a varied selection of these buildings, including the *wikala*s and the bazaars, to experience the atmosphere and characteristics of markets in those times, many of which still survive today.

Itinerary VI takes us to Alexandria, gateway to the West. In Mamluk times its port became the most important one in Egypt and the largest centre of trade activity in the Islamic world. The sultans had citadels and military fortifications built in order to protect their wealth and products, which came from the East. Among these fortifications we visit the old city walls and Qaytbay Fortress, built on the foundations of the ancient lighthouse.

Itinerary VII takes us to the mouth of the River Nile on the Mediterranean Sea and to the city of Rosetta. The strategic situ-

ation of the city led the Sultan al-Zahir Baybars to have the port built as an observation post in order to keep guard and control over the seas. It was from the port of Rosetta that the fleet left to invade the island of Cyprus and bring it under Mamluk rule. The route includes the military fortifications built on the banks of the Nile and on the coast of this Mamluk era trading centre. Our attention is drawn to a local style of architecture peculiar to the city.

With Itinerary VIII we reach the city of Fuwa, from where a splendid panoramic view of the Nile can be enjoyed. Located in the rice province on a stretch of the river leading towards the city of Rosetta, it was one of the most important centres of trade in Mamluk times and one of its most important river ports. Among the secular and religious buildings scattered throughout its streets, the itinerary includes buildings most representative of Mamluk art and we visit centres of the rug and kilim industry, which give the city its fame today.

T. T.

THE CITY OF CAIRO IN THE MAMLUK ERA

Mohamed Hossam El-Din

*Plan of the Citadel
(drawing by Mohammed
Rushdy), Cairo.*

been built one beside another when Gawhar al-Siqilli began the construction of Cairo to the northeast.

Under Fatimid reign the city expanded in all directions. This was a natural occurrence stemming from Caliph al-Mu'izz li-Din Allah's arrival in the city in 362/973 along with his extensive family and considerable numbers of soldiers. The size of the army increased, as did the numbers of men of the Fatimid State. While native inhabitants of the country lived in areas belonging to the earlier capital cities, the caliph, his government and army lived in the Fatimid city of Cairo.

With the fall of the Fatimid Caliphate in 569/1173, Salah al-Din al-Ayyubi immediately began to plan the foundation of a new centre for his State, which would include the congregational mosque, government palace and chancelleries as well as housing for its soldiers. The construction of a great wall began to surround, protect and control the cities of Cairo, al-Qata'i', al-'Askar and al-Fustat and the citadel built almost in the centre of the eastern length of wall on a low hill at the foot of Mount al-Muqattam. Thus, the city of Cairo was forged together becoming one city, which with time would reach imperial proportions. It was the first time that an attempt had been made to unite the cities in one truly fortified city. Such plans, however, under the reign of Salah al-Din, never reached completion. Only the northern stretch of the Fatimid-period wall was extended as far as the Nile, while the wall which was to join Fustat with *al-Qahira* was never finished, and the wall planned to border the Nile never started.

The shift of the Abbasid Caliphate (in the times of Sultan Baybars) from Baghdad to Cairo greatly favoured the development

In the Mamluk era the city of Cairo was the resulting blend of earlier capitals of Islamic Egypt. They were: the city of al-Fustat, built by 'Amr Ibn al-'As in 21/641 on conquering Egypt; the city of al-'Askar, built by the Abbasids in 133/750 to the north east of Fustat; the city of al-Qata'i', also built to the north east founded in 256/870 on Ahmad Ibn Tulun's arrival in Egypt where he settled and established an independent State from the Abbasid Caliphate; and finally, the city of Cairo built in the same area by the Fatimid general Gawhar al-Siqilli (the Sicilian), in 358/969.

The layout of these cities generally included a congregational mosque, seat of government or Caliph's Palace and surrounding these, land on which lodgings for civil servants and soldiers were built. The three former capitals had already

and expansion of the city. Cairo not only became the seat of the Abbasid Caliphate but also capital of the Mamluk State of Egypt and Syria.

With the resulting transfer of the cultural centre of Islam to Cairo came the revival of religious, scientific and cultural life. Educational institutions such as *madrasas* and *khanqas* were filled with scholars and academics from East and West. Two main factors contributed to the growth of Cairene markets; firstly the secure and stable environment the Mamluk State provided for trade from the East and secondly the significant increase in Cairene population, due to both immigration and to the enormous influx of visitors to the city. Thus, markets flourished, numerous trading establishments were built and the *suqs*, sated with all kind of merchandise, bustled with endless trading activity. Commercial exchange gained great importance and numerous *wikalas*, *caravanserais* and *khans* were constructed. A significant part of this activity was concentrated around the city's main north-south axis where markets were grouped into "corporations", which in turn gave their names to the corresponding crossroads of the streets on which they were located. Other markets were grouped on the edge of the city boundary, to the south and west around the lateral axes.

Mamluk governors would soon begin to develop the urban infrastructure within the city of Cairo with repercussions on the outside. Camp Qaraqush, located to the north, was used for military sports where Sultan Baybars trained in archery (*al-qabaq*, "the target") a game combining shooting and horse-riding. Baybars had a congregational mosque constructed there and ordered the rest of the land to be built upon to establish *waqfs* (charitable endowments) to defray the expenses of his mosque. The square where the games were played, (the black square or target square) was transferred to the eastern area, known as the Desert or Cemetery of the Mamluks, stretching from the area of al-Darrasa to the present-day al-Sayyida 'A'isha Square. It continued to be used for the same purpose up until the time of al-Nasir Muhammad Ibn Qalawun. Later sultans and *amirs* began to have their *madrasas* and *khanqas* built there, to which their tombs were added.

In the second half of the 9th/15th century, and later in the times of the Circassian Mamluks, building work was to extend to the east of Camp Qaraqush in the al-Raydaniyya area (nowadays al-'Abbasiyya). During the time of Sultan Qaytbay (872/1468-901/1496), Amir Yashbak min Mahdi would commission two *qubbas*: one in the al-Matariyya area opposite the Palace of *al-Qubba*, and the other known as the al-Fidawiyya *Qubba* in the al-'Abbasiyya Quarter, in 882/1477 and 886/1481 respectively. Likewise, al-Muhammadi al-Damardash had a *qubba* built in the same area prior to 901/1496. So numerous were the buildings around

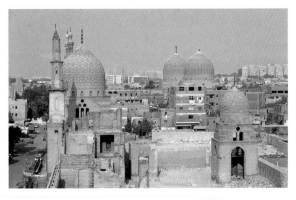

View of the Mamluk Desert: Khanqas of Sultans al-Ashraf Barsbay and Farag Ibn Barquq, Cairo.

65

these *qubbas*, that when Sultan Qaytbay and his successors went out to stroll and relax, they reached the mausoleum of Yashbak in the al-Matariyya Quarter on the northern edge of the city. Mamluk Cairo effectively covered the area of the present day *al-Qubba* Gardens.

In the western part of the city between the canal and the banks of the Nile, and between Old Cairo to the south and Shubra to the north, an area of land was to form as a result of the Nile flood plains. Stretching from present-day Ramses Square to the Quarter known as Bulaq, *al-Fil* Island was joined to the mainland and today's Shubra Quarter developed. As such, in the 8th/14th century, the northern port of Cairo was to move to Bulaq from where it had previously been located in what is nowadays Ramses Square. From the time of al-Nasir Muhammad Ibn Qalawun onwards, numerous buildings were constructed in Bulaq, many for trade purposes, to which activity related with affairs of the sul-

tanate was transferred. During Sultan Barsbay's reign, at the beginning of the 9th/15th century, a river port was constructed along with shipyards in the same area. Building activity commenced in the area to the east of Bulaq, in Bab al-Luq and 'Abidin during the reign of al-Zahir Baybars, Mongols who came to Cairo embracing Islam were accommodated in this area.

Al-Nasir Muhammad Ibn Qalawun would commission al-Sultani Square and the al-Nasiriyya reservoir in its vicinity. In the surrounding area of the same name *amirs* had several buildings constructed which may still be seen today. Later on in the second half of the 9th/15th century, during the Circassian Mamluk era, work commenced once again in the area. In Sultan Qaytbay's reign, Amir Azbak min Tatakh al-Dahiri had the al-Azbakiyya reservoir built (then known as Batn al-Baqara reservoir) in the surrounding area. In the same location in around the year 410/1019, the Caliph al-Zahir li-'I'zaz

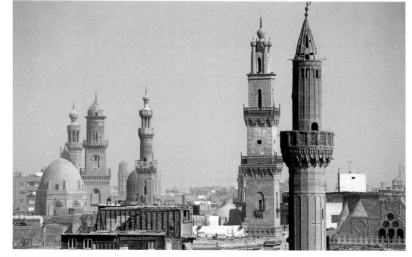

View from the top of al-Mu'izz Street: Complex of Sultan al-Ghuri, Madrasa of Sultan Barsbay, Complex of Sultan Qalawun and Madrasa of Sultan al-Nasir Muhammad, Cairo.

Din Allah commissioned the building of al-Muqas Gardens, towards which the waters of the Nile were channelled from the al-Dikr canal.

Following the period from 880/1475 to 882/1477 the area went by the name of Azbakiyya, in honour of Amir Azbak. With the construction of his palace and other buildings in the area, he was to become its main patron. Not only was he to have the reservoir excavated, but he would also have its perimeter paved and its source transferred from the al-Nasiri canal.

Finally, the Palace of Qasr al-'Ayni to the west of Bab al-Luq must not be missed. It was commissioned by al-Shahabi Ahmad Ibn al-'Ayni and was to give the area the name it still bears today.

The city of Cairo stood out for its variety and number of buildings, designed for a multiplicity of purposes covering the full range of activities of the time, the majority of which still stand today. Among them we find mosques, *madrasas*, *khanqas*, *zawiya*s and *wikalas* all closely linked to the nature of the city as both commercial capital and a centre for students and academics who came to Cairo along with merchants and traders from the East and the West. Filled with places for public entertainment and industrial reservoirs, the city, while bustling with activity, also provided solace and rest for the spirit.

Cairo became the model for all Islamic cities, dazzling the world with its opulence. With its magnificence and progress, Cairene society attracted admirers from far and wide. Cairo and its splendour were described throughout the centuries, not only by her sons, but also by many erudite men of Islam who came to her from East and West. Among them are 'Abd al-Latif al-Baghdadi, Yaqut al-Hamawi, Ibn Jubayr al-Andalusi and the most famous of travellers, Ibn Battuta.

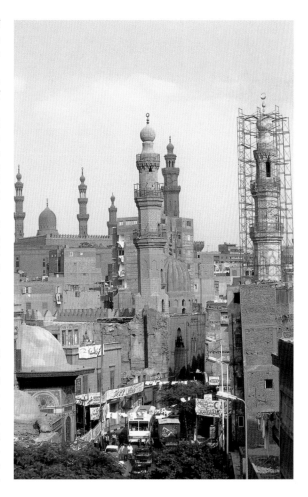

Al-Saliba Street: Khanqa and Qubba of Shaykhu, minarets of the Mosque of Sultan Hassan, Cairo.

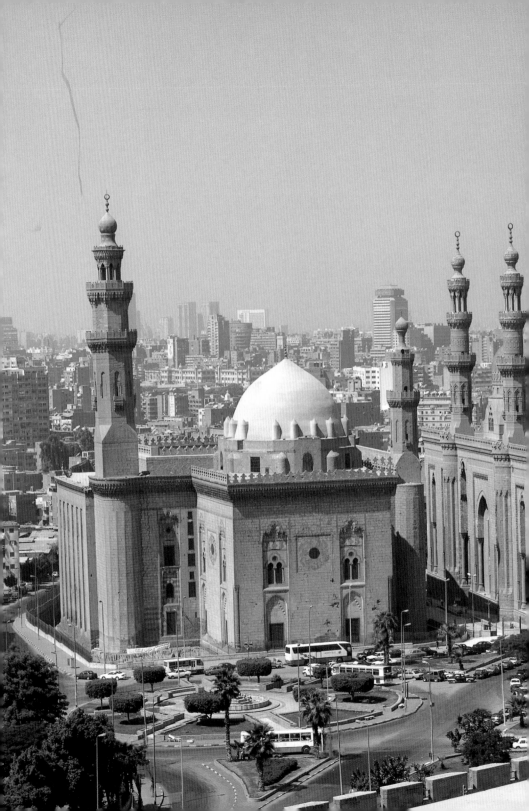

The Seat of the Sultanate
(the Citadel and its Surroundings)

Salah El-Bahnasi, Mohamed Hossam El-Din,
Gamal Gad El-Rab, Tarek Torky

Mamluk Dress
Sports and Games in the Mamluk Era

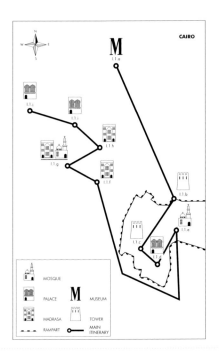

Mosque and Madrasa
of Sultan Hassan,
general view, Cairo

The Citadel, view from the North Cemetery, Cairo (D. Roberts, 1996, courtesy of the American University of Cairo).

north and Fustat to the south, the desert and rocky hills bordering to the north and east.

The North Wall of the Citadel (military section)

Salah al-Din entrusted the construction of the Citadel to his Minister Baha' al-Din Qaraqush al-Asadi who began with the north curtain wall which he built along an irregular line for defensive purposes. The main gate, *al-Bab al-Mudarrag* (the "Staircase Gate") is located in the west wall crowned by a foundation plaque, which dates the gate to the year 579/1183. It was later restored in 709/1309 by the Sultan al-Nasir Muhammad Ibn Qalawun. Several semicircular towers are placed along the length of the walls, of which al-Ramla and al-Haddad towers, located on the eastern edge, are particularly noteworthy (I.1.b). This section, which was reserved for the armies, contained buildings used as Mamluk lodgings, none of which have survived to our day.

In the year 901/1496 the German knight Arnold Von Haref arrived in Cairo on his way to Jerusalem, seeking permission from the Sultan of Egypt, al-Nasir Muhammad Ibn Qaytbay to travel to Palestine and Syria. The Sultan took interest in the man and invited him to an audience at the Citadel. The book that Arnold Von Haref wrote on his journey provides us with records of palaces, houses and a Mamluk school, where 500 young men were trained in the art of horse-riding, while also learning to read and write.

Next to Bab al-Mudarrag we find three marble plaques bearing details of succes-

When Salah al-Din al-Ayyubi had his Citadel built, his desire was for it to be both a defensive fortress and the seat of the Sultanate. His initial lack of trust in Cairenes led him to have the Citadel located at a distance from the city, the construction of which followed the fortress model of the Crusades. Architectural innovations were introduced, however, mainly ideas gathered during Salah al-Din al-Ayyub's time spent in Aleppo and on campaigns carried out in Syria and Palestine against the Crusaders. Such elements are evidenced by the bent passageway entrances rendering access from the outside difficult while aiding defence from the inside and by the machicolations, or projecting galleries, from which to observe and attack the enemy. The Citadel was sited in an ideal defensive position, overlooking the city of Cairo to the

sive restorations carried out by different sultans. Firstly Sultan Jaqmaq's renovations on the gate in 842/1438; the second was carried out by Sultan Qaytbay in 872/1468 and the third by Sultan al-'Adil Tumanbay in 922/1516, the latter two being aimed at strengthening the walls of the Citadel.

The South Wall of the Citadel (residential section)

There is evidence that work commenced in this area with the well Qaraqush dug at the same time that the northern walls were being built. The well, guaranteeing the supply of water to the garrison, is accessed by a descending spiral staircase and is divided into two parts by a water wheel of earthenware vessels. The wheel raised water to a tank located half-way up the well shaft and from there, water was brought to the surface by other wheels.

Later, Sultan al-Kamil Ibn al-'Adil al-Ayyubi would have the royal palaces built and it was then that he had the seat of power established in the Citadel to which he brought his family and government. Henceforth, the Citadel remained the seat of government and residence of governors of Egypt until 1291/1874 in the era of the Khedive Isma'il.

With the arrival of the Mamluk Sultans, earlier palaces built by al-Kamil were reconstructed and converted into three royal residences known as the Palaces of al-Guwaniyya near the al-Ablaq Palace (I.1.d). Furthermore, Sultan al-Nasir Muhammad commissioned a great *iwan* for the council of the Sultanate to meet. The southern stretch of wall was surrounded by

another, the ruins of which still survive today in the al-Siba' tower (I.1.c) dating back to the reign of Sultan Baybars I al-Bunduqdari.

These walls separated the residential area from the Sultan's stables. Among those who most influenced the building of the Citadel are Sultan Baybars and the Qalawun family, who definitively established the seat of the Mamluk Sultanate there. Unlike the events marking the first half of the Citadel's history, when the Ayyubid governors made every attempt to isolate it from their people, the two Mamluk Sultans were concerned with opening up the Citadel to its people.

In the stables' area we find the mosque known as Ahmad Katkhuda al-'Azab which goes back to the time of the *Burgui* Mamluks. It was built in the year 801/1399, during the reign of Farag Ibn Barquq.

Mosque and Madrasa of Sultan Hassan, entrance, Cairo (D. Roberts, 1996, courtesy of the American University of Cairo).

71

Mamluk Monuments outside the Citadel

During the times of the Mamluk sultans, the wall over the Citadel Square (al-Rumayla) was embellished with several dazzling palaces, reflecting the grandeur and opulence of the Sultanate. Citadel Square is considered one of the oldest squares in Cairo. During Ayyubid rule and from the beginning of the 6th/12th century it became the city's centre of gravity. Al-Nasir Muhammad Ibn Qalawun planned the urban layout and had palm and other trees planted; around it he was to have a stone wall built, such that the square was transformed into a vast space stretching well below the walls of the Citadel, from the gate of the stables to the cemetery (nowadays Sayyida 'A'isha).

During the Mamluk era building work continued within the Citadel walls around the square of the same name and with the houses of Sultan Baybars' *amir*s and successors. Among the most noted constructions are the Palaces of Yashbak min Mahdi (I.1.j), Manjak al-Silahdar (I.1.i) and Alin Aq al-Husami. The horse (*al-Khuyul*) and armourers (*al-Silah*) *suq*s, thought to have reached perfection as model specialist *suq*s, were also transferred to this area, in the vicinity of the Mosque of Sultan Hassan.

Around the Citadel, numerous religious buildings were erected, among them the Madrasas of Sultan Hassan (I.1.g), Gawhar al-Lala (I.1.h) and Qanibay al-Rammah (I.1.f).

M. H. D. and T. T.

I.I CAIRO

I.1.a Museum of Islamic Art

The museum is located near Bab al-Khalq, opposite the Cairo Directorate of Security. Opening times: daily from 09.00-16.00 closed Fridays 11.30-12.30 in winter and 13.00-14.00 in summer. There is an entrance fee.

In 1880, the Commission for the Conservation of Arab Monuments was founded with the aim of creating a complete inventory of works of art in the different Islamic houses, palaces and mosques. Of these pieces, 110 were transferred to the Arab Archaeological Museum, a building in the courtyard of the Fatimid Mosque, al-Hakim bi-Amr Allah, next to the north walls of the city. The collection continued to expand acquiring artefacts from the Commission and the first catalogue of the collection was published in 1895. Given the limited space of the site, another larger museum was built in Bab al-Khalq, next to the Egyptian National Library in 1903, to which the Arab Archaeological Museum transferred its collection. The building, designed along traditional Islamic lines in keeping with the works on display, held onto its name. While the collection belonged to the artistic legacy of the Arab countries, it also housed a variety of art collections from non-Arab Islamic countries, such as Turkey, Iran and India. Thus, it was decided in 1953 that the name should be changed to the Museum of Islamic Art.

The greatest collection in the world of Islamic archaeology, comprising some 100,000 pieces is found here. The works occupy 25 rooms on two floors and are

Museum of Islamic Art, main façade, Cairo.

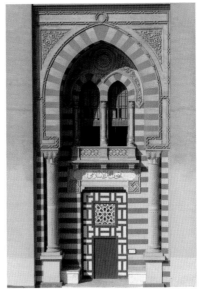

Museum of Islamic Art, entrance, Cairo.

displayed in chronological order from the Umayyad period through to the end of the Ottoman period. The pieces are classified according to the materials used in their manufacture and their country of origin. Mamluk art occupies a special place among the acquisitions. The collection includes ceramic vessels (the style imitates celadon porcelain from China and Sultanabad ceramics from Iran), and a collection of enamelled terracotta pieces, characterised by the inscriptions and arms of the Mamluk Amirs and Sultans. The collection of wooden articles testifies to the variety of techniques used in the decoration of this material, including carving, turning and inlay. Among the most important wooden articles is a screen from the Madrasa of Sultan Hassan, demonstrating the turned wood technique and a Qur'an case, decorated with ebony and ivory, from the Madrasa of Umm al-Sultan Sha'ban.

Among the Mamluk masterpieces in the museum is a collection of metal artefacts, a testimony to the degree of per-

fection attained in the period and to the skill with which artisans produced all manner of decoration in gold and silver inlay on bronze basins and bowls. Zayn al-'Abidin Katbugha's candlestick, Sul-

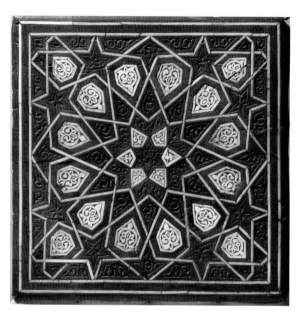

Wooden panel, Museum of Islamic Art (reg. no. 11719), Cairo.

as evidenced by this collection of 60 glass lamps from the Mamluk era, a representative sample of some 300 lamps in different museums of the world. Most outstanding are the lamps from the Madrasa of al-Nahhasin belonging to Sultan al-Nasir Muhammad Ibn Qalawun. The 19 lamps bear the name and titles of Sultan Hassan, son of al-Nasir Muhammad Ibn Qalawun, and those of Sultan al-Ashraf Sha'ban.

The Museum's collection of textiles from the Mamluk era highlights the characteristics of this art form. On a piece of silk bearing the name of Sultan al-Nasir Muhammad Ibn Qalawun, depicting a family of leopards, the fineness of the cloth and its exquisite decoration may be fully appreciated. The carefully hand-crafted rugs of Mamluk artisans were highly prized among Europeans. Proof of their widespread popularity in Europe is found in their representation in the work of other artists during the Renaissance, in particular in Italy, and above all in the paintings of Carpaccio.

tan al-Nasir Muhammad's *kursi al-'asha'* (dining table) and Qaytbay's candlestick are among the most representative examples of metalwork from the Mamluk period.

The technique of glass enamelling was to reach its greatest expression in both precision and perfection during this period,

Among other valuable works of art we find examples of manuscripts, which help us to understand book-production techniques of the period, including calligraphy, illumination, gilding and binding. These manuscripts, and in particular the work *Al'ab al-Furusiyya*, show how the Egyptian school of illustration held onto characteristics from the Arabian school, which by then had already disappeared in Iran and Iraq following Mongol invasion.

Among the most important acquisitions of the Museum of Islamic Art is its coin collection, comprising gold Dinars, silver Dirhams and bronze coins, all rich in inscriptions.

S. B.

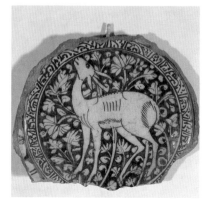

Ceramic bowl, Museum of Islamic Art (reg. no. 5707), Cairo.

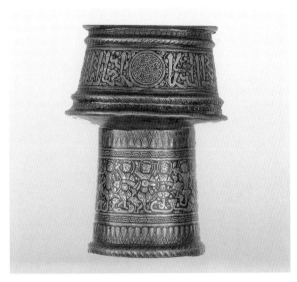

*Bronze candlestick,
Museum of Islamic Art
(reg. no. 4463),
Cairo.*

Decorated wooden panel
(Mamluk room, reg. no. 11719,
8th / 14th century)

This wooden panel is decorated with
small interlocking pieces forming geo-
metric shapes. The centre bears a star-
shaped motif, inlaid with ebony and ivory.

Ceramic bowl (Mamluk room, reg.
No. 5707, 8th / 14th century)

Under the glazed enamel, this large
ceramic bowl is decorated with a gazelle
raising her head as if to eat the leaves from
trees. The drawing is outlined in white on
a blue background, bearing Chinese-style
decoration of branches covered in leaves
and lotus flowers. The drawings are sur-
rounded by a circular border, closely
resembling inscription in *naskhi* script, of
exquisitely slender letters.

Brass candlestick (Mamluk room,
reg. no. 4463, 7th / 13th century)

The brass candlestick with silver inlay
(height 14 cm. and 8 cm. diameter at the
top) has a cylindrical base, that narrows
to form a cone-shaped top with a flat ring
and protruding edges. The broad band
around the base shows figures of dancers,
which are at the same time the body of
the letters of a *naskhi* inscription; it reads
"glory and eternal life triumph over the
enemy". The edges of the upper ring also
bear *naskhi* inscriptions on a background
of carefully spaced small leaves. The
inscription reads: "the victorious, the glo-
rious, Zayn al-'Abidin Katbugha, painted
the *tashtakhana* (crockery store) of this
venerated place".

Decorated marble plaque (Mamluk
room, reg. no. 278, 8th / 14th century)

*Marble plaque,
Museum of Islamic Art
(reg. no. 278), Cairo.*

The centre of this decorated marble plaque
bears a large oval medallion. The bas-relief
decoration presents a background of hands
reaching out to branches with flowers and

75

Glass lamp, Museum of Islamic Art (reg. no. 33), Cairo.

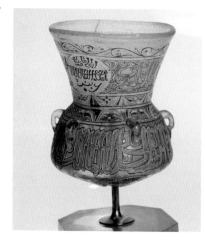

Glass lamp, Museum of Islamic Art (reg. no. 270, Cairo.

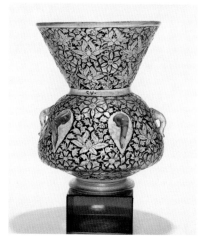

birds. The plaque comes from the Mosque of Amir Sarghatmish built in Cairo in the year 757/1356 (IV.1.h).

Glass lamp (Glass room, reg. no. 33, 9th/15th century)

This glass lamp bearing red and blue enamel is decorated with inscriptions

that bear the name of the Sultan Qaytbay. It no longer has its base, but the neck bears a band with flower decorations in Renaissance style, evidence that it was made in Europe, probably in Venice.

Glass lamp (Glass room, reg. no. 270, 8th/14th century)

This glass lamp decorated with red and blue enamel and gold measures 33 cm. in height and the neck, 25 cm. in diameter. It is decorated with a symmetrical lotus flower and peony design common in Chinese art, on a background of smaller six-petalled flowers and small plant leaves. The drawings have a red enamel outline on a background of blue enamel. The lamp, with handles, comes from the Mosque of Sultan Hassan (I.1.g).

Fragment of carpet (Carpet room, reg. no. 1651)

This fragment of Mamluk-style rug bears geometric designs and measures 20.9 m.

Fragment of carpet, Museum of Islamic Art (reg. no. 1651), Cairo.

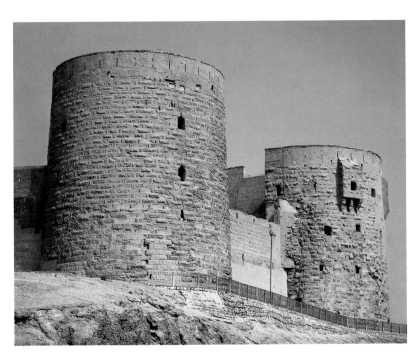

Towers of al-Ramla and al-Haddad, Cairo.

in length and 1.94 m. in width. A large octagonal medallion can be seen in the centre with eight pointed stars in red, violet, sky-blue and white.

T. T.

I.1.b The Citadel Towers: al-Ramla and al-Haddad

The Citadel can be reached from Salah Salim Avenue on the road to Mount al-Muqattam. The entrance is through the present-day Main Gate in front of which there is a large car park for coaches and cars. Al-Ramla and al-Haddad towers are located in the (military section) Citadel on its eastern edge.
Within this area of the walls and towers there is an open-air amphitheatre (Mahka

al-Qal'a) officially opened in 1994 where exhibitions, artistic events, concerts and summer festivals are held. Near the amphitheatre there are public toilets as well as those inside the Citadel near the cafeteria.
Opening times: from 08.00 to sunset. There is an entrance fee.

Since their construction, the Citadel towers (*burg* in the singular) were used as barracks for soldiers. The towers were closely associated with the Circassian Mamluks, from the reign of Sultan Qalawun onwards, who had his soldiers lodged in them on their arrival in Egypt, hence the nickname they acquired "*Burgui* Mamluks".
Among the towers located on the northern stretch of wall we find al-Ramla and al-Haddad on its eastern end. These cir-

77

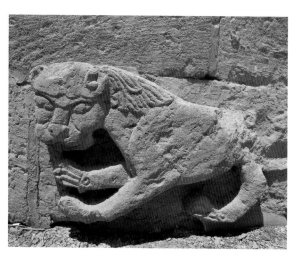

Tower of Sultan Baybars al-Bunduqdari (Burg al-Siba'), Arms of Sultan Baybars on the façade, Cairo.

I.1.c Tower of Sultan Baybars al-Bunduqdari

This tower is located in the residential sector of the Citadel, where the north wall joins the west. The Police Museum (with a cafeteria) was built in 1983.

Sultan Baybars al-Bunduqdari had the tower built on the intersection of the north and west walls of the southern Citadel wall, known as Burg al-Siba' ("Tower of Lions") inside the Citadel. As such, historians have referred to it in their writings as the "Corner Tower". It owes its true name, however, to the upper section of its façade, uncovered when construction of the Police Museum commenced. Figures of lions, the emblem of Sultan Baybars, were uncovered. A total of 100 lions were painted on its eastern wall and 12 on its north. Lions were also found on many other buildings of his; on the façades of the al-Ablaq Palace constructed in Marja, Damascus; on the bridges built in Cairo (in the present day al-Sayyida Zaynab Quarter) hence the name of the "al-Siba' Bridges", which are now extinct.

S. B.

cular towers of a height of 20.8 m. have three floors including the upper flat roof. The walls are built of rusticated blocks with loopholes at intervals. These openings were widened during the time of Sultan al-'Adil, brother of Salah al-Din and can be reached from a platform covered by a vault.

The upper open-air floor can be reached by an inner staircase. Openings on the parapet at intervals allowed surveillance and control tasks to be carried out. Al-Haddad tower differs from al-Ramla tower and others in that it has four machicolations supported on brackets and its middle floor is octagonal similar to a *durqa'a*.

G. G. R.

From the top of the towers the visitor has a splendid panoramic view of Mount al-Muqattam, which includes al-Guyushi Mosque, Salah Salim Avenue, ruins of the Citadel towers and its surrounding wall.

From here you have a panoramic view of both Old Cairo and Modern Cairo. On looking over the Citadel Square, major Cairene monuments are in view; among them the Mosques of Sultan Hassan and al-Rifa'i, the Madrasas of Qanibay Amir Akhur and Gawhar al-Lala, the Mosques of al-Mahmudiyya and Ahmad Ibn Tulun and hundreds of minarets scattered throughout the city affording a splendid and unforgettable view.

I.1.d Ruins of al-Ablaq Palace

The ruins of the al-Ablaq Palace are located in the vicinity of Sultan Baybars al-Bunduqdari tower, below what is today ground level.

Sultan al-Nasir Muhammad Ibn Qalawun was to commission his palace, called al-Ablaq Palace on the west side of the southern enclosure of the Citadel of Salah al-Din in 713/1313. On the basis of archaeological finds in the area, the palace is believed to have stretched from the outer wall of the Citadel to the entrance hall of al-Gawhara Palace. The palace was reserved for the Sultan to hold his daily audiences and above all, for the administration of State affairs, though special occasions were also celebrated there. Its name derives from the building technique known as *al-ablaq*, consisting of alternating courses of black-and-white stone (the white stone over time has yellowed).

From archaeological finds we know that the floor plan comprised two *iwans* and a *durqa'a*. This layout closely follows that of other palaces of the period such as the Alin Aq al-Husami and Bashtak Palaces (see Itinerary II). On evidence from other similar structures we can assume this palace had two *iwans* and a *durqa'a*, its centre covered by a dome. From the northern *iwan*, larger than the southern *iwan*, the Sultan could look out over the imperial stables, the horse bazaar (*al-Khuyul*) in the Citadel Square and over the city of Cairo, and from the River Nile to Giza. Access to the remaining palace rooms and to the complex of buildings, such as the great *iwan* and the al-Guwaniyya Palaces, was gained through the southern *iwan*, built

by al-Nasir Muhammad in the Citadel. The palace was subsequently abandoned. It was later turned into the *Kiswa* factory for the *Ka'ba* in Ottoman times, and finally Muhammad 'Ali Pasha (1220/1805-1265/1849) was to have his mosque built over the hypostyle hall of the palace. Alterations have left the building stripped of its original wealth and magnificence. Nevertheless, the works of the *Khitat* written by the historian al-Maqrizi bear testimony to its decorative features. He mentions floors and walls covered with marble and ceilings of gold and lapis

Ruins of al-Ablaq Palace in the Citadel, Cairo (painting by Mohammed Rushdy).

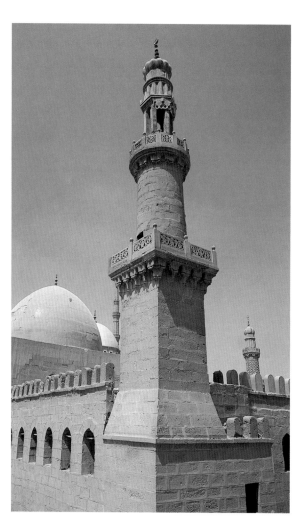

Mosque of Sultan al-Nasir Muhammad, dome and minaret, Cairo.

similar to those panels still visible today in the Umayyad Mosque in Damascus.

S. B.

I.1.e Mosque of Sultan al-Nasir Muhammad

This mosque is situated within the grounds of the Citadel, opposite Bab al-Qulla and is reached on leaving the Police Museum area.

The third reign of Sultan al-Nasir Muhammad from 709/1310 to 740/1340 was marked by the unprecedented development that took place in the city of Cairo, which saw an increase in the number of monumental buildings there. The Sultan began a vast building programme in the Citadel. The enormous domes of his palace (al-Ablaq Palace) and mosque (measuring 8 m. and 15 m. in diameter respectively) were to dominate the skyline until the 19th century when Muhammad 'Ali (1820-1857) had his mosque built in the grounds.

Sultan al-Nasir Muhammad was to build his mosque in 718/1318 in the southern area of the Citadel. In 735/1335 it was extended to accommodate nearly 5,000 faithful, and remained the congregational mosque for the inhabitants of the Citadel and its vicinity throughout Mamluk rule and beyond into the Ottoman period.

The mosque appears suspended as the supporting arches of the lower floor can be seen. Its rectangular plan (63 m. x 57 m.) centres on a courtyard surrounded by four porticoes or arcades of two rows of arches in height. The side and rear arcades are two aisles deep, while the largest arcade is that of the *qibla* sanctu-

lazuli. On the lower part of one of the *durqa'a* walls there are still vestiges of marble, and on the upper part of the same section a piece of gilt marble mosaic can be seen indicating that a panel of the same material once covered the entire wall. The mosaic contains floral and geometric designs very

ary comprising four aisles. The horseshoe arches are supported on marble and granite columns taken from different buildings of earlier periods (Ptolemaic, Roman and Coptic). In each of the two nearest arcades to the *qibla*, two columns have been left out directly in front of the *mihrab* in order to open up a square space there. A dome rises above the space originally made of wood, but it has on several occasions since its construction been restored and more recently rebuilt. The rest of the ceiling over the prayer hall is wooden with a coffered ceiling of small octagons. The *mihrab* in the *qibla* wall and the two niches on either side equal in height to the *mihrab* are decorated in marble and mother of pearl.

The mosque has two entrances and two minarets. The stone minarets, one in the southeast corner over the residential quarter, and the other over the northwest entrance towards the military sector, are the most outstanding feature of the mosque. The southeast minaret has a rectangular base, a cylindrical middle section and is crowned with a *gawsaq* (colonnaded pavilion). The second minaret decorated in high relief has cylindrical lower and middle sections with carved horizontal zigzags and vertical zigzags, respectively. The upper section displays a deep-fluted carved design. Both minarets are crowned with fluted bulbiform domes, the finials decorated with green glazed tiles similar to the main dome, and bearing an inscription in white on a blue background. This unusual decorative style formed part of the restoration work carried out on the mosque in 736/1335, during which the walls were raised, the ceiling rebuilt, and the upper sections of the minarets decorated with brick and glazed tile.

Faience, or glazed tile, and brick techniques along with bulbiform domes are clearly not a tradition of Cairene origins. Renowned for her prosperity, Cairo attracted many foreign artisans to the city during the reign of Sultan al-Nasir Muhammad. With Mamluk-Mongol relations growing closer in the 720s/1320s Persian techniques and motifs became more widespread. Al-Maqrizi recounts how a master craftsman from Tabriz (a city in northwest Iran) took part in the reconditioning of the mosque and how the minarets were built in the same style as those of 'Ali Shah Mosque in Tabriz.

The main entrance portal to the mosque on the north west façade displays a tri-lobed arch. The second entrance is on the north east side, opposite Bab al-Qulla where the north and south Citadel walls join. Like the main entrance, this portal has a characteristic tri-lobed arch. A third

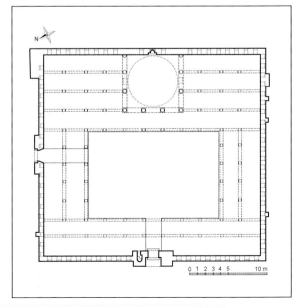

Mosque of Sultan al-Nasir Muhammad, plan, Cairo.

Mosque of Sultan al-Nasir Muhammad, decorations of the dome over the mihrab, Cairo.

was to take charge of its restoration, rebuilding its dome and adding a wooden *minbar*, bearing the name of King Faruq I.

S. B.

I.1.f Madrasa of Qanibay Amir Akhur

The Madrasa of Qanibay Amir Akhur is located in Salah al-Din Square opposite Bab al-Silsila (nowadays Bab al-'Azab) leading to the Sultan's stables.
Opening times: all day except during midday and afternoon prayers (12.00 and 15.00 in winter, 13.00 and 16.00 in summer). The madrasa *is currently being restored and visitors are not allowed inside.*

entrance in the south east wall is once thought to have existed in the second *qibla* aisle, the private access of the Sultan from the area reserved for the harem (*al-harim*); nowadays the door is blocked.

The upper row of arcades overlooking the courtyard shows openings resembling those in the Umayyad Mosque of Damascus. Around the courtyard we find cresting, the corners topped with small incense-burner decorations. While this mosque awoke great interest during the Mamluk reign, in particular in Sultan Qaytbay who was to have the *minbar* restored in coloured marble, the mosque was abandoned during the period of the Ottoman Empire, and the dome and *minbar* fell into ruin. During the British occupation of Cairo, the mosque was used as a military store and prison. In 1947, the Commission for the Conservation of Arab Monuments

Amir Qanibay, *amir akhur* (in charge of the Sultan's stables), ordered this *madrasa* to be built in the time of Sultan al-Ghuri. This information is shown on the entrance and on one of the walls of the mausoleum. The *madrasa* was located near both the horse bazaar (*al-Khuyul*; in its singular *al-Khayl*) and the stables on the lower enclosure of the Citadel.

The problem of the irregular, stepped ground was ingeniously resolved by building its different rooms on various levels. The *sabil* and *kuttab* were located on the lower-ground floor while the mosque and *madrasa*, which are reached by a staircase, were built above the storerooms. The *madrasa* is located next to the southwest wall. The entrance is a tri-lobed arch, above which there is another arch, the *voussoirs* of which take the shape of interlocking trefoil leaves. A hollow space has been left between the lintel and the arch. The minaret is

located to the left of the entrance and has square lower and middle sections, both of which are crowned with balconies supported on stone *muqarnas* brackets. The upper section comprises two tall rectangular-based bodies, both crowned with a *muqarnas* cornice and a bulbiform dome. The minaret has two finials or "heads", rather than the usual one, thus appearing to be a double minaret. It is the oldest of its kind in Cairo followed by the minarets of the al-Ghuri and al-Azhar Mosques.

The *madrasa* comprises an open *durqa'a*, surrounded by two *iwans* and two *sadlas* (small *iwans*). The sanctuary occupies the largest *iwan*, containing a stone *mihrab* and a small wooden *minbar* and is covered by a sail vault, while the *iwan* on the opposite side has a cross vault and two *sadlas* pointed barrel vaults.

The mausoleum is reached through a door in the southeast corner of the *durqa'a*. The tomb is square in shape with a dome resting on pendentives decorated with *muqarnas*. The sides of the octagonal drum under the dome have lamps recessed in the walls.

The wealth of innovative architectural and decorative elements in the *madrasa* makes it one of the finest examples of Mamluk art. These features can be seen on both the façade, the floral decoration of the dome and the double-topped minaret, and on the inside, in the variation of its *iwan* and *sadla* ceilings and in the fascinating decoration on the walls.

The Commission for the Conservation of Arab Monuments restored the *sabil*, *kuttab* and minaret to their original style in 1939.

S. B.

I.1.g Mosque and Madrasa of Sultan Hassan

The Mosque and Madrasa of Sultan Hassan are on Citadel Square opposite the Mosque of Qanibay al-Sayfi. Opposite the mosque and madrasa is al-Rifa'i Mosque, built at the beginning of the 20th century, where Khedive Isma'il and King Fu'ad are buried along with, more recently, the Shah of Iran. The pedestrian walkway lined on either side by the buildings, opens into a garden with a café for those who wish to relax and enjoy the atmosphere of the place.

Opening times: all day except during midday and afternoon prayers (12.00 and 15.00 in winter, 13.00 and 16.00 in summer).

In 757/1356 Sultan Hassan Ibn al-Nasir Muhammad Ibn Qalawun ordered the demolition of the palaces of Amirs Yalbugha al-Yahyawi and al-Tunbugha al-Maridani. They were located on the site of the horse bazaar (*al-Khuyul*) in the

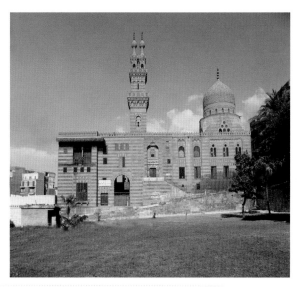

Madrasa of Qanibay Amir Akhur, main façade, Cairo.

Citadel Square, and in their place, he had an architectural complex built. One of the main features of the buildings are their extensive façades on a slight up-hill slope crowned by *muqarnas* cornices, with tall shallow recesses regularly spaced along their length. Such positioning cleverly married the need for surveillance over the city with its facing Mecca, while also facing the direction followed by the Sultan's procession in that period. It allowed anyone approaching the building from the Armourer's bazaar (*suq al-Silah*) and in the direction of the Citadel to contemplate its vast façade in all its detail but not anyone approaching from the opposite direction.

The Sultan Hassan Complex, combining a mosque and a *madrasa*, as was usual in the times of the Mamluk sultans, represents the apogee of several architectural achievements from the earlier *Bahri* era. Its proportions and positioning, howev-

Mosque and Madrasa of Sultan Hassan, decoration on the ceiling of the entrance derka, Cairo.

er, render it exceptional, and as such, it has been chosen here to represent the masterpiece of Cairene Mamluk architecture.

With its lofty portal (36.7 m. high) and majestic semi-dome stalactite vault, the main entrance is the most lavish of Mamluk portals. From here access is gained to the cruciform-domed entrance hall that leads to the service area on one side and to the centre of the building along a double-bending passageway on the other. The floor area of this monumental complex, some 8,000 sq. m., is comprised two main bodies at angles to one another; the service wing with the main entrance being placed at an angle to the building housing the mosque, *madrasa* and mausoleum.

The complex contains lodgings for both teachers and students, and for employees of the *madrasa*. There were also rooms reserved for doctors, a library, baths, kitchens and the *sabil* with the *kuttab* above. The latter two are located on the side of the Armourer's (*al-Silah*) bazaar, into which the original minaret to the right of the main entrance once fell killing every single person in the square at the time. The complex was originally designed to have four minarets; two, however, on either side of the portal were never built, the other two, restored in the 20th century, can be seen on either side of the *qubba* on the south east wall.

The mosque courtyard is paved with marble, in the centre of which an octagonal ritual ablutions fountain stands covered by a wooden dome supported on eight marble pillars. The courtyard is surrounded by four *iwan*s. The largest is that of the *qibla*, in the centre of which we find the *mihrab* decorated in marble of three dif-

ferent colours, with gilt inscriptions. Beside the *mihrab* is the *minbar*, also in marble though undecorated. Its wooden door is faced in brass with gold and silver inlay. In front of the *mihrab* is the splendid marble *dikkat al-muballigh*, (recitation platform) from where the prayers of the day were repeated for all the faithful present to hear. The doors on either side of the *mihrab* lead to the mausoleum *qubba*. The positioning of the mausoleum behind the *iwan* meant that three of its sides were exterior walls gaining maximum visibility from the Citadel, the seat of Mamluk power.

An enormous vault the arch of which is said to be the largest ever built over an *iwan* in Egypt covers the sanctuary. Around the wall of the *iwan* a stucco band bears an inscription of Qur'anic verses, carved in *Kufic* script on a foliate background.

The remaining three *iwans* are smaller also covered by vaults. The doors flanking the north and south *iwans* lead to each of the four *madrasas* destined to be the venues for the teaching of each of the four legal rites (*Shafi'i*, *Maliki*, *Hanafi* and *Hanbali*). The largest of the four is the Hanafi Madrasa in which the name of the surveyor Muhammad Ibn Bilik al-Muhsini appears, who oversaw the building work. Each *madrasa* is centred on an open courtyard with a fountain for ritual ablutions, surrounded by four *iwans*. Adjoining are the students' cells rising up to six floors in height.

In the centre of the square mausoleum hall, whose outer wall overlooks Salah al-Din or Citadel Square, is a wooden screen surrounding the raised marble tomb, which was initially prepared for the burial of Sultan Hassan. Here, however, it was his son al-Shihab Ahmad who was

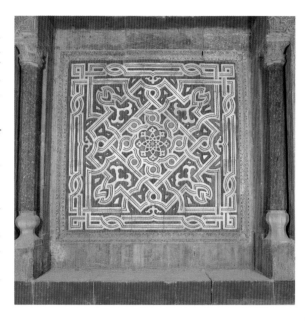

buried, as on the Sultan's assassination his body was never recovered.

Nowadays, the large stone dome over the mausoleum is the result of 17th-century restoration work following a fire that destroyed the original dome. The wooden pendentives with their carved *muqarnas*, luxuriously decorated in coloured paint and gold, originally supported the wooden dome. The mausoleum, with its beautiful *mihrab*, contains a *Qur'an* lectern said to be the oldest one known to Egypt. It also houses the largest mausoleum dome in the country, measuring 21 m. across and 30 m. in height. In addition to other innovative elements, such as the positioning of the *qubba* behind the *iwan*, the domed entrance hall and the plan to crown the portal with two minarets, the building is also outstanding for its water-supply system. Sultan Hassan used the nearby irrigation channel (to the north

Masque and Madrasa of Sultan Hassan, decorative detail in the wall of the derka, Cairo.

Mosque and Madrasa of Sultan Hassan, qibla iwan, Kufic calligraphy on a foliated background, Cairo.

west of the building) to bring and distribute water to the various rooms of the *madrasa* and student lodgings located on different floors. Stone brackets, which used to hold the pipes bringing water to the different areas of the building, can still be seen along the length of the south west façade.

S. B.

I.1.h Madrasa of Gawhar al-Lala

Gawhar al-Lala Madrasa can be reached from the Citadel Square (Salah al-Din) up a steeply stepped street behind the Mosque of al-Rifa'i. This madrasa *is next to the Madrasa of Qanibay Amir Akhur.*
Opening times: all day except during midday and afternoon prayers (12.00 and 15.00 in winter, 13.00 and 16.00 in summer). The madrasa *is currently being restored and visitors are not allowed inside.*

The *madrasa* was built by Amir Gawhar al-Lala (*al-Lala* is the name given to the post of private tutor to sons of a sultan), civil servant in the palace of Sultan Barsbay. Gawhar al-Lala was an emancipated slave,

at one point in service to the son of Barsbay, who died in prison suddenly as a result of an epileptic fit.
The *madrasa* was planned along the lines of the cruciform *madrasas*, popular at the time of the Circassian Mamluks in the 9th/15th century. Inside the building adjacent to the *madrasa* there is a *sabil*, *kuttab* and *qubba* in which its founder is buried, as well as storerooms and lodgings for the students and civil servants. The main entrance in the centre of the southwest façade overlooking Darb al-Labbana Street and the *sabil*, with its wall built of wood, is located in the southern section. It is of the type of *sabil* with a corner column, which came about in the 8th/14th century. The *kuttab* is typically located above the *sabil* and above the façade the minaret rises, built in a style called *al-qulla* or "knob" style, with a single balcony. On the western corner is the mausoleum *qubba*, the door to which is made of wood and distinguished by its copper decoration common to that period. The door, flanked by stone benches, leads to a *derka* (a rectangular hallway), from where via a bent passageway with a *muzammala* and a hidden door leading to Gawhar al-Lala's house, is the *durqa'a*. The Madrasa *durqa'a* is decorated with marvellously coloured marble and covered by a decorated wooden lantern. It has two *iwans* and two *sadlas*, the largest *iwan* being that of the *qibla*.

G. G. H.

I.1.i Entrance of Manjak al-Silahdar Palace

Manjak al-Silahdar Palace is found at the beginning of Suq al-Silah Street, near the

86

*Armourers' bazaar (*al-Silah*) next to Sultan Hassan Mosque.*
Closed to the public, it can only be viewed from the outside.

This palace receives its name from Amir Manjak al-Yusufi al-Silahdar who held the post of *amir al-Silah* or *amir* of Arms during the era of Sultan Hassan. All *amirs* who held this title resided in the palace. Among them was Taghri Bardi, father of the historian Abu al-Mahasin, who was born there.

With the opening of Muhammad 'Ali Street in the 19th century the palace was destroyed and today only the main entrance remains. Its pointed arch is framed by a surround of stone relief that narrows in the middle taking the shape of the Arabic letter *mim*. The arms of its founder, a circle divided into three sections with a sword in its centre, appears on the spandrels. The entrance leads to a *derka* previously covered by a sail vault, which rested on plain pendentives.

G. G. R.

I.1.j **Entrance of Yashbak min Mahdi Palace**

Yashbak min Mahdi Palace is located to the west of the Citadel, near Sultan Hassan Madrasa in Salah al-Din Square.
Closed to the public, it can only be viewed from the outside.

Madrasa of Gawhar al-Lala, general view, Cairo.

Though nowadays only the main-entrance, part of the great hall and a few other vestiges remain from the 7th / 14th century palaces, the Palace of Yashbak min Mahdi is the best conserved of the *amirs'* residences. Built for Amir Sayf al-Din Qusun, *saqi* (cup bearer) and son-

Madrasa of Gawhar al-Lala, marble courtyard floor, Cairo (painting by Mohammed Rushdy).

in-law of Sultan al-Nasir Muhammad Ibn Qalawun, it was nevertheless used by

87

Entrance to Manjak al-Silahdar Palace, Arms of its founder, Cairo.

those who held the post of *atabek* or commander-in-chief of the armies. Amir Yashbak min Mahdi was the first Mamluk to hold simultaneously the posts of First Secretary, Regent of the Kingdom and Commander-in-Chief. During his period of residence in the palace in the Qaytbay period, he had it restored in around the year 880/1475.

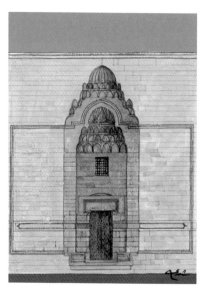

Entrance to Yashbak min Mahdi Palace, Cairo (painting by Mohammed Rushdy).

The majority of what can be seen today dates back to this period. The ruins are on the same site as the palaces of the *amirs*, near the seat of government in the Citadel. In those times, the proximity of the *amirs*' palace to the Citadel was proportional to the importance of his post, hence the location of this residence, belonging to the *atabek* of the armies.

The magnificent portal, second only to that of the Mosque of Sultan Hassan, opens on the north west façade, where the main entrance is crowned by a trilobed arch of coloured marble with decorative motifs carved in stone. An inscription on the entrance with the names of Sultan al-Nasir Muhammad Ibn Qalawun and Amir Yashbak min Mahdi provide us with information about the different stages of construction and reconditioning of the palace.

The deep recessed portal crowned with an extraordinary stalactite vault supporting a ribbed cushion dome, bears the name of two artists, Muhammad Ibn Ahmad and Ahmad Zaghlish al-Shami the Syrian, both of whom took part in its construction.

The solid vaulted halls of the lower floor served as stables and storerooms and upheld the sumptuous reception hall and other rooms above it. The reception hall adopted the traditional design of a large covered courtyard (*durqa'a*), of some 12 m. across, with wide *iwans* along its length and *sadlas* along its width. Despite the state of ruin in which it finds itself today, the importance of this palace can be deduced from the quality and size of the pointed horseshoe arches, with their *al-ablaq* stonework giving us a clear idea of the dimensions of the original building. It is

*Entrance to Yashbak
min Mahdi Palace,
detail, Cairo.*

easy to imagine the splendid marble
paving, the carved wooden ceilings with
their gold and paint work, the central
fountain, the glass windows and the
turned wood screens which in previous
times adorned its interior.

G. G. R.

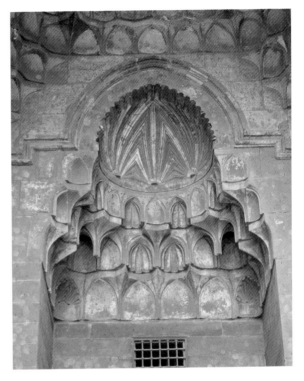

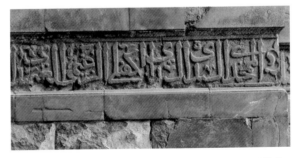

*Entrance to Yashbak
min Mahdi Palace,
naskhi inscription,
Cairo.*

MAMLUK DRESS

Salah El-Bahnasi

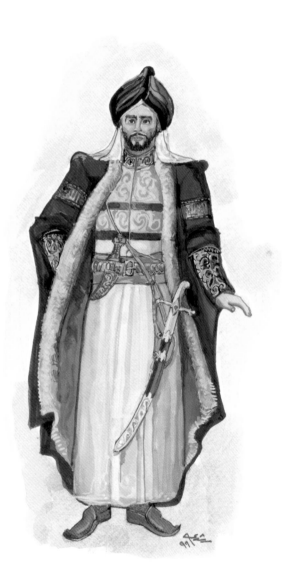

Mamluk Sultan, (painting by Mohammed Rushdy).

This included the manufacture of silk and in particular of patterned materials created with carved wooden printing stamps. Alexandria became famous for the weaving trade and in the words of al-Qalqashandi, the historian, the cloth manufactured there was without equal in the world. Sultan al-Ashraf Sha'ban visited the workshops in Alexandria, and was deeply impressed.

With each social class being identified by a particular style of dress, Mamluk garments were produced in great variety. In addition to this, diplomatic and trading relations between the Mamluks and Europe, India, Iran and China brought further variety to manufacturing and favoured the importation of designs from these countries. Many decorative elements on Mamluk clothing found their inspiration in art forms from Europe and the East.

The garments used by the different social classes of the Mamluks, characterised by their warrior spirit, were associated with military equipment, above all suits of armour, swords, and helmets, shields and axes, which were only displayed on festive occasions.

The Sultan's official dress comprised a turban and black *jubbas*, and a gold belt from which hung a sword. The use of black was considered a sign of loyalty to the Abbasid Caliph, for the Standard of the Abbasid State was of the same colour. On occasions, the sultan would don a fur-lined coat over a woollen or silk garment embroidered with gold thread; on other occasions he wore velvet, and in the summer, white vestments.

*Amir*s wore the fez rather than the turban as a head-dress, which like the cape or cloak was reserved for religious men. In

Mamluk clothing was characterised by designs and decorations that varied according to use or occasion. Clothing formed part of one of the largest industries of the times: the weaving industry.

90

winter they would wear cloth cloaks (*al-jukh*) known as *jukha*.

On Fridays the *khatib*, or prayer leader, would wear black garments, carry a banner of the same colour and a sword, a sign of his rank. Silk garments, however, were deemed to infringe religious law. Muslim religious figures wore white turbans whereas their Christian counterparts wore blue, and Jews yellow. These colours extended to Christian and Jewish dress in general.

Qadi (judges) and learned men wore garments characterised by long loose-fitting sleeves. The majority of men also wore a turban and a cotton tunic, with a low neck and long sleeves. Turbans were on occasions used to carry coins, making them a common target for thieves and bandits.

Dress for women consisted of a long chemise and loose fitting pleated trousers over which a dress or tunic was worn. Women wore a loose-fitting white cloak, known as *izar*, and a headscarf. With the exception of dancers and singers, women also wore the *hijab* (veil) to cover their faces.

Mamluk-period dress generally stands out for its extravagance, often using imported animal furs and skins, and gold or silver adornments. One story has been passed down through the ages recounting how the wife of Sultan Baybars ordered a dress for her son's (al-Aziz Yusuf) circumcision ceremony costing 30,000 Dinars. For each separate dress type there was a special *suq* with its own artisans. Amongst the most important markets is the *al-sharabshiyyin suq*, specialising in head-dresses for the sultan, *amir*s, viziers and judges.

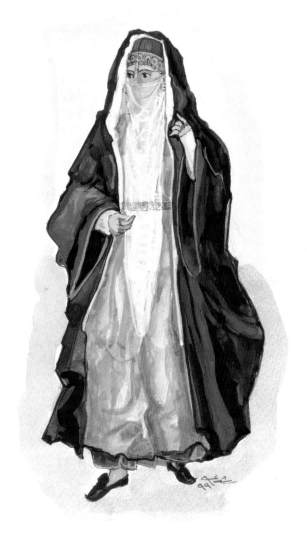

Mamluk woman, (painting by Mohammed Rushdy).

SPORTS AND GAMES IN THE MAMLUK ERA

Salah El-Bahnasi

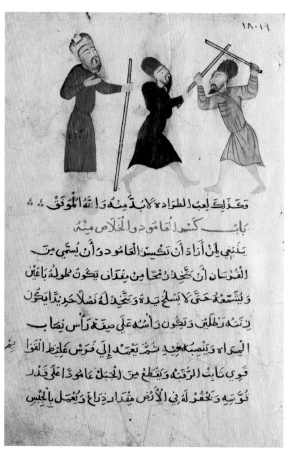

١٨٠١٩

وَكَذَلِكَ لِعِبَ الطَّرَادِ لَا بُدَّ مِنْهُ وَاللّهَ الْمُوَفَّقُ ٠
بَابُ كَسْرِ الْعَامُودِ وَالْخَلَاصِ مِنْهُ
يَنْبَغِي لِمَنْ أَرَادَ أَنْ يُكَسِّرَ الْعَامُودَ وَدَلَّ أَنْ يُسَمِّيَ مِنَ
الْفُرْسَانِ أَنْ يَجِدَ رُمْحًا مِنْ مَفْدَانٍ يَكُونُ طُولُهُ بَاعَيْنِ
وَيَشْتَغِلُ حَتَّى يُسَلِّحَ يَدَهُ وَيَجِدَ لَهُ نَصْلًا حَدِيدًا يَكُونُ
دِنَّهُ رَطْلَيْنِ وَيَكُونُ رَأْسُهُ عَلَى صِفَةِ رَأْسِ نِصَابٍ
الْبَيْرَاهُ وَيُنَصِّبَهُ جَيِّدٌ ثُمَّ يَعْمِدُ إِلَى فَرَسٍ غَلِيظِ الْقَوَى
قَوِيِّ ثَابِتِ الرَّقَبَةِ وَيَقْطَعُ مِنَ الْجَبَلِ عَامُودًا عَلَى قَدْرِ
قُوَّتِهِ وَيَحْفُرُ لَهُ فِي الْأَرْضِ مِقْدَارَ ذِرَاعٍ وَيَعْمَلُ بِالْجِبْسِ

Manuscript on horse riding and fencing, fencing scene, 9ᵗʰ/15ᵗʰ Century, Museum of Islamic Art (reg. no. 180199), Cairo.

In accordance with the overriding principle of "the survival of the fittest" in the times of the Mamluks, they placed great importance on acquiring such virtues as valour and fortitude by means of sport. Horse riding formed an essential part of these activities, for soldiers, *amir*s and the sultan himself. As such, Mamluk governors, and in particular al-Nasir Muhammad Ibn Qalawun, spent enormous sums of money on the purchase of excellent horses. A special administrative unit

(known as *al-rikkab khana*, or horsemen's rooms) was established to take care of the sultan's stables.

Sultan al-Ashraf Qaytbay made sure that, as well as the Mamluks, other sectors of society would learn to ride. Among the many events of the closing ceremony in the equine games during the reign of al-Ashraf Qaytbay, the main event was the day of the procession in honour of the convoy that was to carry the *Kiswa* to Mecca. Among many principles, Islam promotes that of horse riding. There is not a better example of the importance of horses in Mamluk times than the positioning of the *suq* dedicated to their sale near the Citadel – the seat of government. The more than 7,000 horses left behind on Sultan Baybars' death bear even greater testimony to their importance.

The *al-Baytara* manuscript (veterinary science; the profession and art of shoeing horses) conserved in the Egyptian Library contains an illustration of two riders racing. The Museum of Islamic Art houses another manuscript displaying equine games and fencing dating back to Mamluk times. Manuscripts dedicated to horse riding also bear scenes of fencing between two contenders accompanied by a third holding a pole seemingly acting as referee.

Of the most attractive sports for the Mamluks was *qabaq*. This consisted of firing an arrow at a gold or silver recipient, inside which a dove was placed. Whoever hit the target – decapitating the dove – won the competition and was awarded the gold recipient as a trophy. A special area on the edge of Bab al-Nasr was reserved for the practice of this sport. An illustrated Mamluk manuscript dating from the year 875/1471, kept in the National Library in Paris, shows two

horsemen aiming their arrows at a target – a recipient placed on high ground.

Hunting was another of the Mamluks' favourite sports and was considered a manifestation of power and prestige. Specially trained birds and dogs were used in the hunt, as well as firearms. The prey caught was considered among the most precious presents exchanged between the governors of the time. It was customary to hunt during the spring. Furthermore, hunting was not considered simply a sport, but also a form of entertainment, and singers, musicians and jesters usually accompanied sultans on a hunt. From time to time, however, such events would end in disaster. Once outside the protection of the city, enemies of the sultan would take the opportunity to do away with their master; a fate Sultans Qutuz and al-Ashraf Khalil were to meet.

Sultans were also passionate about ball games and especially *jawkan*, a sport played on horseback with a long pole with a curved end. Sultan Baybars was said to play three matches a day on Saturdays during the festivities that followed the annual flooding of the Nile. Such was the interest the Mamluks had in this game that certain civil servants were chosen and given special tasks for this activity, such as the *jawkandar*, in charge of having the sultan's playing equipment ready. Mamluk works of art show scenes inspired by the sport. Examples can be seen on a gold and silver inlaid brass recipient from the end of the 7th/13th century, kept in the Panaki Museum in Athens; also on an enamelled glass bottle in the Islamic Museum in Berlin.

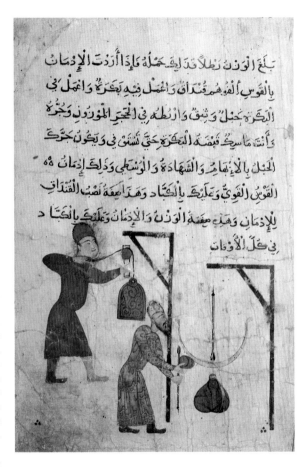

Swimming was another important sport of the times and skill was demonstrated by swimming across the Nile from bank to bank. One of the sultans most famed for his skill in this sport was al-Mu'ayyad Shaykh. Wrestling had many followers, but it was reserved for *amirs* and not for sultans given the inappropriate postures required.

Manuscript on horse riding and fencing, weight-lifting scene, 9th/15th Century, Museum of Islamic Art (reg. no. 18235), Cairo.

93

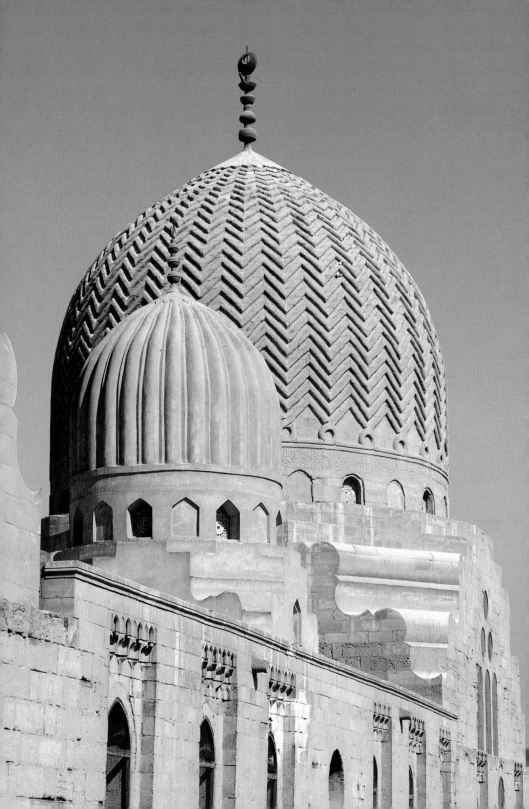

The Sultan's Procession

Ali Ateya, Salah El-Bahnasi, Mohamed Hossam El-Din, Medhat El-Menabbawi, Tarek Torky

II.I CAIRO

First day

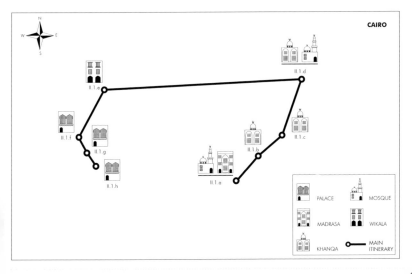

Khanqa of Sultan Farag Ibn Barquq, detail of the domes, Cairo.

95

*Khanqa of Sultan
Faraq Ibn Barquq,
minaret, Cairo.*

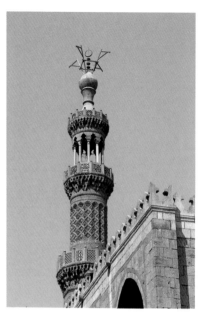

Since Fatimid times and thereafter throughout the reign of the Ayyubids and the Mamluks, Caliphs and Sultans held processions to celebrate important events such as religious festivals, the investiture of high-ranking officials and victorious military campaigns. Such celebrations were among the few occasions in the year that ordinary people would view the display of wealth of the Sultan and his court.

While these events varied greatly the most spectacular and the richest in symbolism and vestments was the procession in honour of the accession of a new sultan, an occasion of great pomp and ceremony for the palace, which ended with the celebration of a magnificent procession through the city. The sultan would take part in the procession surrounded by his *amirs* and Mamluks, while the head of the sultan's guard would lead the pro-

cession, followed by his mounted guard. The Mamluks wore special tunics for the occasion of yellow silk embroidered in gold with gold ribbons attaching them to their sovereign. The sultan, on his pure bred horse, wore black, embroidered in gold, while a high-ranking *amir* sporting a black turban (black being the colour of the Abbasids) would hold the royal sunshade over his master's head. The sunshade shone with gold embroidery and was topped with a gold-plated silver bird. The sultan wore a long-sleeved black or green silk tunic embroidered in gold thread, and around his waist was tied a golden sword. Halberdiers would surround the sultan behind whom would be horsemen throwing coins to the crowds. Then came the standard bearers led by a high-ranking official who carried the royal flag. The city was decorated and illuminated, *amirs* placed silk banderols along the route, which the people would pull down once the new sultan had passed.

On leaving the rear of the Citadel, the sultan would go down around its outer walls to the west and then to the north, entering the Desert of the Mamluks on the edge of Cairo. There the procession would reach the present-day Gate of Qaytbay, near the *madrasa* and mosque of the same name, whence the procession truly began. The procession would follow its route as far as the *qubba* of Sultan Abu Sa'id Qansuh before turning west to enter the city through Bab al-Nasr, "Gate of the Victory", adjacent to the Fatimid Mosque of al-Hakim bi-Amr Allah.

Studies have shown us that Bab al-Nasr, was the only gate through which sultans would enter the city of Cairo. Sultan al-Ghuri, nevertheless, reversed this tradition by leaving through it on setting

out to go into battle against the Ottomans in Syria in 922/1516. This same procession was his last, for he was to die in battle.

Once through Bab al-Nasr, the sultan's procession would follow the street of the same name as far as the Madrasa of Amir Gamal al-Din al-Ustadar, whereupon it turned right into al-Tumbukshiyya Street passing the *sabil* of Amir 'Abd al-Rahman Katkhuda. There the procession turned left along al-Qasba or *al-A'dam* (main) Street, (nowadays al-Mu'izz li-Din Allah Street). On reaching Bab Zuwayla the procession would be led left along Darb al-Ahmar Street, continuing straight on at the crossroads with the Armourers' bazaar Street (*Suq al-Silah*) where the street name changed to Bab al-Wazir Street, until reaching al-Mahgar Street and turning left to return to the Citadel.

This route, known as "the way of the sultan" (*al-tariq al-sultani*), was the same one the sultan took on his return from the north of Cairo to the Citadel.

The same procession was organised on two further major occasions: the investiture of the highest ranking cadis and *amirs* and the celebration of the sighting of the new moon, in particular that of the new moon designating the beginning of the Holy month of *Ramadan*. The latter procession differed only in that it made a stop at the complex of Sultan Qalawun for religious men to ascend its minaret to observe the new moon.

Likewise, the procession of *Mahmal* followed the same route. The *Mahmal* procession would accompany the portable platform bearing the *Kiswa* of the *Ka'ba* prior to its being sent to Mecca with the pilgrims. Its route only varied in that it continued straight ahead on reaching Bab

Zuwayla along al-Khayamiyya and al-Suruguiyya Streets, as far as Citadel Square. There, the sultan on a seat of honour specially prepared for the occasion would receive the retinue. The camel bearing the *Kiswa* of the *Ka'ba* would come forward and kneel down in front of him, for the sultan to examine the quality of the cloth, its detailed decoration and to give his approval.

The fact that the majority of sultans and high-ranking officials of State had their monuments constructed along the route

Bab Zuwayla and minaret of the Mosque of Sultan al-Mu'ayyad Shaykh, Cairo (D. Roberts, 1996, courtesy of the American University of Cairo).

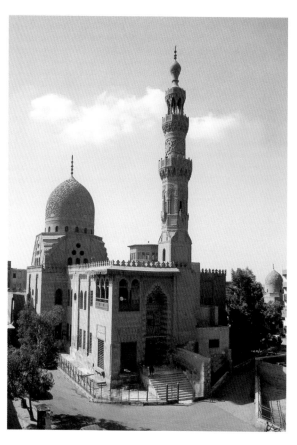

Madrasa and Mosque of Sultan Qaytbay, general view, Cairo.

the Palace of Bashtak, Qa'a of Muhib al-Din and the reception hall (*maq'ad*) of Mamay al-Sayfi, all included in the first day of this itinerary. The second day begins near Bab Zuwayla where we visit the Mosque of Sultan al-Mu'ayyad Shaykh, followed by a visit to the Madrasa of Qujmas al-Ishaqi, the Mosque of al-Tunbugha al-Maridani, and the Madrasa of Umm al-Sultan Sha'ban.

M.H.D. and T.T.

II.1 CAIRO

II.1.a Madrasa and Mosque of Sultan Qaytbay

Qaytbay Madrasa and its annexes are located in the Mamluk Cemetery, (or North Cemetery). From Salah Salim Avenue, turn right for Farag Ibn Barquq Street as far as the khanqa *of the same name and then turn right and southwards past the Khanqa of Barsbay until you come out right in front of the monument. Notice that this architectural complex appears on the Egyptian one-pound note.*
Opening times: all day except during midday and afternoon prayers (12.00 and 15.00 in winter, 13.00 and 16.00 in summer).

bears testimony to the importance of the procession. Many of their buildings can be seen in the Mamluk Cemetery, (between Salah Salim Avenue and the modern-day motorway opposite the area of al-Azhar), beginning with the Madrasa and Mosque of Sultan Qaytbay, followed by the *khanqa*s of Sultan al-Ashraf Barsbay and Sultan Farag Ibn Barquq, and finally by the complexes of Qurqumas Amir Kabir and of Sultan Inal. Near Bab al-Nasr, we find the *wikala* of Sultan Qaytbay, followed by

This complex was commissioned by Sultan al-Malik al-Ashraf Abi al-Nasr Qaytbay. Born in 826/1423, he held different positions in the Circassian Mamluk State before acceding to the throne in 872/1468. Qaytbay was the longest reigning Sultan of Circassian origin. His reign of almost 29 years in total, ended with his death in 901/1496 and was not only exceptional for its length but also for

passers-by to drink from, above which a *kuttab* is located for the schooling of children. This huge enclosure has a *madrasa* specialising in the four religious doctrines located in the main part of the building, which given the presence of a *minbar* and a minaret also served as a congregational mosque.

Located in the desert on the crossroads of trading routes with Syria from north to south and with the Red Sea from east to west, the complex married both the pro-

Madrasa and Mosque of Sultan Qaytbay, metal decoration on the door, Cairo.

Madrasa and Mosque of Sultan Qaytbay, qibla iwan, Cairo.

his efficient running of the country and military victories. With the stability Sultan Qaytbay brought to the economy, a hitherto unprecedented artistic renaissance was allowed to flourish and he earned himself a place in history notably for his interest in architecture. He promoted over 60 projects, of all kinds of buildings, in and around Cairo, Mecca, Medina, Damascus and Jerusalem. Those built during his reign range from mosques and houses to *wikalas*, such as the Bab al-Nasr *wikala,* among others. They are noted not so much for their dimensions as for their elegance and stylistic harmony. Decorated using products from the renewed industry of Mamluk artisans, in particular damascene and manuscript, they are fine examples of the architecture of the period.

The Mosque and Madrasa Complex of Sultan Qaytbay, built to serve several purposes, is considered the jewel of Mamluk architecture; it was here that Mamluk decorative arts were to coalesce reaching their zenith. The building contains rooms for students, a burial *qubba* and a *sabil* for

Madrasa and Mosque of Sultan Qaytbay, durqa'a ceiling, Cairo. *Madrasa and Mosque of Sultan Qaytbay, wooden minbar, detail* *of decoration with ivory and Qur'an lectern, Cairo.*

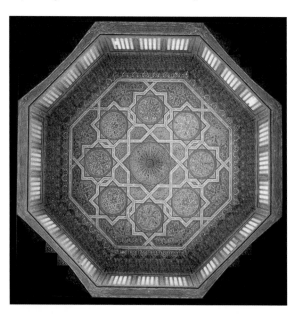

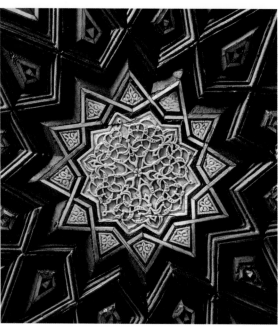

vision of accommodation (*rab'*) for travellers and traders with the function of a trading centre.

Beside the complex are the tombs of the Qaytbay family, the Madrasa of Qaytbay's sons, a drinking place for animals and a reception hall (*maq'ad*), all of which display impressive architectural finesse.

The façade comprises the monumental doorway, a *sabil* façade and a minaret. Along the southeast wall, crowned with a row of fleur-de-lys cresting, the *qibla iwan* wall is clearly visible – symmetrically divided into two vertical recesses.

Characteristic of the Mamluk era is the flight of stairs ascending to the high front entrance which is typically crowned by a tri-lobed arch with its stone benches (*mastaba*) on either side. The door leads to a rectangular *derka* (hall) with a stone bench decorated with marble of different colours. To the left a door leads into the *sabil* room on the ground floor, above which is the open balcony of the *kuttab*. The doorway to the right leads to the stairs up to the minaret, the *kuttab* and to rooms for Sufis and students. The *derka* leads to a winding passageway, in which we find a *muzammala*, a recess with an earthenware jug inside, eventually leading to the *madrasa* courtyard and the tomb. The *madrasa* is located around a small square courtyard, known as a *durqa'a*, and covered by a wooden ceiling with a central lantern. There are two *sadlas*, one on each side of the courtyard and two *iwans*, the largest being that of the *qibla*, which on occasion takes the role of a prayer hall. Four stucco windows set with coloured-glass encrustation crown the *qibla* wall, with its *mihrab*.

The walls of the courtyard were original-
ly covered by marble panels, which with
time have disappeared, while the ceiling
is constructed out of wood and decorat-
ed with paint and gold. A band bearing an
inscription runs around the upper section
of this *iwan*, in which the titles of the sul-
tan and the date of construction of the
madrasa (877/1472) appear. The wooden
minbar is inlaid with ivory and mother of
pearl in clearly defined star-shapes. In the
same *qibla iwan* there is an inlaid chair in
which the reader of the *Qur'an* sat on Fri-
days. To the right of the sanctuary and
behind a wooden screen is the sultan's
tomb. The mausoleum is square (9.25 m.
in length and 31 m. in height), its walls
over 2 m. thick in order to bear the
weight of the structure with its enormous
dome. Inside, the mausoleum floor, walls
and *mihrab* were covered by a splendid
marble decoration. The transition zone of
the dome is supported by pendentives
with nine rows of simple yet delicately
carved stone *muqarnas*. The dome has nar-
row triple-arched windows, above which
there are three bulls-eye windows. A
narrow drum with 16 windows upholds
the dome, which inside is completely
plain. In contrast, the outside of the
dome displays a double design: one of
geometric lattice patterns, and the other
floral arabesques, which become
entwined and fall naturally in harmony
with the curve of the dome. The geo-
metric design is cut in smooth lines,
while the leaf pattern is scored with bev-
elled edges. The two networks of pat-
terning contrast with the plain dome
surface and the complexity of the design
along with the refinement of its execu-
tion and elegance makes it one of the
most perfect expressions of decorative
stonework from the Mamluk era. It is an

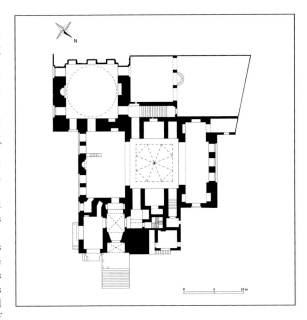

often-quoted masterpiece of Cairene
carved stone domes. In addition, the tri-
angular spaces in the corners have been
used on either side of the windows to
carve roundels with the distinctive epi-
graph of Sultan Qaytbay.
The slender and elegant minaret is locat-
ed to the right of the main entrance and
the combination of its construction and
decoration make it one of the most per-
fect examples of Mamluk minarets. It
soars from its square base to the height of
40 m. in a series of sections, octagonal,
circular and then a colonnaded pavilion
(*gawsaq*), each one separated by a balcony
supported on a *muqarnas* cornice. The
cylindrical shaft is decorated in stone, a
similar design to that of the dome, while
the upper section has open arches sup-
ported on columns (*gawsaq*) and is crown-
ed by a bulbiform finial.

A. A.

*Madrasa and Mosque
of Sultan Qaytbay,
plan, Cairo.*

101

In the small square opposite the main entrance to the madrasa *is a popular workshop in which traditional local glasswork is still made. Glassblowing techniques, which have been passed down from ancient times, the origins of which date back to the pharaohs (Middle Empire), are still used today. Murals in the tombs of the ancient Necropolis in Bani Hassan, El-Minya, represent glass manufacture using the blowing technique.*

II.1.b **Khanqa of Sultan al-Ashraf Barsbay**

Khanqa of Sultan al-Ashraf Barsbay, general view, Cairo.

This khanqa *is located in the Mamluk Cemetery, half way between the Mosque and Madrasa of Qaytbay and the Khanqa of Farag Ibn Barquq walking northwards.*

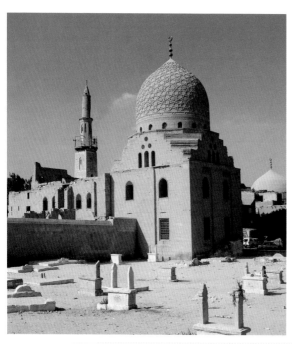

Opening times: All day except during midday and afternoon prayers (12.00 and15.00 in winter, 13.00 and 16.00 in summer).

Sultan al-Ashraf Barsbay (780/1378-841/1438) had this architectural complex built to serve several purposes. He was one of Sultan Barquq's Mamluks and had held different positions from *saqi*, or cupbearer, to *amir* in the times of al-Mu'ayyad Shaykh, before becoming Sultan in the year 825/1421. His era is noted for the overriding stability and security it provided.

This complex comprises a *khanqa* where Sufis had rooms, a small mosque, the Sultan's private mausoleum and two tombs for his relatives. It also had two *sabils* and a kitchen. The building has sadly been affected by successive subsidence and collapse: its minaret toppled to the ground and was replaced in the Ottoman era, and nowadays only the mosque remains.

The façade bears an inscription indicating the creation of a *waqf* foundation specifically for the complex. The text sets out the role of each of its quarters including stipulations with reference to expenses and the source of its financing. According to the inscription, construction was completed in the year 835/1451.

The most notable feature of the complex is the lengthy façade along the main street uniting the *khanqa*, *sabil*, *qubba* and *madrasa*. The mosque is reached by the west door, a monumental portal with the traditional Mamluk tri-lobed arch. The entrance leads to a *derka*, with a polychrome wooden ceiling. A passageway to the left leads to the *madrasa* and mosque, comprising a rectangular *durqa'a* with an *iwan* on two of its sides. This design is the resulting blend of the hypostyle mosque

plan with the cruciform *madrasa* layout, with its *iwans* divided from the centre by aisles parallel to the *qibla* wall. The marble columns supporting the arches, in turn support a ceiling decorated with truly magnificent colours. The sanctuary is bare but for the decoration of the *minbar*, donated to the mosque in 857/1453. With its elegant star-shaped decorations and ivory inlay, the *minbar* is one of the most beautiful examples of its kind from the Mamluk period still preserved in Cairo.

The *qubba* occupies a square hall the walls of which are decorated with coloured marble, the marble tomb of Sultan Barsbay placed in the centre. The *mihrab* is lavishly decorated in marble and mother-of-pearl mosaics.

Outside, the dome bears geometric motifs with star shapes. The minaret has three sections; the lower square-based section is the only surviving part of the building's original construction, onto which a second octagonal and a circular upper section were later added. The pointed finial dates back to Ottoman times.

A. A.

II.1.c **Khanqa of Sultan Farag Ibn Barquq**

The khanqa is located in the Mamluk Cemetery, near the Khanqa of Barsbay to the north. Opening times: All day except during midday and afternoon prayers (12.00 and 15.00 in winter, 13.00 and 16.00 in summer).

The mosque was commissioned by Sultan al-Nasir Nasir al-Din Farag, son of the first Circassian Mamluk Sultan Barquq.

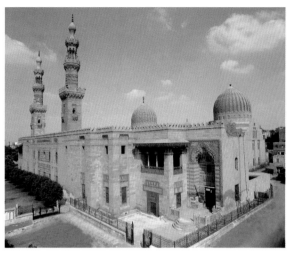

Khanqa of Sultan Farag Ibn Barquq, general view, Cairo.

Sultan Farag Ibn Barquq was born in 791/1388 and on the death of his father acceded to the throne in 801/1399 at the tender age of 10. He was deposed once in 808/1405 but returned to power a year later. He died in 810/1412 at the hands of Amir Shaykh, who succeeded him to become Sultan al-Mu'ayyad Shaykh.

On locating the complex on the site of what had previously been used as a hippodrome, Sultan Farag Ibn Barquq aimed to unite this district with the rest of urban Cairo and to turn the barren land into a residential quarter. He had the annual procession at the beginning of the pilgrimage to Mecca redirected so that it passed through the grounds of his complex and commissioned the building of *suqs*, lodgings for travellers, *hammams*, ovens and bakeries on the site. He was, however, to die before the project reached completion. Located in the desert on open ground to the east of the Fatimid city walls, the *khanqa* was built without the usual urban land restrictions. The building served many purposes; first-

103

*Khanqa of Sultan
Farag Ibn Barquq,
sanctuary aisle, Cairo.*

*Khanqa of Sultan
Farag Ibn Barquq,
wooden screen of the
Sultan's tomb, Cairo.*

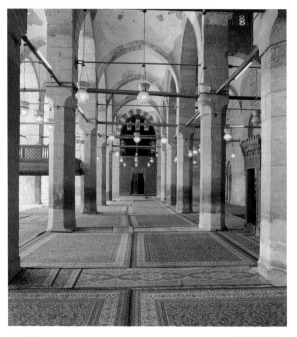

ly, that of mausoleum for his father, Sultan Barquq, who in his will, had expressed the wish to be buried in the North Cemetery. It also housed two *qubbas*, one for men and the other for women. The two minarets on the northwest wall not only indicate that the building also fulfilled the role of mosque, but its *minbar* and *dikkat al-muballigh* (recitation platform) indicates that it was also used as a congregational mosque for Friday prayer.

Rooms annexed to the building provided a residence for Sufis and a school for their students. An additional function was that of the two *sabils* built into its walls, supplying water to passers-by in the desert. Above each *sabil*, a *kuttab* was built for the schooling of orphans.

The outer four walls of this architectural complex are plain. The northwest façade and main wall is divided into sections by vertical recesses crowned by a stalactite cornice. In each recess there are two windows, one above the other, the lower window being the larger of the two, and framed by *al-ablaq* stonework. This façade, which has decorative fleur-de-lys cresting, supports the two minarets placed symmetrically in its centre, and two *sabils*, one at each end. The southeast façade is next in importance, also sectioned by similar recesses with a *qubba* dome rising at each end.

The building has two double entrances one at either end of the northwest wall (the western entrance is the one in use today). These monumental entrances are crowned by tri-lobed arches with their semi-domes filled with *muqarnas*, or stalactite, decoration.

The entrances have stone benches on either side and through the doorway, the *derka* is reached covered by a rib vault.

From here various passageways, each with a *muzammala* and several doors leading off, one of which goes down to the *sabil*, lead to the wide-open courtyard with a portico on each of its four sides. The largest portico is along the *qibla* wall comprising three aisles of arcades running parallel to the *mihrab* wall. Perpendicular to these aisles are rows of arches meeting at the ceiling thus forming square areas covered by small sail vaults. The aisle nearest the *qibla* wall, in contrast, has a drum dome over the section directly in front of the *mihrab*. The *qibla* wall is punctuated by rectangular windows with bronze grilles and at the top, coloured glass set in stucco windows. The sanctuary has a stone *minbar*, which was donated by Sultan Qaytbay in the year 888/1483. It is noted for its delicate decoration, the carved pattern formed of star shapes similar to the work more frequently encountered in wood designs. The wooden *dikkat al-muballigh* (recitation platform) was also part of renovation work carried out by Sultan Qaytbay. On each side of this hypostyle hall a door leads to the burial *qubbas*. The doorways

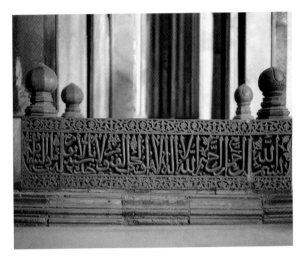

are decorated with wooden screens bearing geometric and inlaid designs similar to those of the *mashrabiyyas* in the complex of Sultan Barquq in al-Mu'izz li-Din Allah Street.

Each mausoleum comprises a square chamber with a *mihrab* and a high dome rising above painted with red-and-black floral motifs imitating marble, a material that would have been too costly and too heavy for the structure. The pen-

Khanqa of Sultan Farag Ibn Barquq, the Sultan's tomb, Cairo.

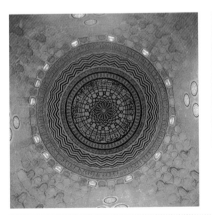

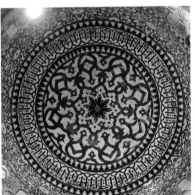

Khanqa of Sultan Farag Ibn Barquq, women's qubba dome, detail of decoration, Cairo.

Khanqa of Sultan Farag Ibn Barquq, men's qubba dome, detail of decoration, Cairo.

dentives are impressive with their nine rows of stone *muqarnas* decoration, while the outer surface of the domes is decorated with a horizontal chevron design gradually reducing in size towards the top of the dome. The considerable thrust of these twin domes is absorbed by the solid masonry transition, which appears lighter to our eyes by the ingenious positioning of concave and convex mouldings. These domes measuring over 14 m. in diameter clearly demonstrate the evolution that stonemasonry underwent, which here substitute the earlier ribbed vault designs, and which became one of the most popular styles of decoration on Cairene domes. Both are among the earliest domes of such dimensions to be built in Cairo, and show the degree to which Mamluk architecture was to develop.

Sultan Barquq and his son 'Abd al-'Aziz are buried in the northern *qubba*; the Sul-

tan's other son Farag Ibn Barquq, was assassinated in Syria where his body remained. His daughters are buried in the southern mausoleum along with their nanny.

The Sufis' rooms are grouped together to the rear on the north east side. Their rectangular rooms are located on the three floors. The identical minarets rise high above the northwest façade. The square, lower section is followed by a cylindrical middle section bearing a knotted design and crowned with a *gawsaq*. The transition between each section supports a balcony with a *muqarnas* cornice. Both minarets support bulbiform finials, characteristic of Mamluk minarets.

A. A.

II.1.d Complexes of Qurqumas Amir Kabir and Sultan Inal

These enormous architectural complexes are located in the Mamluk Cemetery, adjacent to each other and surrounded by the same fence. From the previous monument, walk towards Salah Salim Avenue and turn right onto Ahmad Ibn Inal Street.

Opening times: All day except during midday and afternoon prayers (12.00 and 15.00 in winter, 13.00 and 16.00 p.m. in summer). This monument is currently undergoing restoration and visitors are not allowed inside.

Complex of Qurqumas Amir Kabir

Qurqumas was one of Qaytbay's Circassian Mamluks who held several different military ranks. While under Sultan al-Ghuri (r.906/1501-22/1516), Qurqumas was to shine and soon became an extreme-

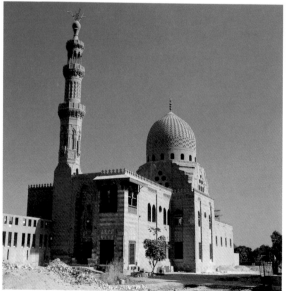

Complex of Qurqumas Amir Kabir, general view, Cairo.

*Complexes of
Qurqumas Amir Kabir
and Sultan Inal, view
of the residential
palace, Cairo.*

ly close confidant to his master. He was named *amir* and later became commander in chief of the armies.

Qurqumas had the building constructed in several stages. First, the cemetery *qubba* was constructed in the year 911/1506, followed by the residential palace and the burial enclosure located to the rear. Subsequently a *madrasa* was added followed by the mosque, *sabil*, *kuttab* and a square room before the *qubba* for banqueting. In the final stages, two floors were added for Sufis, the building reaching its completion in the month of *rajab* in the year 913/November 1507.

The skilful combination of its varied architectural elements characterises this complex designed for multiple purposes. The entrance, crowned by a tri-lobed arch, is flanked by the *sabil* to its left, above which a *kuttab* is located. To the right of the entrance is the highly stylised minaret, with its magnificent carved stone decoration. Comprising four sec-

tions, (square based, hexagonal, cylindrical and then *gawsaq*) it soars up from ground level acquiring an overall sense of stability. The base of the carved-stone dome bears three rows of rhombuses, which transform into a chevron design on the upper part of the dome.

Such skilled architectural balance between the harmony of its decoration and its multifarious functions has earned it a place among the most impressive complexes built by the Circassian Mamluks. In its layout and proportions it closely parallels the complex of Sultan Qaytbay, with the *kuttab* to the left of the entrance above the *sabil* and the minaret to its right rising majestically from ground level; the mausoleum dome, towards the rear, overlooking the whole complex. Originally, the complex included storerooms, kitchens, houses, wells, water wheels, stables and courtyards for ritual ablutions. Today only the building housing the mosque, *madrasa*, *sabil*, *kuttab*, private houses and the mau-

107

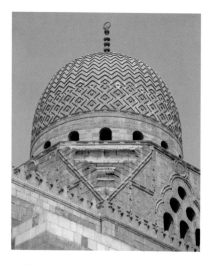

Complex of Qurqumas Amir Kabir, mausoleum dome, Cairo.

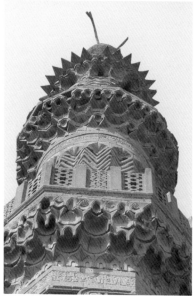

Complex of Sultan Inal, detail of the minaret, Cairo.

storerooms and stables and on the upper floor there is an open space, the reception hall, a bedroom and a toilet. This is the only surviving example of these extremely important multi-purpose architectural complexes built in the desert.

Complex of Sultan Inal

It was not until 857/1453 at the age of 73 that Sultan Inal acceded to the throne and commissioned this architectural complex. The complex comprises several buildings designed to fulfil different purposes, such as the *madrasa*, with its cruciform plan and four *iwans* (remarkably similar to the Qurqumas and Qaytbay *madrasa*s). The *khanqa*, residence of the Sufis and a burial *qubba*, built by Amir al-Gamali Yusuf. An enclosure for the burial of Sufis and a *sabil*, to provide drinking water for passers-by and a watering trough for animals, also a palace and reception hall (*maq'ad*). Begun in 855/1451, its construction was completed five years later.

The main façade of this architectural complex, built with the *mushahhar*, or two-coloured masonry technique, lies along the street facing south east. It comprises the *qubba*, *madrasa* and main entrance on which the foundation inscription is located.

The burial *qubba* with its *muqarnas*-decorated pendentives supporting the dome is reached via the sanctuary. The outer decoration on the dome is a horizontal chevron design similar to that of the domes on the *khanqa* of Farag Ibn Barquq. The minaret, located to the south of the building, starts from a square base, followed by an octagonal

soleum remains; the most outstanding of its sections being the rooms located to the rear of the building, understood to be the palace. On the ground floor there are

middle section, and is crowned with a bulbiform finial similar to other Circassian minarets.

Parts of the building have collapsed on several occasions and only the area described above is now visible.

A. A.

II.1.e Wikala of Sultan Qaytbay

This trading establishment is to the right of the entrance through Bab al-Nasr. From the complexes of Qurqumas and Inal, go towards Salah Salem Avenue and take Galal Street as far as Bab al-Nasr.
Opening times: from 08.00 to sunset. Currently being restored, visitors are not allowed inside. Nevertheless, an information panel displaying its floor plan gives a good overall view of the monument.

In 884/1479 on a pilgrimage to Mecca, Sultan Qaytbay was so overcome by the hardship of the destitute people he saw there, that on his return in 885/1480, he decided to build a *wikala*. He would invest a proportion of its income to purchase *dashisha* (milled grain) to distribute among the poor at Holy places, hence the popular name for the building, "*dashisha wikala*". From this moment onwards it became the model for *wikalas*, used as storerooms, trading posts and lodgings for traders.

A *thuluth* inscription over the door reads: "In the name of God, Compassionate and Merciful, our Lord, Defender and King, his majesty al-Malik al-Ashraf Abi al-Nasr Qaytbay, ordered this blessed place to be built, may God glorify him and his victory, who ordered the founding of the *waqf* to subsidise the costs of the brethren of

Wikala of Sultan Qaytbay, façade, Cairo.

Medina and of the Prophet, to buy wheat with which to make *dashisha* for the needy of the city and for those who come to her, in God's honour".

Parts of the original *wikala* can still be seen today such as the ground-floor storerooms and some of the first floor rooms adjacent to the back wall of al-Hakim bi-Amr Allah Mosque.

The façade along Bab al-Nasr Street is divided by horizontal lines into three sections. The main entrance is in the centre, flanked on both sides by five shops, each one crowned by a *mashrabiyya* screen, which in turn is topped at the highest point by three openings with iron grilles. The tri-lobed arch over the entrance rises to the same height as these windows, its spandrels decorated in a floral relief pattern and in its centre a

Palace of Bashtak, present-day entrance, Cairo.

senting ribs, the second covered by a barrel vault.

The document of the constitution of the *wikala* as a *waqf* foundation, mentions a courtyard in which the stores were located. Access to these storerooms was via a staircase within the courtyard. Rooms on the upper floor where traders lodged were reached from the side doors. There are currently 30 stores in the form of vaulted chambers opening onto the courtyard in which goods were deposited or displayed.

M. H. D.

II.1.f Palace of Bashtak

The Palace of Bashtak is located on al-Mu'izz li-Din Allah Street, opposite the Madrasas of Barquq and al-Kamiliyya. It is reached by following Bab al-Nasr as far as the Khanqa of Sa'id al-Su'da' and then turning right. Continue as far as the crossroads with al-Mu'izz li-Din Allah Street and follow it to the left until you reach the next crossroads with Qurmuz Street, where the present-day entrance to the palace is found.

Following an agreement between the Organisation for Egyptian Monuments and the German Institute for Oriental Monuments in Cairo, the first stage of renovation on the building was completed in 1984, which uncovered many of the palace's features.

Opening times: from 08.00 to sunset.

circular medallion bearing Sultan Qaytbay's arms.

Of the five entrances to the *wikala*, only three remain. On one side of the main entrance *thuluth* inscriptions read: "Damned be the son of the damned who cheats in this *wikala*, the *wikala* of the Prophet, or he who cheats with weights".

The entrance leads to a passageway covered by two types of dome; the first being a cross vault with its decoration repre-

The palace was built on part of the land belonging to the Great Eastern Fatimid Palace. Amir Bashtak al-Nasiri, husband of one of Sultan al-Nasir Muhammad's daughters commissioned the palace which was to see many owners before finally being abandoned and left to fall almost

*Palace of Bashtak,
aghani in the durqaʻa
façade, Cairo.*

completely to ruin. In spite of this, what can still be seen today reveals the splendour and beauty of the original palace. Al-Maqrizi's *Khitat* contains a description of the palace, which in those days rose five storeys high. The builder made the most of the building's location between the main streets where trading activity flourished, to include shops on the ground floor of the building.

The western wall of the palace faces al-Muʻizz li-Din Allah Street, the northern façade onto Qurmuz Street, and the original main entrance, currently closed up, lies on Bayt al-Qadi Street. The present-day entrance portal, comprising three pointed arches carved successively into the depth of the wall and flanked by a pair of stone *mastaba*, leads to a *derka* with a door on either side. The left door leads to a vaulted passageway and to the stables while a staircase through the right-hand door leads to the upper floor.

The main hall is reached from the balcony of the second floor, organised around a *durqaʻa,* with four *iwans.* The magnificent coffered ceilings are made of wood with elaborate decorations. The ceiling extends up to the three rows of *muqarnas* decoration in each corner. A marble fountain in the centre of the *durqaʻa*, would have humidified and cooled the atmosphere with its fine droplets while the *amir* held audience with his visitors.

The third floor housed living quarters and the palace *al-haramlek* (the ladies' residence). Over the main *iwan* are six pointed arches resting on seven octagonal marble columns, between which fine *mashrabiyya* screens were placed. Small windows known as *aghani* opened in the screens onto the *durqaʻa* where *aghani* (chant concerts) and other recitals were

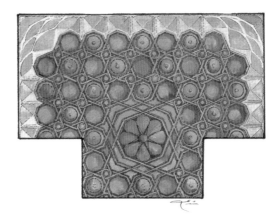

held. The men would attend while the women sat behind the *mashrabiyya* screens (out of sight) from where they could listen.

It is worth noting that the climactic conditions and high temperatures of Cairo

*Palace of Bashtak,
durqaʻa ceiling, Cairo
(painting by
Mohammed Rushdy).*

111

Qa'a of Muhib al-Din, plan, Cairo.

dictated the use of different building materials. As such, the main building was constructed of stone, which helped insulate from the heat, along with extensive use of marble for floors and wall panels. *Mashrabiyyas* were used both to give the palace residents privacy, and to shield them from the dazzling sunlight, softening the air inside.

M. M.

II.1.g Qa'a of Muhib al-Din

The Qa'a of Muhib al-Din is located on Bayt al-Qadi Street, opposite the Maq'ad (reception hall) of Mamay al-Sayfi. It is reached from al-Mu'izz li-Din Allah Street towards Bab Zuwayla. When level with the Qalawun complex turn left and go along Bayt al-Qadi Street.
Opening times: from 08.00 to sunset.

Qa'a of Muhib al-Din, section AA, Cairo (painting by Mohammed Rushdy).

Unfortunately, the information pieced together on this building is too scarce to understand its true characteristics. What we do know, however, is that this room is all that remains of a palace commissioned

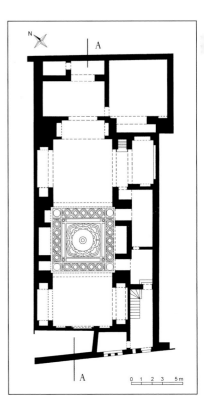

by the *al-faqih* Muhib al-Din al-Mu'aqqi al-Shafi'i. Later it came to be known as the 'Uthman Katkhuda Hall (after the Ottoman Amir 'Uthman Katkhuda al-Qazughli), when it fell into his hands in 148/1735, and he converted it into one of his *waqfs*.
The rectangular hall, comprises as is habitual, a central square *durqa'a*, with an *iwan* on two of its sides and a *sadla* on the two remaining sides. The hall still maintains its wooden ceilings and *mashrabiyyas* almost intact, while the majority of the marble that covered the lower part of the walls has disappeared.

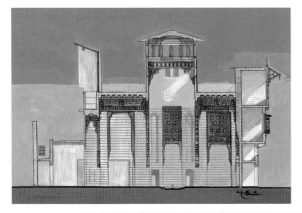

112

The recess decorated with *muqarnas* and located in the centre of the south *iwan* testifies to the earlier presence of a wall fountain. Another fountain dating back to the time of the building's construction was located in the centre of the *durqa'a* (the present-day fountain was brought from Dar Waqf 'A'isha (*Waqf*-house of 'A'isha) in 1330/1911 in al-Alfi Street, Cairo).

The wooden ceilings decorated with paint and gold bear inscriptions and Qur'anic verses. Around the upper part of the *durqa'a*, there is an inscription in which the name of the founder and the date of its construction are stated.

Both *iwans* are framed by heavy wooden beams supporting the *durqa'a* ceiling, each one resting on corresponding wooden brackets decorated with long *muqarnas* stalactites, known in the Ottoman era as *al-kurdi*. The brackets facing each other in pairs thus make up an enormous arch taking up the whole of the opening to the *iwan*. The *durqa'a* ceiling is on a higher level than the *iwan* ceilings. It has an octagonal frame and rests on a drum, punctuated with windows thus ventilating and allowing light into the hall. The upper corners of the extended length of the *durqa'a* walls still preserve vestiges of *muqarnas* decoration.

The northern *iwan* had a *malqaf* or "windcatcher" consisting of a free space or shaft between the two walls at the end of the *iwan*, covered at the top by a sloping roof and open on its north and west sides. The *malqaf* was designed to catch the cooler air, which throughout most of the year blew from the north west. The air entering through the sloping vent towards the lower part of the hall would replace the warmer air expelled through the upper openings of the *durqa'a*, a system guaranteeing excel-

lent ventilation. Furthermore, the height of the ceiling gives the hall a feeling of glory and majesty.

<div align="right">M. M.</div>

II.1.h Maq'ad of Mamay al-Sayfi

The Maq'ad (reception hall) of Mamay al-Sayfi is found at the end of Bayt al-Qadi Street; turn left on leaving the previous monument.

Opening times: As the building is currently being used as a mosque, it is open all day except during midday and afternoon prayers (12.00 and 15.00 in winter, 13.00 and 16.00 in summer).

The maq'ad forms part of what was once the Palace of Amir Mamay al-Sayfi, one of the Mamluk *amirs* who lived during the reigns of Sultan Qaytbay and his son al-Nasir Muhammad. He rose through the ranks of the Mamluk army to the post of *muqaddim alf* (commander of the troop of a thousand soldiers) but was assassinated in 901/1496. The construction of the palace is thought to date back to earlier times, however, as the historian Ibn Iyas mentions Mamay's restoration of the palace.

In 1315/1897 the palace was destroyed and only the reception hall now remains; a rectangular room, 32 m. long by 8 m. wide and 11.5 m. in height. Around the base of the wood-framed roof with its gold surround runs a decorated wooden band bearing *thuluth* inscriptions. The corners are further embellished with wooden *muqarnas*. The monumental entrance to the hall is located to the right of the façade, consisting of a stone trilobed arch in the *mushahhar* technique

*Maq'ad of Mamay
al-Sayfi, partial wiew
of the façade, Cairo.*

(two-coloured stone). The entrance is flanked by *mastaba* and the door jambs bear a foundation inscription.

The *maq'ad* façade has five pointed arches resting on four cylindrical marble columns, the bases of which are inverted roman capitals in the shape of a lotus flower. The arch cords are of wood and between the columns are small parapets in carved wood.

The reception hall extends the length of the basement, built of four roofed sections each with a cross vault and reached through a pointed arch. During the Ottoman era, the military cadi used the palace as a residence and held his audiences in the reception hall. As such, people referred to the reception hall as Bayt al-Qadi, or House of the Cadi, and the surrounding area adopted the same name.

M. M.

*Maq'ad of Mamay
al-Sayfi, detail of
entrance decoration,
Cairo.*

The Sultan's Procession

**Ali Ateya, Salah El-Bahnasi, Mohamed Hossam El-Din,
Medhat El-Menabbawi, Tarek Torky**

II.I CAIRO

Second day

The Festivities of Ramadan *and the Sighting of the New Moon*

II.1.i Mosque of Sultan al-Mu'ayyad Shaykh

This mosque is adjacent to the Fatimid Gate, Bab Zuwayla, at the southern end of al-Mu'izz li-Din Allah Street.

Opening times: all day except during midday and afternoon prayers (12.00 and 15.00 in winter, 13.00 and 16.00 in summer). The building is currently being restored and visitors are not allowed inside.

Sultan al-Mu'ayyad Shaykh had this mosque built on the site of the prison in which he had been confined while an *amir* under Sultan Farag Ibn Barquq. He vowed to turn the prison into a place of study and prayer should God ever bestow upon

Mosque of Sultan al-Mu'ayyad Shaykh, entrance and dome, Cairo.

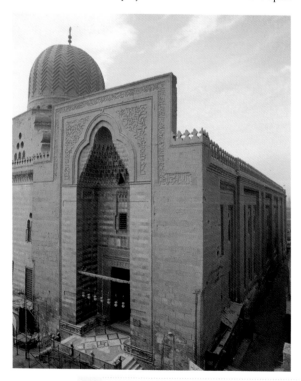

him the honour of ruling Egypt. In 818/1415 construction began. This vast pious foundation was to include a congregational mosque, three minarets, two mausoleums and a *madrasa* for the four rites for Sufi students. On al-Mu'ayyad Shaykh's death, the building had not reached completion. It is one of Cairo's largest mosques and when the Ottoman Sultan Salim I saw it, he is said to have exclaimed "It is indeed a building fit for kings".

It has been called the mosque of sin by some historians due to the fact that some of its furnishings were taken from other buildings. Despite having spent enormous sums of money on the construction and furnishing of the building, when al-Mu'ayyad could not afford costly materials he expropriated them from other earlier foundations. In spite of paying for their removal, such practice was deemed illegal given that once a complex had been furnished, both its buildings and its fittings could no longer change hands. All the same he paid 500 dinars for the lamps and main entrance-door panels faced in bronze and inlaid with metal originally from the Sultan Hassan complex (I.1.g). The marble panels and friezes come from the *qibla* wall in the Mosque of Qusun and from other mosques and houses. Sultan al-Mu'ayyad made his *amir*s pay for the paintings in the mosque and the artisans for the expenses on carpentry and wood decoration.

The main entrance on the south east façade is decorated in alternating bands of black and white marble and crowned by a tri-lobed arch. Its deep recess is crowned with a vault of nine rows of *muqarnas*, all of which are enclosed in a rectangular frame rising above the cornice, characteristic of Iranian architec-

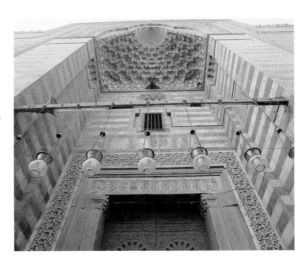

Mosque of Sultan al-Mu'ayyad Shaykh, detail of the tri-lobed arch, Cairo.

tural origins. The door-jambs and the lintel of pink granite are framed in a white interlaced band with earthenware red and turquoise incrustations. The entrance leads to a *derka,* where a cross vault rises above it. To the right there is a passageway paved in marble leading to the mosque courtyard, in the centre of which an ablutions font replaces the old fountain. To the left we gain access to the mausoleum in which the Sultan and his oldest son Ibrahim are buried. The *mihrab* in the square mausoleum is decorated with marble and a dome resting on *muqarnas* pendentives rises above it. On the outside, the dome is decorated with the same horizontal zigzag design as the domes of the *khanqa* of Farag Ibn Barquq. The prayer hall was to be flanked on either side by a domed mausoleum, but only the tombs of the Sultan and his son are housed in such a way. The second mausoleum, set apart for the women and covered by a flat roof, is located to the south of the *qibla* hall, at the foot of one of the two minarets.

Of the three minarets along the south-west axis of the building, the western-most one collapsed. The other two, supported by the towers of Bab Zuwayla, also collapsed not long after being built in 842/1438; they were soon reconstructed.

With the use of the towers of Bab Zuwayla as the base for the two minarets, they dominate the skyline from a distance clearly visible from the Citadel. The two minarets with their octagonal section shafts and transitions each separated by a balcony resting on a *muqarnas* cornice, and *gawsaq* crowned with a bulbiform top standing 50 m. high above street level, have become a symbol of the city of Cairo.

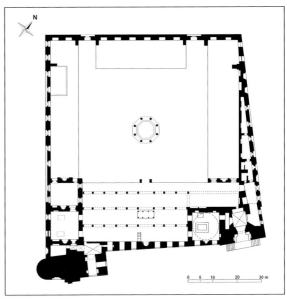

The mosque layout follows the lines of the traditional hypostyle mosque plan. The central courtyard was originally surrounded by four porticoes. Today

Mosque of Sultan al-Mu'ayyad Shaykh, plan, Cairo.

117

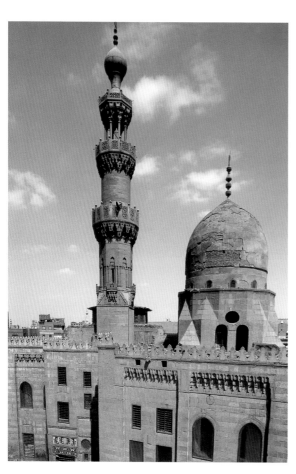

Madrasa of Qujmas al-Ishaqi, minaret and dome, Cairo.

panelling at the base of the *mihrab* is divided into two areas by differing types of marble decoration and crowned by a frieze of paired colonettes in turquoise blue. To its right is the original wooden *minbar*; it is decorated in mother-of-pearl and ivory inlay, a magnificent example of the richness of carpentry at the time. The marble *dikkat al-muballigh* (recitation platform), supported on eight marble columns, is located in the second aisle of the *qibla* hall.

Its extensive provision of over 200 rooms for students and its large library brought recognition to the mosque as a renowned academic institution in the 9th/15th century. Its academic chairs were held by the most eminent of scholars such as Ibn Hajar al-Asqalani (b.774/1372 d.853/1449) from Ascalon, (an ancient city of Palestine), an expert in interpretation of the Qur'an.

S. B.

II.1.j Madrasa of Qujmas al-Ishaqi

The madrasa of Qujmas al-Ishaqi, also known by the name of Abu Hriba, is on Darb al-Ahmar Street on the left as you leave Bab Zuwayla.

It is interesting to note that its façade appears on the Egyptian fifty pound note.

Opening times: all day except during midday and afternoon prayers (12.00 and 15.00 in winter, 13.00 and 16.00 in summer).

One of Sultan Abu Sa'id Jaqmaq's *amirs*, Qujmas al-Ishaqi, had this *madrasa* built. His exact date of birth is unknown, but we do however know that he was a con-

only one remains, that of the *qibla* wall. Archaeological excavations have revealed that the other three sides comprised a double aisle divided by an arcade. Parallel to the *qibla* wall, three rows of marble columns uphold the richly decorated wooden ceiling. The walls around the sanctuary are covered by coloured marble panels, which originated from earlier buildings. The richest decoration was naturally reserved for the *qibla* wall. The high

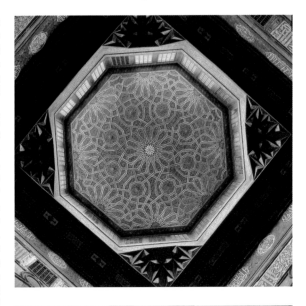

*Madrasa of Qujmas
al-Ishaqi, durqa'a
ceiling, Cairo.*

*Madrasa of Qujmas
al-Ishaqi, entrance,
Cairo.*

temporary of eight Circassian Mamluk
Sultans and that he died and was buried in
Damascus in 892/1486. Qujmas worked
in the government palace, and went on to
hold the post of *khaznadar* (treasurer). In
the reign of Sultan Qaytbay he was named
Governor of Syria.

Qujmas had this tall *madrasa* constructed
over a row of shops, the income from
which paid for the building's upkeep.
Comprising a *madrasa*, *qubba*, *sabil*,
rooms for the Sufis, a watering trough
(above which there is a *kuttab*), a water
wheel and a fountain for ritual ablutions,
it is the archetypal religious complex so
popular in the Circassian Mamluk era.
Though the layout inside the building is
similar to that of the cruciform *madrasa*s
(a *durqa'a* with four *iwan*s), in the
founding documents it is clearly stated
that it was designed as a congregational
mosque.

With the building constructed on a tri-
angular plot of land, the architect had to
plan the rooms within the restrictions of
the surrounding street layout using every
inch of land available. The façade over-
looks Darb al-Ahmar Street running par-
allel to the Fatimid City walls. It
includes the north west *iwan* and south
west *qubba* walls as well as two alcoves in
which the entrance and the *sabil* were
situated. The main entrance is above
street level and crowned by a tri-lobed
arch filled with *muqarnas*. Above the
stone benches on either side an inscrip-
tion reads: "In the name of God the
Compassionate, the Merciful, mosques
are for God, let none [of you] take God's
name in vane". This Qur'anic verse
clearly alludes to the role of the building
as a mosque. Another inscription
includes the date the *madrasa* was com-
pleted (886/1481).

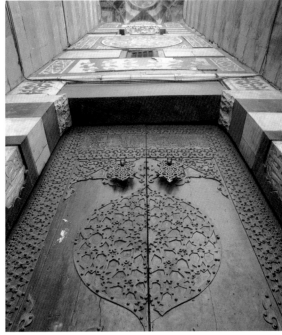

Mosque of al-Tunbugha al-Maridani, detail of entrance decoration, Cairo.

ings with their decorated gilt design of exquisite figures.

A. A.

II.1.k Mosque of al-Tunbugha al-Maridani

Al-Tunbugha al-Maridani Mosque is located on Darb al-Ahmar Street walking towards the Citadel.
Opening times: all day except during midday and afternoon prayers (12.00 and 15.00 in winter, 13.00 and 16.00 in summer).

Amir al-Tunbugha al-Maridani al-Saqi (cupbearer) was born around the year 719/1319. He was Sultan al-Nasir Muhammad's son-in-law and one of his *amir*s and went on to govern Aleppo where he died at the age of 25.

The similarities apparent between the layout of this mosque and the mosque of al-Nasir Muhammad in the Citadel are not surprising when we learn that the same court architect, master (*mu'alim*) al-Suyufi, designed them. Nevertheless, it is precisely some of the differences that are most worth pointing out. The main entrance to the mosque of al-Tunbugha al-Maridani has a plain pointed arch and in the centre of the courtyard there stands an octagonal marble font covered by a wooden dome from Sultan Hassan's Madrasa. A dome covers the *mihrab* stretching across two aisles, rather than three as in the sanctuary of the Mosque of al-Nasir Muhammad. Its dimensions are similar to those rising above *mihrab*s in Fatimid times and to that of the Mosque of Sultan Baybars – the first of the *Bahri* Mamluk Sultans. Though restored in 1905, the pendentives still possess their original wooden stalactites, below which

Mosque of al-Tunbugha al-Maridani, detail of mihrab decoration, Cairo.

This mosque is considered one of the most important buildings of the Qaytbay period and among the most outstanding in artistic terms. Noted in particular for its decoration; the synthesis of colours in the marble panelling, the stonework on the walls and the innovative wooden ceil-

a wooden band bears gilt inscriptions of Qur'anic verses on a blue background.

The decoration inside the mosque is magnificent, displaying all the finery of the most outstanding decoration of the period, from stucco and marble panels inlaid with mother of pearl, to carved wood, windows and tiles. One of the most characteristic elements of the mosque is the splendid *mashrabiyya* screen; separating the prayer hall from the courtyard it is one of the oldest screens still preserved in Egypt.

The minaret, too, is believed to be one of the oldest to use the bulbiform finial, a style that would later be used extensively throughout the Mamluk period.

A. A.

Mosque of al-Tunbugha al-Maridani, mashrabiyya screen separating sanctuary from courtyard, Cairo.

II.1.l Door to the House of Qaytbay in al-Razzaz
(option)

The al-Razzaz House is on Bab al-Wazir Street, after Darb al-Ahmar. Cross the courtyard to see the door to the house.
Opening times: from 08.00 to sunset.

Built in the 9th / 15th century, the only part that remains of Sultan Qaytbay's house is the door, which while shorter due to its domestic purpose, maintains the traditional Mamluk-period style. It is crowned with a stalactite vault and tri-lobed arch, and has a stone bench on either side taking up the full width. The stone lintel, above which the Sultan's emblem appears, bears a floral decoration in relief, and on the imposts a foundation text naming Sultan al-Ashraf Sha'ban Abi al-Nasr Qaytbay.

T. T.

II.1.m Madrasa of Umm al-Sultan Sha'ban

The Madrasa of Umm al-Sultan Sha'ban is adjacent to the al-Razzaz house in Bab al-Wazir Street.
Opening times: Open all day except during midday and afternoon prayers (12.00 and 15.00 in winter, 13.00 and 16.00 in summer).

Al-Sultan Sha'ban, grandson of al-Nasir Muhammad, had this *madrasa* built for his mother Khuwand Barka in the year 770/1369. Its layout is that of the classic cruciform *madrasa* with four *iwans* around a *durqa'a* or open central courtyard. Furnished with the traditional elements (watering trough, *sabil*, *kuttab*, students' room, prayer hall, minaret and two mausoleums), one of its most outstanding features is the way in which it is woven into the urban fabric.

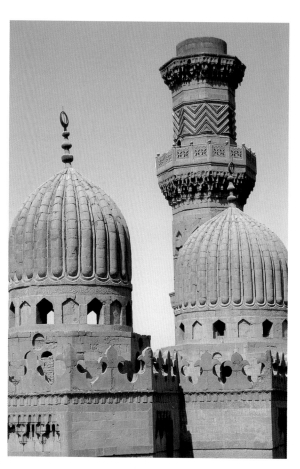

Madrasa of Umm al-Sultan Sha'ban, minaret and domes, Cairo.

To the left of this innovative entrance overlooking Bab al-Wazir Street is the *sabil* façade. It is formed by a wooden screen of individual panels that interlock to form geometric shapes: it is believed to be the first example of its kind.

There are two *qubbas*, one on either side of the *qibla iwan*. The southwestern *qubba* houses the tombs of Khuwand Barka (buried in 774/1373) and her daughter. The southeastern *qubba* is larger and houses the tombs of Sultan Sha'ban (buried in 778/1377) and one of his sons. Both stone domes bear the same exterior decoration of vertical ribs dividing them into segments. The minaret, however, preserves only two of its three original sections. The lower section is octagonal with alternating blind and open pointed arches resting on double columns, with a balcony resting on rows of *muqarnas*. The second, while smaller, is also octagonal decorated with a horizontal chevron design.

A. A.

II.1.n Mosque of Aqsunqur (option)

The Mosque of Aqsunqur, more commonly known as the Blue Mosque, is located on the left in Bab al-Wazir Street when walking towards the Citadel.

Opening times: all day except during midday and afternoon prayers (12.00 and 15.00 in winter, 13.00 and 16.00 in summer).

Amir Aqsunqur was one of al-Nasir Muhammad's *amirs*, he was also one of his sons-in-law and later became governor of Tripoli, Lebanon. Among the many buildings commissioned by Amir Aqsunqur, in this same street, we find his house, sev-

The *madrasa* is located on Bab al-Wazir, the main street leading to the Citadel. The minaret and main *qubba* are strategically placed in the far south east of the *madrasa* on a corner with a smaller street and thus clearly visible to the Sultan's procession on his return to the Citadel.

Of the two entrances to the *madrasa*, the main one is characterised by its unusual design of Seljuq influence, characterised by the lancet arch filled with nine rows of gilt *muqarnas* decorated with leaf design.

eral public drinking fountains and a watering trough for animals. With his interest in architecture, he personally took charge of the supervision for the building work on the mosque. Built in 747/1347, it follows the traditional hypostyle plan; a central courtyard surrounded by four porticoes, the largest of which is the prayer hall with two aisles.

Its name derives from its east wall, tiled from floor to ceiling in beautifully coloured majolica, the predominant shade being blue. This tile work is a later addition from one of the renovations carried out by the Ottoman Ibrahim Agha Mustahfazan, in 1062/1652.

Another notable feature of this mosque is its marble *minbar*, decorated with an unusual design of bunches of grapes and vine leaves and inlaid with coloured stones. It is one of the few *minbars* ever built with this costly material and one of the oldest in Cairo.

A. A.

II.1.o Palace of Alin Aq al-Husami
(option)

The Palace of Alin Aq al-Husami is on Bab al-Wazir Street following on from the previous monument.

Closed due to its poor state of repair, visitors are not allowed inside.

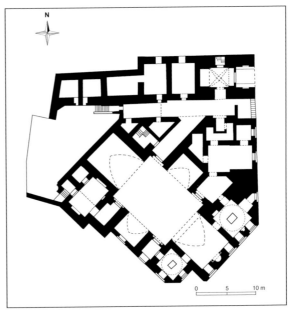

Madrasa of Umm al-Sultan Sha'ban, plan, Cairo.

What remains of this palace, built by Alin Aq al-Husami one of Sultan Qalawun's *amirs*, tells us that it was a residential palace with two floors and one of the noblest examples of the architecture of the *Bahri* Mamluk era. On passing through a curved passageway the visitor reaches the ground floor which once contained storerooms, stables, a bakery, courtyard and *takhtabush*. The upper floor has a balcony overlooking the courtyard and small rooms covered by barrel or cross vaults.

T. T.

THE FESTIVITIES OF *RAMADAN*
AND THE SIGHTING OF THE NEW MOON

Salah El-Bahnasi

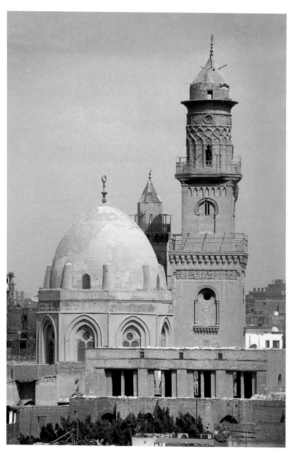

Complex of Sultan Qalawun, dome and minaret of the madrasa, Cairo.

built on its summit for those who had climbed the mountain to rest and observe the new moon. When in 478/1085, the Fatimid *vizier* Badr al-Din al-Ghamali built his mosque on the slopes of Mount al-Muqattam, it was from there that the new moon was officially sighted. In the Mamluk era the chosen site for the event was the minaret of the Madrasa of Sultan Qalawun in the al-Nahhasin quarter (III.1.c).

While the sighting of the new moon was of great importance for Muslims, it was more so at the beginning of the Holy month of *Ramadan*. The sighting was carried out with special reverence for it filled the souls of the Muslims with reverence and awe. Many historians record the procession held to celebrate the event as equal to any Sultan's procession: streets were decorated, oil lamps lit throughout and as soon as the month of *Ramadan* was declared official great rejoicing took place in the streets with festivities and cannon fire.

On occasions there were discrepancies over the sighting of the new moon, and people were left confused not knowing whether to fast or to eat. One such paradoxical situation took place in the time of Sultan Barquq (r.784/1382-801/1398). The sighting of the new moon was not approved unanimously and on the following day when the Sultan was preparing to eat with his guests, news spread through Cairo that the Holy month had in fact begun. The Sultan threw his guests out, ordered the food to be taken away and declared the beginning of the fast official.

Muslims celebrate the end of the Holy month of *Ramadan* with the Bairam Feast or "Breaking of the Fast", an important Islamic feast. The Sultan would go out in

The beginning of the Islamic lunar calendar is designated by the official sighting of the new moon. In Mamluk times a celebratory procession was held in which the great Cadi, Cadis of the four Sunni legal rites, (*shafi'i, hanafi, hanbali* and *maliki*), *ulemas* (doctors of jurisprudence) and the public took part. During the first three centuries of the *Hijra*, the new moon was officially sighted from the mosque of Mahmud on the slopes of Mount al-Muqattam. Later a *dikka* (platform) was

a solemn procession and take part in prayer. With the prayers finished, people would begin to greet each other and the Sultan and his *amirs* would give away gifts of clothing, presents and bags of coins to those who greeted them. Great quantities of food were prepared for the public and festivities continued in public squares and gardens with music, song and acrobats. One such activity involved walking along a tightrope stretched between the top of Bab al-Nasr and the ground, or stretched between Sultan Hassan Madrasa and the Citadel.

During Sultan al-Ghuri's reign (906/1501-922/1516), the King of India sent two large elephants draped in red velvet that acted out a fight; the Sultan and the people were naturally overjoyed to see the show.

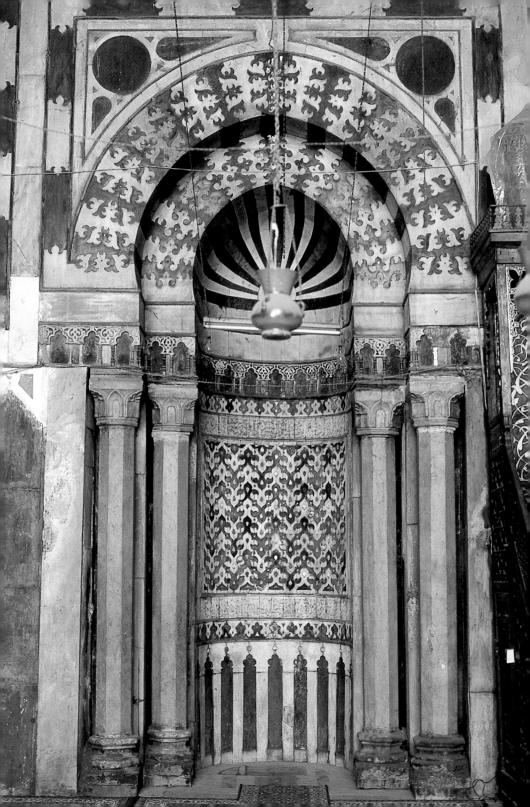

Science and Learning

Salah El-Bahnasi, Medhat El-Menabbawi, Mohamed Abd El-Aziz, Mohamed Hossam El-Din, Tarek Torky

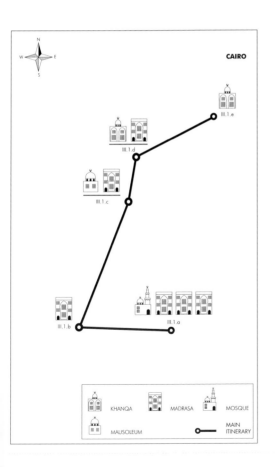

Khanqa and Madrasa of Sultan Barquq, mihrab, Cairo.

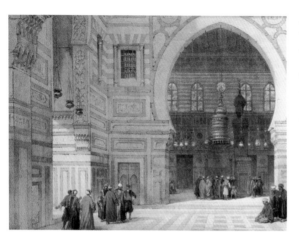

Inside the Mosque of Sultan al-Ghuri, Cairo (D. Roberts, 1996, courtesy of the American University of Cairo).

The Mamluk era saw the rapid growth of Cairene educational institutions to which numerous learned men and academics were attracted. With the construction of institutions such as *madrasas* and *khanqas*, sultans and *amirs* contributed significantly to the growth of intellectual activity.

With the Crusader threat over and the risk of Mongol invasion contained, Egypt enjoyed a period of great security. She proved an attractive destination for learned men from all four corners of the Islamic world, in particular for those arriving from her eastern and western regions, areas that had suffered at the hands of both the Mongols and Crusaders. At the same time, the Christian Reconquest of the Muslim territories of Al-Andalus (Spain) was gaining ground, causing many Muslims to emigrate to a safe haven in Egypt.

Conditions were to coalesce such that Egypt became "place of residence for *ulemas* and a resting place for the most virtuous travellers" as al-Suyuti (b. 849/1445) writes. In the 8th/14th century al-Balawi the Maghrebi traveller,

and one of the great Cadis of al-Andalus to visit Cairo during the reign of Sultan al-Nasir Muhammad, described Egypt as: "the source of knowledge" and that "while in Cairo there was nothing more than what is known as *al-maristan* (III.1.c) it alone is sufficient, for this majestic palace was among the most astounding palaces, for its beauty, elegance and spaciousness".

In the first half of the 8th/14th century the Moroccan traveller Ibn Battuta also visited Egypt. He observed great activity in the field of sciences recording what he saw in his book of travels. The competition between sultans and *amirs* to surpass each other with each new building and the importance of the *khanqas* in the spread of scientific knowledge resulted in new advances. Each *khanqa* was devoted to a different ethnic group of Sufis (the majority of non-Arab origin) who were Muslim mystics of culture, instruction and good manners and who attempted to return to their original spirituality.

The famous Tunisian philosopher, Ibn Khaldun, came to Egypt where he lived until his death (b.784/1382, d.809/1406). He finished writing his works there and took on the administration of the *khanqa* of Sultan Baybars II al-Gashankir (III.1.e) in the year 792/1389 writing the following about Egypt:

"... palaces and *iwans* shine on her face, *khanqas* and *madrasas* flourish in harmony, and the full moon and stars shine on her *ulemas*. Thus the *waqfs* multiplied, and those thirsty for knowledge grew in numbers, her masters encouraged by the high wages, and people came to her from Iraq and the Maghreb in search of science".

In the time of the Mamluk Sultans, learned men came from Egypt and were

warmly received by her governors, who offered friendship and hospitality and provided accommodation in accordance with their visitor's status. History books mention Sultan al-Nasir Muhammad Ibn Qalawun's friendship with the historian Abu al-Fida and record how Sultans Barquq, al-Mu'ayyad Shaykh, Jaqmaq, Barsbay, Qaytbay and al-Ghuri were passionately interested in the meetings of learned men and writers. Barsbay had the historian Badr al-Din al-'Ayni sit next to him and tell him the history of the Ottomans while al-Ghuri showed great generosity towards learned men and their sciences. The founding documents of *waqfs* testify to this interest. Those who made donations to the pious foundations specified in the documents exactly how their contributions were to be invested and the salaries that learned men and masters were to receive.

This growing interest in learning resulted in the appearance of numerous encyclopaedias, both in areas of the humanities and in applied sciences. Among them we find historical encyclopaedias such as *al-Suluk li-ma'rifat duwal al-muluk* (History of the Ayyubids and the Mamluks) by al-Maqrizi; *al-Nujum al-zahira fi muluk Misr wa al-Qahira* (History of Egypt from the Arab Conquest to the Mamluk Era) by Abu al-Mahasin Ibn Taghri Bardi; *Bada'i' al-zuhur fi waqa'i' al-duhur* (History of Egypt in the Mamluk Period, with particular reference to Cairo) by Ibn Iyas. There are translations including *Wafayat al-a'yan* (Biographical Dictionary of Noted Egyptian *Ulemas* and Learned Men from the Muslim World) by Ibn Khalikan; *al-Daw' al-lami' li-ahl al-qarn al-tasi'* (Biographical Dictionary of Egyptian *Ulemas* and Learned men from the Mamluk Period) by al-Sakhawi; *al-Nahl al-safi* by Ibn

Taghri Bardi and *'Aqd al-juman fi tarikh ahl al-zaman* by al-'Ayni, to name but a few.

Among the literary encyclopaedias the following are most notable: *Subh al-a'cha fi sina'at al-incha'* by al-Qalqashandi and *Nihayyat al-arb fi funun al-adab* (History of Egypt and the Islamic East from the Beginning of Islam to the Mamluk Period) by al-Nuwayri. In addition, Ibn Manzur collated his dictionary *Lisan al-'arab* and al-Busiri wrote his popular poetic work *al-Kawakib al-durriyya fi madh*

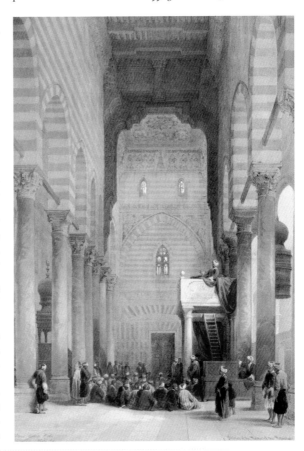

Lessons inside the Mosque of Sultan al-Mu'ayyad Shaykh, Cairo (D. Roberts, 1996, courtesy of the American University of Cairo).

129

khayr al-barriyya known as *al-Burda*. Other major works exist such as *al-Intisar li-wasitat 'aqd al-amsar* and *Masalik al-absar fi mamalik al-amsar* by al-'Umari on matters of geography including descriptions of different countries, their topography, the nature of their people and origins of their wealth.

Political writings include *Athar al-awwal fi tadbir al-duwal* by Hassan Ibn 'Abd Allah al-'Abbas, as well as other valuable works of which the heads of neighbouring States ordered copies.

In the sciences of religion and jurisprudence, commentaries and exegesis of the *Qur'an* and *Sunna* came to light. The most noted ones are: *Fath al-bari bi-charh sahih al-bukhari* by the imam Ibn Hajr al-'Asqalani, who dictated the text in the *khanqa* of Sultan Baybars al-Gashankir (III.1.e).

The Egyptian renaissance in the search for knowledge was not merely limited to the Humanities, but also prevailed through the many learned men well versed in medicine, astrology and other specialist fields of knowledge. Interest in astrology and astronomy was evidenced by the sobriquet "*al-miqati*" (he who determines the use of a time) adopted by many academics of the period. It was common knowledge by then that astronomy established the months of the year, determined the beginning of prayers as well as other religious duties such as fasting or pilgrimage, all with great precision.

Medicine was also studied in several places such as the *maristan* (hospital) of Qalawun (III.1.c) or the Tulunid Mosque where Sultan Lajin held classes, which in 696/1296 ten pupils attended. Such was the reputation of Egyptian doctors that Ottoman Sultan Bayazid I sent an envoy to the Mamluk Sultan Barquq requesting an experienced doctor and some medicine. Among contributions to this science in the Mamluk period is that made by Ibn al-Nafis (7th/13th century) of his description of pulmonary haematosis. The results of his studies put an end to the greatest mistake made on inter-ventricular communication by the Greek doctor Galenus (129-201). While his discoveries were completely ignored in Europe, Ibn al-Nafis had in fact anticipated two European doctors by almost three centuries; Miguel Servet, doctor and theologian (1511-1553), who confirmed the theory of pulmonary circulation and the Italian doctor and anaesthetist Realdo Colombo (1516-1559), who had refuted Galenus' theory on cardiac physiology. Ibn al-Nafis composed his encyclopaedia *al-Chamil fi al-tibb* and it is said of him that not another man on the face of the earth could match him in his time.

A religious tutor known as Abu Haliqa was among the most famous doctors of the time who had studied medicine in the hospital of Qalawun. Other well-known names were the sultan's doctor Ibn al-'Afif, whose manuscript on prescriptions for the treatment of intestinal problems is now preserved in the Museum of Islamic Art while Shams al-Din al-Qusuni and Abu Zakariya Yahya Ibn Musa were famous for their understanding of bone disease.

The Mamluk Sultans' great interest in medical science was closely related to treatment centres called *maristan*. The traveller al-Balawi, visiting Egypt in the 7th/14th century, described the Qalawun hospital furniture as rivalling that of palaces of *amirs* or caliphs. There was a section in the hospital for treatment using music, provision for which was set out in the *waqf* document as commissioned by

Qalawun stipulating that: "every night four musicians were to make themselves present with their instruments to play the lute and to watch over the sick". The singers also repeated suplications and short prayers at night from the minaret "to relieve the sick of their illnesses and insomnia".

Al-Dumayri collated an encyclopaedia on veterinary science, *Hayat al-hayawan al-kubra*, in which the majority of known animals were studied and described in minute detail. Shahab al-Din Abi al-'Abbas, who died in 684/1285, was widely recognised in these times for his scientific treatise *Kitab al-istibsar fi-ma tudrikuhu al-absar* on the subject of the rainbow. It was written expressly on Sultan al-Kamil's request as he wished to send it to Emperor Frederic, and it is thought to be one of the first studies to deal with such an important subject in the field of physics. Such wealth of information provides us with a clear picture of the state of science and learning in Mamluk Egypt.

S. B., M. H. D. and T. T.

III.1 CAIRO

III.1.a Mosque of al-Azhar and its Mamluk Madrasas

Al-Azhar Mosque is located on al-Azhar Street in the area of the same name, opposite the Mosque of al-Husein.
Opening times: all day except during midday and afternoon prayers (12.00 and 15.00 in winter, 13.00 and 16.00. in summer)

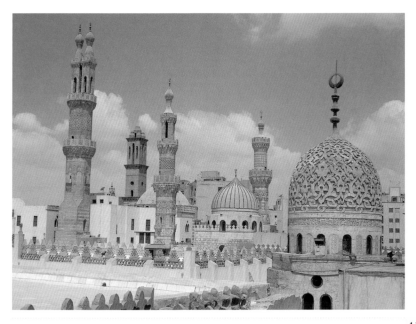

Mosque of al-Azhar, view with dome of the Madrasa of al-Gawhariyya, Cairo.

The Mosque of Al-Azhar is both the oldest and largest university in the Islamic world with students from all the Muslim countries studying there. Al-Azhar Mosque was commissioned by the Imam al-Mu'izz li-Din Allah, Prince of Believers, the fourth Fatimid Caliph and the first to govern Egypt. It was also the first mosque to be built in Cairo by General Gawhar al-Siqilli.

Work began in 359/970 and was completed two years later. As the Mosque of 'Amr Ibn al-'As was to Fustat, and the Mosque of Ahmad Ibn Tulun to al-Qata'i', so the founder intended the Mosque of al-Azhar to be to the city of Cairo, her congregational mosque. Al-Azhar was also designed for another purpose; the instruction, to a small group of pupils, of *Shi'ite* jurisprudence.

The building originally covered only half the surface area it occupies today though it was later enlarged, rooms were added, and successive renovations carried out until it reached its present size. The mosque was first built with a central courtyard and porticoes on three sides. The sanctuary comprised five aisles parallel to the *qibla* wall, while the north and south porticoes had three aisles each, the arcades around the courtyard resting on brick pillars. While the north west wall had no arcade, the main door was located in its centre, and it is believed to have projected out from the main wall. The original minaret rose up above this north west wall and another two doors were located one on the south east and another on the east walls.

The central aisle in the *qibla* hall, with the *mihrab* at the end, is wider and taller than the others. The arches of this aisle run perpendicular to the *qibla* wall and are decorated with *Kufic* inscriptions and various floral motifs, the only original decorations the mosque still preserves today. The *mihrab*, also dating back to the original Fatimid construction, is ornamented with *Kufic* inscriptions. The dome above the prayer hall is a later construction of Mamluk times, (9th/15th century) and replaces the earlier Fatimid dome. During the reign of Salah al-Din and of the Sunni Caliphs al-Azhar Mosque was closed, for it was considered a centre of propaganda of *Shi'ite* doctrine.

On reinstating the Abbasid Caliphate in Cairo, Sultan Baybars found affinity with the *ulemas*, cadis and *al-faqihs* and turned the *Qur'an*, the *hadith* (prophetic tradition), religious and other sciences into core subjects of education and culture. After almost 100 years of neglect, Baybars successfully reinstated Friday

Masque of al-Azhar, plan, Cairo.
1. Madrasa of al-Taybarsiyya
2. Madrasa of al-Aqbughawiyya
3. Madrasa of al-Gawhariyya.

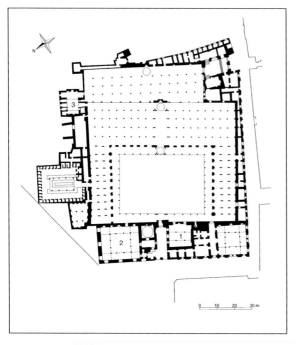

prayers in the Mosque of al-Azhar in 665/1267 and restored it to its former glory of the first mosque of Cairo. Of the restoration work carried out under him, only the fine stucco around the upper part of the Fatimid *mihrab* still remains.

In 873/1468 Sultan Qaytbay ordered the main door to be demolished and replaced with the more ornamental one with the floral decoration and *Kufic* script that we see today. He also had a minaret added which rose above and to the right of the door. This intricately designed and elegantly decorated minaret is characteristic of the Qaytbay period.

Towards the end of the Mamluk era, Sultan al-Ghuri ordered a second minaret to be built, which was completed in 915/1510. Placed to the right of the minaret commissioned by Qaytbay, it is noted for its extraordinary height, the highly original blue ceramic arrows encrusted in the second section of its shaft and its double (or twin) finial, similar to that of the Madrasa of Qanibay Amir Akhur, (I.1.f).

The minaret is characterised by its double staircases separated by a wall, which lead to each of the minaret tops crowned by bulbiform finials. Qusun (736/1336) and the Azbak al-Yusufi (900/1495) minarets are the only ones in Cairo with a double-staircase construction.

M. M.

Madrasa of al-Taybarsiyya

The madrasa is located within the mosque, to the right of the entrance. It now houses a collection of the most precious and rare manuscripts of the al-Azhar library.

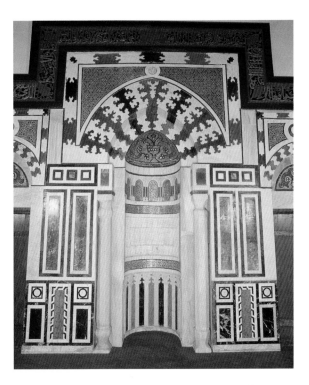

Mosque of al-Azhar, Madrasa of al-Aqbughawiyya, mihrab, Cairo.

Amir 'Ala' al-Din Taybars, *khaznadar* (treasurer) and captain of the armies during the reign of al-Nasir Muhammad, had this *madrasa* built and consecrated as a mosque annexed to al-Azhar. It contains a watering trough and an ablutions fountain and the *amir* founded courses there for the *al-faqih*s of the *shafi'i* and *maliki* legal schools.

The gilt ceilings brought innovation to the building and the elegant marble work has a finely crafted frieze representing small *mihrab*s, a style of ornamentation that can be seen with even finer detail on the main *mihrab*. The latter dates back to the early *Bahri* Mamluk era, a masterpiece of Mamluk art.

The *madrasa* was completed in 709/1309

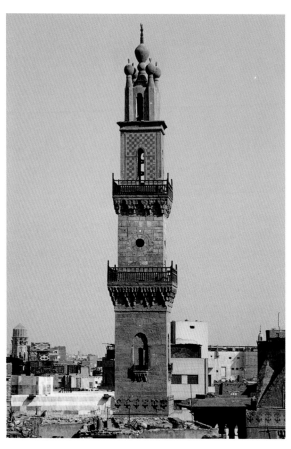

Madrasa of Sultan al-Ghuri, minaret, Cairo.

Amir 'Ala' al-Din Aqbugha, *ustadar* (private tutor) to al-Nasir Muhammad, had this *madrasa* built in 740/1340. Original elements of the construction are preserved in the entrance, *qubba* wall, *mihrab* and minaret. The minaret was the second one in the building to be built of stone, after Sultan Qalawun's minaret. Prior to this, minarets were built of brick.

Both the minaret and the *madrasa* were built by the master Ibn al-Suyufi, head architect to the court of al-Nasir Muhammad.

Madrasa of al-Gawhariyya

Located in the far west of al-Azhar Mosque.

Amir Gawhar al-Qunquba'i al-Habashi, *khaznadar* (treasurer) to Sultan al-Ashraf Barsbay had the smallest of al-Azhar's three *madrasas* built. The layout has a *durqa'a* surrounded by four *iwans*. The *durqa'a* is paved in coloured marble with a lantern ceiling above. Its doors are of wood with ebony and ivory inlay, while the windows are inlaid with coloured glass.

Turning left on entering al-Gawhariyya from the main al-Azhar Mosque is the mausoleum where its founder was buried in 844/1440. The outside of the dome is noted for a floral lattice design carved into the stone, its exquisite ornamentation is recognised as a milestone in the development of dome ornamentation in the Mamluk era.

M. M.

III.1.b Madrasa of Sultan al-Ghuri

This madrasa, *also called a mosque, is locat-*

and in 1167/1753 during the Ottoman era, Amir 'Abd al-Rahman Katkhuda had its main wall renovated.

Madrasa of al-Aqbughawiyya

The madrasa to the left of the entrance is located within the mosque founded at the beginning of the 20th century by the Khedive (or Viceroy) 'Abbas Hilmi II. It now houses the al-Azhar library with its collection of priceless manuscripts and Qur'ans.

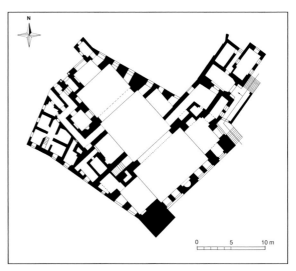

Madrasa of Sultan al-Ghuri, plan, Cairo.

ed on al-Mu'izz li-Din Allah Street on the crossroads with al-Azhar Street.
Opening times: all day except during midday and afternoon prayers (12.00 and 15.00 in winter, 13.00 and 16.00 in summer)

Mukhtass the Eunuch, cupbearer to Sultan Qansuh Abi Sa'id (r. 904/1498-905/1499), undertook the building of a mosque on the site of the present day *madrasa*. With Sultan al-Ghuri's accession to the throne in 906/1501, he ordered Mukhtass' arrest along with the confiscation of his wealth, and demanded a large sum of money in addition. Mukhtass, having no other source of money, gave up the land and the building with all that it contained as part of the sum demanded. Sultan al-Ghuri ordered the buildings on the land to be destroyed and acquired neighbouring properties thus extending the plot. He had shops built on the ground floor to expand the commercial value of the site, which came to be known as al-Ghuriya. Al-Ghuri took particular care in his choice of marble to decorate the building, completed in 909/1503. The architect excelled himself in the ornamentation of the cruciform building, leaving not a single corner untouched. Not only the lintels, but the intrados, *voussoirs* and archways, too, were carefully sculpted with inscriptions and floral motifs.
Along the top of the façade on al-Mu'izz li Din Allah Street, a Qur'anic inscription in *naskhi* script sings the praises of the Sultan: "man of the sword and the pen, of wisdom, of science ... ".
The *madrasa* is on the corner with al-Azhar Street. Its main entrance, on the corner of the building, is reached by a double staircase, one rising in al-Mu'izz li Din Allah Street the other in al-Azhar

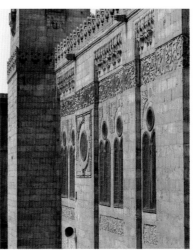

Madrasa of Sultan al-Ghuri, partial view of the façade, Cairo.

Street. Its monumental entrance is crowned by a tri-lobed arch with several rows of *muqarnas*, an original geometric formation, and the Sultan's circular emblem in the spandrels.
A bent passageway with a *muzammala* leads from the entrance *derka* to the

Madrasa of Sultan al-Ghuri, mihrab, detail of the arch, Cairo.

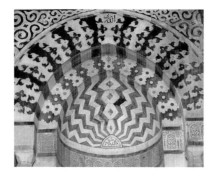

Madrasa of Sultan al-Ghuri, mihrab, detail of the arch, Cairo.

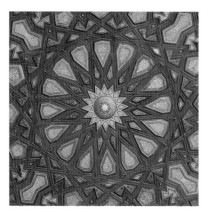

Madrasa of Sultan al-Ghuri, wooden minbar, detail, Cairo.

nated by the finely ornamented marble *mihrab* crowned by a pointed arch resting on white marble columns. The *minbar* to the right of the *mihrab* is made of small interlocking pieces of wood forming geometric shapes inlaid with ivory and mother of pearl. The *iwan* opposite the *qibla* opens onto the courtyard through a pointed arch with its apex meeting the ceiling. It is noted for the wooden *dikkat al-muballigh* platform suspended half way up the span of the arch, which rests majestically on wooden brackets painted with inscriptions and gold floral motifs.

In the far south east corner of the *madrasa* the minaret base rises up from the top of the façade, which is crowned by a row of fleur-de-lys. The three sections of the minaret shaft are separated by wooden balconies, which are supported on delicate stone *muqarnas*. The original ceramic chequered decoration on the third section has now been replaced by painted ornamentation of a similar design. The unusual upper section was originally built of stone and had four "heads" crowned with bulbiform finials. Soon after its construction, the weight of this unique element proved too much and it started to lean to one side, the minaret threatening to collapse. Sultan al-Ghuri decided to reduce the heads from four to two, and they remained that way until the 12th/18th century when they were again replaced with five wooden finials as we see them today.

Sultan al-Ghuri was the last of the great patrons of architecture among the Mamluk Sultans in Egypt. His buildings reflect his will to improve certain urban areas, in particular in favour of education and science. The historian Ibn Iyas reveals his enthusiasm for the *madrasa* in the follow-

square inner courtyard, around the upper part of which are four rows of gilt wooden *muqarnas*. Up to a height of 2 m., the walls are panelled with vertical strips of coloured marble. A frieze bearing a floral *Kufic* inscription runs around the top of the panelling, written in a black paste inlaid in the white marble. The students received their classes in the four *iwan*s located on the edge of the courtyard and lodged in rooms on the upper floors.

The *qibla iwan* is the largest of the four and opens onto the courtyard through a pointed horseshoe arch supported on jambs crowned with stone *muqarnas* in the form of capitals. The *iwan* is domi-

*Complex of Sultan
Qalawun, main view,
Cairo.*

*Complex of Sultan
Qalawun, plan,
Cairo.*

ing sentiment: "this is a splendid building, of magnificent elegance … This *madrasa* is one of the wonders of our era".

M. M.

III.1.c Complex of Sultan al-Mansur Qalawun

The architectural complex of Sultan Qalawun is on al-Mu'izz li-Din Allah Street on the other side of al-Azhar Street, opposite the Muhib al-Din (Bayt al-Qadi).
Opening times: all day except during midday and afternoon prayers (12.00 and 15.00 in winter, 13.00 and 16.00 in summer). Mausoleum and hospital opening times are from 08.00 until sunset. The complex is currently undergoing restoration work and visitors are not allowed inside.

When serving Sultan Baybars al-Bunduqdari as an *amir*, Qalawun fell ill and was treated in the *maristan* (hospital) of al-Nuri in Damascus. So impressed and pleased was he by the hospital that he vowed to build a similar institution some day in Cairo, should God favour him by making him Sultan of Egypt. Soon after acceding to the throne in 678/1279, he bought the land and buildings from the owners of a plot of land, which had at one time partly belonged to the Fatimid West or Small Palace. He had the hospital built there as part of this large complex, which was also to include a *madrasa* and mausoleum.
Work began in 683/1284 and was completed in the uncommonly short period of time of a year and a month. The historian al-Maqrizi relates several anecdotes on the subject of its construction. He recounts how the man in charge of

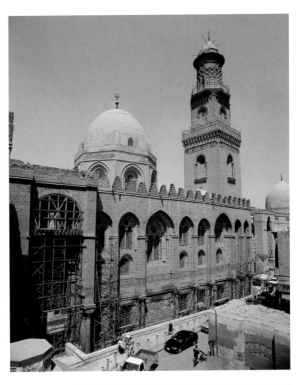

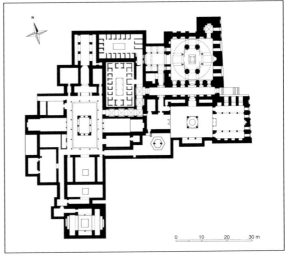

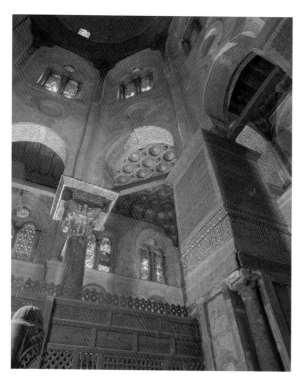

Complex of Sultan Qalawun, mausoleum interior, Cairo.

façade. The structural importance of this north-south artery since Fatimid times constituted another decisive factor in its location.

The architect provided access to the three buildings through a single doorway facilitating security of the building and from there into a long bent passageway measuring 5 m. in width. The entrance portal is formed of two superimposed arches over the door lintel, the first of which is slightly pointed while the second is a horseshoe arch. It is the first entrance portal of its kind in Mamluk architecture in Cairo.

The façade measures 67 m. in length along the street with subtle variations in design separating the mausoleum, to the right and set back some 10 m. from the street, from the *madrasa* to the left, which stands further forward. The architectural detail of the mausoleum indicates that this is where most care was taken with the housing of the tomb. At the end of the entrance passageway to the right, a domed *derka* leads to an open, arcaded courtyard. On passing through a wooden *mashrabiyya* screen crowned by one of the most impressive stucco ornaments still preserved intact, we reach the magnificent *qubba* of Sultan al-Mansur Qalawun and his son al-Nasir Muhammad. The large dome rising above the mausoleum rests on an octagonal drum supported by four columns, and between them, four paired pillars – one of the elements most associated with Syrian influence. With its varied ornamentation, encrusted with mosaics, the *mihrab* is said to be one of the most splendid examples of Islamic architecture.

To the left of the passageway two entranceways lead to the *madrasa* – a central courtyard surrounded by four *iwans*.

the building used to force passers-by to carry building materials into the complex. The news spread quickly through the city and soon people stopped going past the site.

This building complex is said to mark the beginning of a new style of construction for great architectural complexes. These comprised buildings of different sizes according to their uses – a model, which would soon become the predominant one in later Ottoman architecture.

The choice of location for this impressive construction on the western side of al-Mu'izz li-Din Allah Street was partly due to the need for the *qibla*, *madrasa* and *qubba* walls to coincide on the same street

The sanctuary *iwan* is the largest of the four. The foundation documents stipulate that the students' rooms should be located around the *iwans*, and the *al-faqihs'* lodgings on the upper floor.

The southeast *iwan* has three aisles separated by arcades, perpendicular to the *qibla* wall, the widest aisle being the central one. Here the layout is clearly influenced by the Christian basilica model.

Little remains of the hospital located at the end of the passageway. Nevertheless, historical sources and archaeological excavations have revealed a considerable amount of information regarding its layout.

It continued to be used as a working hospital until the mid-13th/19th century, though today two large *iwans* are all that remain of the original building. The Ministry of *Waqf*s built a specialist eye hospital on the site of the rest of the building in 1915.

With the complex built over the remains of the Fatimid Western Palace, archaeological excavations have also uncovered fragments of wood on which musicians, dancers, fishing and hunting scenes were carved during the Fatimid era. These fragments were placed facing the walls, for such figural representations were considered blasphemous in that era. Nowadays, they can be seen in the Museum of Islamic Art, Cairo.

In addition, there is evidence to suggest that the layout of the building was a divided one with different sections for men and women in each of the care units of the hospital. This design resembles that of the al-Nuri Hospital in Damascus. The hospital had 100 beds available shared among the areas of surgery, fractures, intestinal disorders, ophthalmology, neurology, psychology, as well as outpatients, isolation for contagious diseases, a pharmacy, store rooms for instruments and other rooms for various other services.

In addition, medicine was taught in the hospital, which also had a library. The main hall, previously one of the halls of the Fatimid Palace, was used as an observation room and for post-operational intensive care.

The minaret on the eastern edge of mausoleum wall has three sections, which become successively narrower. The first two sections are square-based while the third is circular. This is the work of Sultan al-Nasir Muhammad, son of Qalawun, who commissioned its building in 703/1303 to replace an earlier minaret

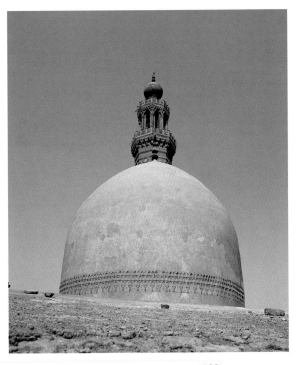

Khanqa and Madrasa of Sultan Barquq, dome and minaret, Cairo.

Sultan Barquq, known by the name
barquq (meaning plums) for his protrud-
ing eyes, acceded to the throne in the
year 784/1382, the first Circassian Sul-
tan of Egypt. Amir Jarkas al-Khalili
supervised the building of the *khanqa* and
madrasa, which took two years to com-
plete between 786/1384 and 788/1386.
The great master Shihab al-Din Ahmad
Ibn Tulun was the chief architect, the
son of a family with a long history in the
profession, who were well known for
several buildings in Egypt and the
al-Hijaz. In the Mamluk era architects
were held in great respect by sultans;
Ahmad Ibn Tulun's marriage to the sul-
tan's daughter reflects the respect
bestowed upon him and his noted posi-
tion in the courts.

The main façade on the west side of
al-Mu'izz li-Din Allah Street, similar to
the Complex of Qalawun, stretches from
the minaret in the north west to the mon-
umental entrance in the south east. Most
notable are the vertical recesses along the
length of the façade, and the windows on
street level covered by bronze grilles. The
windows, crowned by marble lintels with
their *voussoirs* interlocking, are in the *ablaq*
technique. The upper part of the building
has pointed arches framing the windows
with their wooden *mashrabiyya* screens
displaying perfect geometric shapes
formed by small pieces of turned wood.
The *madrasa* wall differs from the mau-
soleum wall in a few aspects, but its
length is unified in the cresting across the
top of the façade and the magnificent
inscription carved in stone on a level with
the third floor.

Despite the vast size of the minaret, it is
well proportioned with its three octago-
nal sections. The uppermost section is
open (*gawsaq*) and crowned with a bulbi-

destroyed by an earthquake that year. The
upper part of the first section bears an
inscription commemorating this act and
mentions the founder, his titles, and the
date of its construction.

S. B.

III.1.d Khanqa and Madrasa of Sultan Barquq

*The Khanqa and Madrasa of Sultan Barquq
are located on al-Mu'izz li-Din Allah Street
next to the Sultan Qalawun Complex.*
*Opening times: all day except during midday
and afternoon prayers (12.00 and 15.00 in
winter, 13.00 and 16.00 in summer).*

Khanqa and madrasa
of Sultan Barquq,
Cairo.
a. Ground floor:
1. Hanafi doctrine.

2. Shafi'i doctrine.
3. Maliki doctrine.
4. Hanbali doctrine.
b. First floor.
c. Second floor.

form finial. The interlaced circles carved in stone and originally covered in marble make for remarkable ornamentation on the middle section. It is the only example of its kind ever built.

A double staircase ascends to the main entrance. The doors are faced in bronze with geometric motifs in relief, which combine with the inlaid floral motifs in silver to form a lattice. The name of Sultan Barquq can be read in the 18-pointed stars.

The red-and-white stone domed *derka* leads to the *khanqa* courtyard along a winding passageway open at each end and paved in coloured marble.

The layout of the building is the resulting blend of two styles; the cruciform *madrasa* with courtyard and four *iwans*, with the hypostyle mosque plan as we see in the south east *iwan*, divided into three aisles perpendicular to the *qibla* wall. The *mihrab* is flanked on either side by two niches high up on the wall with barred windows and decorated with coloured marble panelling and mother-of-pearl inlay. On one side is the wooden *minbar*, work of Sultan Jaqmaq (r. 842/1438-857/1453), and on the other the wooden Qur'an lectern, a masterpiece of craftsmanship inlaid with ivory. Across the entrance to the *iwan* is the marble *dikkat al-muballigh* supported on eight marble columns. The splendid ceiling decoration of this *iwan* displays a blue background with floral images and gilt inscriptions, contrasting with the remaining three *iwans*, covered by pointed barrel vaults. The north western and largest *iwan* was built using the *mushahhar* technique of alternating courses of coloured stone.

Classes on exegesis and Qur'anic recitation were taught in this *khanqa* along with

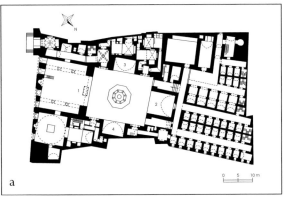

a

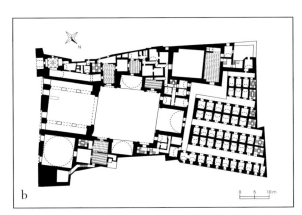

b

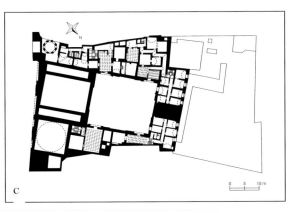

c

141

Khanqa and Madrasa of Sultan Barquq, mihrab and minbar, Cairo.

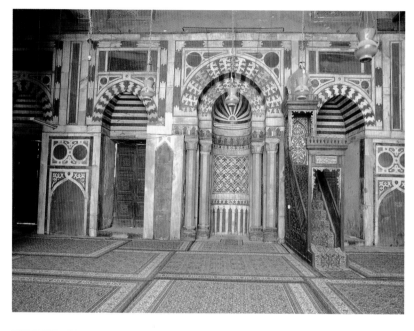

Khanqa and Madrasa of Sultan Barquq, qibla iwan, detail of ceiling, Cairo.

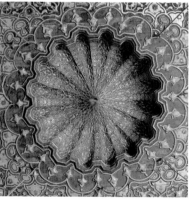

hadith, the prophetic tradition, from the four legal rites. The *qibla iwan* was reserved for the *hanafi* doctrine, the rite followed by the Sultan, the north west for *shafi'i* and the two side *iwans* for the *maliki* and *hanbali* doctrines.

The north west *iwan* has two passageways leading to the students and Sufis' rooms, kitchen, water-well and ablutions hall. On the same side of the courtyard a door in the north west corner leads off to three rooms for the *al-faqihs*, (*shafi'i*, *maliki* and *hanbali*). In the opposite corner a door leads to stairs to the upper floors, where the *hanafi faqih* lived, and where there are more lodgings for the students as well as other rooms.

The mausoleum, in which the father and sons of the Sultan were buried, can be reached from the prayer hall. It is covered by a dome resting on pendentives of seven rows of gold *muqarnas*.

The centre of the courtyard is occupied by a fountain, its wooden dome supported on eight slender columns. In the south east corner of the courtyard a door leads off to several rooms on three different

floors where the Sultan and his family lived during the various religious festivities. This residence, annexed to the *khanqa*, is in fact one of the building's most unusual features.

M. M.

III.1.e **Khanqa of Sultan Baybars al-Gashankir**

The khanqa of Sultan Baybars al-Gashankir is located on al-Gamaliyya Street. Follow al-Mu'izz li-Din Allah Street towards Bab al-Futuh and turn right along Darb al-Asfar Street, which leads to the front of the monument.

Opening times: all day except during midday and afternoon prayers (12.00 and 15.00 in winter, 13.00 and 16.00 in summer).

In 706/1306, two years before Sultan Baybars al-Gashankir acceded to the throne, building on the *khanqa* started on the site of the former Fatimid chancellery. It was officially opened in the Holy month of *Ramadan* 709/February 1310. Sultan Baybars al-Gashankir was, however, forced to give up the throne when al-Nasir Muhammad returned from Syria to rule for the third time. Sultan al-Nasir Muhammad promptly had Baybars al-Gashankir arrested and beheaded. On al-Nasir Muhammad's orders the *khanqa* was closed and did not reopen until 18 years later 726/1326.

The *khanqa* of Sultan Baybars al-Gashankir is the oldest surviving example of its kind. As the *waqf* document states, this *khanqa* was destined to hold 400 Sufis, 100 of which were residents, and another 100 soldiers and sons of *amirs*. This document also provides us with information about

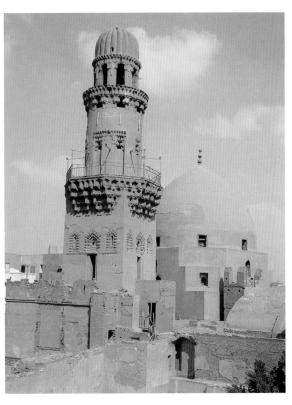

"staff" provisions linked to this type of establishment. The staff consisted of two *faqihs* (one *Hanafi* and the other *Shafi'i*) two reciters, a key keeper, one person in charge of maintenance, one in charge of damping down the building to keep it cool, another in charge of distributing water, a lamplighter, a cook, one person in charge of weights and measures, one to help with bread making, two helpers for making soup, an eye doctor and one to lay out the dead. There were additional employees for the residence and the tomb. Their salaries were paid with income from *waqf* properties, including lands in Egypt and *al-Sham*.

Khanqa and Madrasa of Sultan Baybars al-Gashankir, dome and minaret, Cairo.

*Khanqa of Sultan
Baybars al-Gashankir,
entrance, Cairo.*

*Khanqa of Sultan
Baybars al-Gashankir,
qubba mihrab, detail
on panelling, Cairo.*

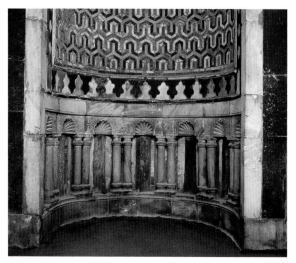

The *khanqa* measures 68 m. in length and runs perpendicular to al-Gamaliyya Street; the façade is shared by the mausoleum and the main-entrance wall. The entrance is covered by a half vault of *muqarnas* and is crowned with a round arch, displaying an innovative develop-

ment in architectural practices. Two niches have been added above the marble benches in the centre of the side wall. Round arches resting on marble columns built in the *ablaq* technique rise above them.

Half way up the façade, a band bearing a *naskhi* inscription runs the length of the building mentioning the *khanqa* as a *waqf* foundation for Sufis and specifying the full name of Sultan Baybars al-Gashankir. The word "sultan" is missing, believed to have been removed by Sultan al-Nasir Muhammad, (see the right hand side of the mausoleum wall).

The *khanqa* is a regular shaped building on an irregular plot of land. Its rectangular central courtyard is open and it has four *iwans*. The south east *iwan* is the largest and was reserved for the teaching of the *shafi'i* doctrine. One of the most unusual aspects of this building is the inclusion of a *mihrab* in each of the side *iwans*. There are cells for the Sufis surrounding the stone-flagged courtyard.

The burial *qubba* is particularly noted for the unusual decoration of its *mihrab*, which comprises small alternating stone-and-shell paired colonettes in an arch formation with their spandrels decorated with leaf motifs in relief. On the opposite side bordering the street, there is a room in which special classes on the prophetic tradition (*hadith*) were taught.

The minaret above the main entrance has three sections (square-based, circular and *gawsaq*), each separated by a balcony supported on several rows of *muqarnas*. The minaret is crowned with a ribbed finial known as *mabkhara* for its incense burner shape, originally decorated with green ceramic tiles or *faience*.

M. M.

WAQF ORGANISATION IN THE MAMLUK ERA

Mohamed Abd El-Aziz

Waqf meaning to stop or to immobilise, also expresses in Islam the act of donating personal belongings as charitable endowments; devoutly bequeathing property to the needs of the religious community, humanitarian needs or for public service. A bequest or donation might constitute wealth in terms of lands or real estate, which once bequeathed, could not be sold, bought, possessed, inherited, given away or mortgaged. Its profits were destined to the upkeep of charitable works or actions in accordance with the conditions set out by the benefactor.

Like many other peoples, the Arabs already knew of the *waqf* system in its broader sense long before the birth of Islam. The *Ka'ba*, al-Aqsa Mosque and churches on the tip of the Arabian Peninsula did not belong to any one person as private property, but rather were used by all followers of many different religions. The *waqf* is based on one of the religious principles set out by Islamic jurisprudence: compulsory almsgiving, proof of which is the *Hadith* (or prophetic tradition of Muhammad). According to Islamic law "when somebody dies his acts die

with him, unless one of the three following circumstances occur, he leaves an ongoing charitable act, he leaves a teaching which is of benefit to mankind, or that he leaves a son who calls upon God in his name".

The Arab conquest of Egypt heralded the arrival of the Islamic *waqf* system, the constitution of which was an act believed to bring man closer to God. From the beginning of the Islamic period Muslims adopted the custom of setting up *waqf* foundations, a tradition which was to proliferate in Egypt. Her oldest *waqf* was founded in agricultural lands in the first century of the *hijra*. Built in 68/687 during the reign of the Umayyad Caliph 'Abd al-'Aziz Ibn Marwan, it was known as the *waqf* of the Garden of 'Amr Ibn Mudarrak in Giza. Under Caliph Hisham Ibn 'Abd al-Malik an institution was founded, considered to be the first of its kind both in Egypt and other Islamic countries, dedicated to the administration of these foundations and whose supervision was carried out by the Cadis, known as the "Ministry of *Waqf*". The Mamluk era was considered the Golden Age of the *waqf* system in Egypt.

Khanga of Sultan Baybars al-Gashankir, detail of the naskhi inscription mentioning the building as a waqf foundation, Cairo.

Cultural, social, political and economic factors all played a significant role in the spread and rise of the system, which was in turn influenced by the popularity of the very system that it promoted.

For those Mamluk Sultans who came to power by non-orthodox means, and were thus considered foreigners by native citizens of Egypt, the *waqf* system provided them with a method of gaining the acceptance of the local people and of promoting their government. Thus, many pious foundations were set up through donations such as land and real estate. Donations such as these were either from the donor's own property or from public funds, to provide drinking water, education (primary schools), hospitals or other services such as the distribution of food to the poor or the laying out and burying of the dead.

It was due to the *waqf* system that the Mamluk Sultans and men of the State also achieved another objective – avoiding the confiscation of their property. It is worth remembering at this point that, with few exceptions, sultans did not rule by hereditary succession and that the newly invested sultan would frequently confiscate the belongings of his predecessor. Thus, through funds raised by *waqf* properties and independent of any changes that might occur in the future, the Mamluks guaranteed an income for themselves and for their descendants.

There were two types of *waqf*s: the first was a family endowment set up by the benefactor and which upon his death would be run by his descendants; and on their death, by a charitable foundation. The second was a charitable foundation, set up and run by a charitable institution. The Mamluk period saw the spread of a third type of *waqf*, a mix of the former

two. In its founding deeds it clearly indicated that once the expenses of the charitable foundation had been paid, any surplus should go back to the founder and on his death to his descendants.

Among the economic factors that encouraged the Mamluk Sultans and the inhabitants of Egypt in general, to turn their property into charitable endowments was the fact that such properties were exempt of taxes and fees, for they were considered to belong to "dead" hands. Furthermore, on donating property to a pious foundation, they were freed of their legal obligations of almsgiving and the *waqf* system became in itself a means of almsgiving. Another reason for the increase in *waqf*s during the Mamluk era was the creation of an administrative foundation (*diwan al-hashriyya*) to deal with the property of those who died without descendants.

During the Mamluk era religious activity assumed unprecedented levels. Some of the motives for such activity are related to the origins of the sultans and *amir*s (slaves and not Arabs) and the education they received. Other reasons are connected with the general policy of strengthening the ties between the court, the state and religious institutions. These sultans founded many religious institutions, *madrasa*s, *khanqa*s and retreats, as well as mosques in order to strengthen religious unity and to help them put their varied pasts, origins and race behind them.

The pious foundation played an important role in maintaining mosques and in spreading the Faith. The institution made an enormous contribution to the spread of Sufism in Mamluk Egypt and part of the profits were invested in supporting Sufis who lived in isolation devoting themselves to prayer.

In addition many of the benefactors included a clause in the deeds of their foundation that part of the profits were to be invested in helping those who could not afford to carry out the religious duty of making a pilgrimage to Mecca.

The *waqf*, to a considerable extent, also supported the sultans' ability to defend Islam and its lands. Citadels and forts were built on the borders to prevent attacks by Crusaders and to gather together the necessary troops, arms and equipment for their defence; hence the building of the Citadel of Qaytbay in Alexandria and the tower in Rosetta.

The increase in scientific activity in Egypt during the Mamluk period was directly related to the spread and consolidation of this system. The profits of such establishments were the principal source of income for the majority of *madrasa*s and primary schools for orphans. As such, had it not been for such abundance of resources, scientific activity and the spread of religion during the Mamluk period would never have occurred.

The *waqf* system also provided a significant impulse to the development and great achievements attained by Egyptian Islamic Art, and promoted the conservation of ancient buildings, which have survived to our day. Masterpieces of Islamic Art as well as documents on the constitution of *waqf*s describing the buildings and their contents in minute detail have provided us with a wealth of artistic terms. Furthermore, the system guaranteed the future of the artisans and their skills, as well as the progressive development of different arts, for much of their income came from *waqf*s. *Waqf* foundations were generally the property of the rich and thus their conservation and the continuity of their use and enjoyment was guaranteed for both religious and civil foundations.

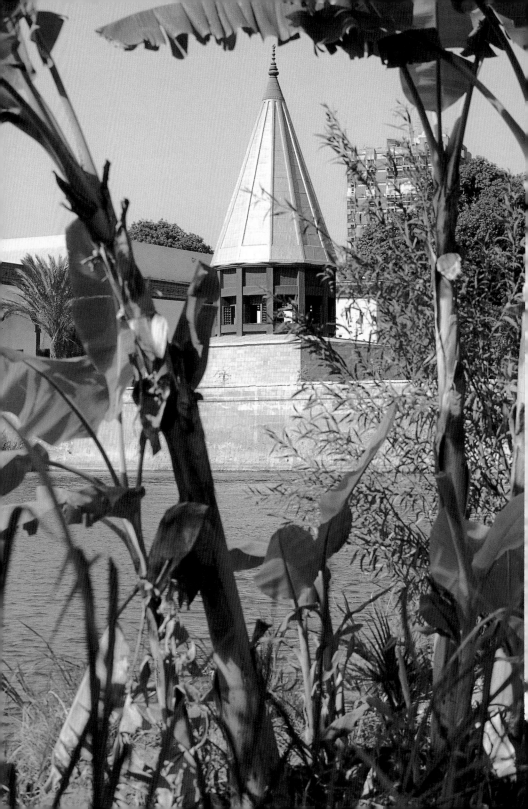

Celebrating the Rising of the Nile

**Ali Ateya, Salah El-Bahnasi, Mohamed Hossam El-Din,
Gamal Gad El-Rab, Tarek Torky**

IV.I CAIRO

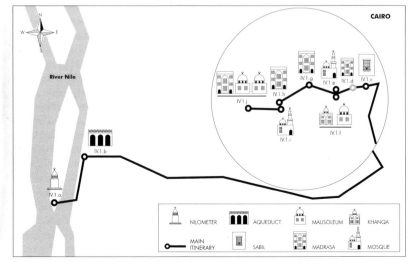

The Nilometre, Roda
Island, Cairo.

The Nile, burg of the aqueduct, Cairo (D. Roberts, 1996, courtesy of the American University of Cairo).

"Egypt is the gift of the Nile", claimed Herodotus, the Greek historian on visiting the country. He observed the close relations between the country's inhabitants and the waters of the Great River and how her people depended on the Nile for everything. His claim was by no means an exaggeration, for throughout different periods of the country's history, her peoples have always been keenly aware of how closely their industries and crops depended on the Nile. How water shortages could cause drought, famine, crop failure and death for both animals and people. The flood season brought with it great celebration, an expression of this deep-rooted dependence.

Following the conquest of Egypt, her Arab governors and Caliphs showed great interest in recording the rise and fall of the Nile and publicly announced their recordings to prepare people for what the future would hold. The Ibn Abi al-Raddad family, responsible for measuring and recording the height of the Nile, held the post until the Mamluk era.

Different governments, concerned with keeping a water supply for the populace, had various installations built for this purpose. During the Ayyubid period, drinking water was supplied from the Nile, reaching the city of Fustat via a canal built along the upper part of the Salah al-Din walls, sections of which still stand today. With a growing population and the city's expansion in the Mamluk period, the sultans faced increasing demand for water. Between 710/1310 and 712/1312, Sultan al-Nasir Muhammad had four water wheels built on the banks of the Nile to raise water to the height of the aqueduct, which, at a level with al-Sayyida Nafisa, joined the Salah al-Din Walls canal; from there, water was transported to the Citadel.

Later the Circassians would restore the aqueducts until, in 912/1506, Sultan al-Ghuri stopped the use of the old aqueduct and ordered it to be replaced with a new one (IV.1.b) and had the water wheels renovated.

The number of *sabil*s in the city increased providing the majority of the water required in order that the needs of the Cairene population could be met. In return for a fee carriers transported the water to private homes, while the supply of water directly from public fountains and *sabil*s, in accordance with Muslim law, was free to Cairenes and her visitors. Apart from wells, there were also watering troughs located throughout the city for animals. The abundance of *sabil*s in Cairo reflects the level of development and progress achieved in those times.

The celebration of the flooding of the Nile, to a level sufficient to guarantee water supply, was patronised by the Mamluk sultans, who would personally attend the event or send a representative from among their generals.

During the period when the Nile was rising, it was customary to announce its level publicly, as the historian Abu al-'Abbas al-Qalqashandi states: "During the flood season the person responsible for the nilometer would measure the height of the water every afternoon and the next day announce the news, sending a written statement to important men of State." He adds that he would also inform them of the difference in level compared with the year before. On reaching a height of 16 cubits (8 m.) messengers would carry the good news far and wide and with it preparation for the festivities commenced.

The celebration would begin in the morning with the Sultan's descent from the Citadel along al-Saliba Street (nowadays bearing different names along its different sections). He would cross the canal (nowadays Port Said Street) by the Bridge of Lions (in the present-day al-Sayyida Zaynab Square), and then to Old Cairo (Fustat) opposite Roda Island where the nilometer was located. From there he would cross with his men-of-state in battleships transporting them to the nilometer, in which the central measuring post was anointed with saffron perfume. Flaming arrows were shot from the battleships and from there the ships would sail in the midst of the celebrations and music to Fum al-Khalig, to where the canal diverted. Its floodgate was opened to reduce the flow of the river thus avoiding the risk of flooding. In the course of the celebrations, the sultan's tents were set up along

the banks of the Nile to house his escorts and guard, and banquets financed by public funds were held. The Sultan gave presents and honorary vestments to the *amirs* and the Ibn Abi al-Raddad family, responsible for the measurements, and poets composed verses for the occasion.

Among the sultans who joined in the celebrations were Sultan Barquq (in 800/1397), al-Mu'ayyad Shaykh (in 816/1413), Khushqadam (in 870/1465) and al-Ghuri (in 917/1511); the latter had a palace built next to the nilometer for celebrating healthy depth of the Nile.

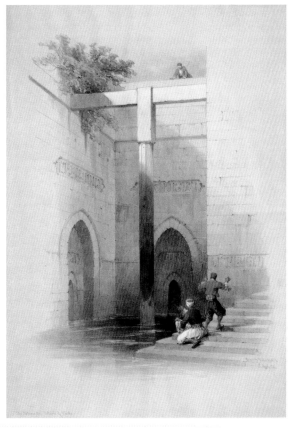

Nilometer, interior, central measuring post, Cairo (D. Roberts, 1996, courtesy of the American University of Cairo).

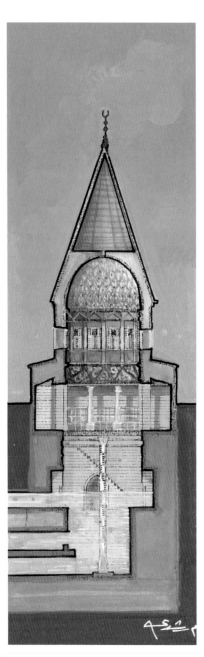

Nilometer, section, Cairo (painting by Mohammed Rushdy).

Historical sources also tell us that al-Mu'ayyad Shaykh swam across the Nile despite his illness to whitewash the nilometer.

If the level of the water did not, however, reach the required level to guarantee supply for domestic and agricultural use, the sultan would order the people to pray for rain.

The enormous importance of the Nile is recorded in the annals of time by historians who took daily readings of the river, included in the works *al-Suluk,* by al-Maqrizi and *Bada'i' al-zuhur* by Ibn Iyas, among many others.

The celebration was not limited to the sultan and his entourage, but for all classes of Egyptian society. At night torches were lit and people celebrated in the streets, playing games, eating delicious foods, bands played music and magicians performed their tricks as well as the festivities taking place inside the tents pitched along the banks of the Nile.

M. H. D.

IV.I **CAIRO**

IV.1.a **Nilometer**

The nilometer is reached by going down the Corniche of the Nil in Old Cairo, and crossing a wooden footbridge recently built by the Ministry of Culture.

Opening times: from 08.00 to sunset.

Given the close relationship between agricultural seasons and State tribute and tax collection, the nilometer is considered one of the most important constructions related to water ever built in Egypt.

Though some historians attribute its construction to the Abbasid Caliph al-Ma'mun (170/786-218/833), Ibn Khalikan, who wrote *Wafayat al-a'yan,* claims it was built by Caliph al-Mutawakkil (r.232/847-247/861).

The nilometer is located on the southernmost tip of Roda Island. It is the oldest monument in Cairo preserved in its original state and a genuine feat of engineering. In order to build the structure with greater precision the engineer is assumed to have built the nilometer in the dry season when the area between Roda Island and Fustat was practically dry. He anchored the measuring post in the centre of a 12.5 m.-deep square with sides 10 m. thick and made three openings at different heights to allow the flow of water to enter.

The central column is one of its most important components. It is octagonal in section and measures almost 10.5 m. in height. Before the walls were built around the column, it was anchored with a wooden base so as not to sink into the riverbed. Later, on constructing the walls, the upper part of the post was secured by placing beams across the top, one attached to the east wall and another to the west wall. To descend into the nilometer, there is a staircase on two sides around the inner wall with a small landing between them in one corner.

An inscription band of *Kufic* script runs around the inside of the top of the walls. Carved in marble relief, it is one of the oldest inscriptions preserved in an Islamic building in Cairo. The text bears verses from the *Qur'an,* and alludes to water and agriculture.

In the Mamluk era, Sultan Qaytbay ordered its renovation and the reconstruction of its foundations in 886/1481. He

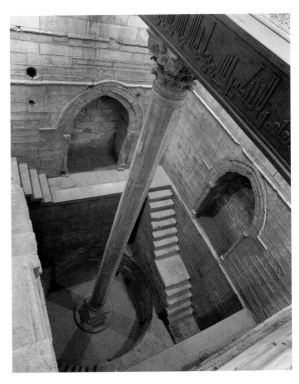

Nilometer, interior, central measuring post and stairs, Cairo.

Nilometer, interior, opening for water flow, Cairo.

also had the dome renovated, originally built by Sultan Baybars al-Bunduqdari, though the dome we see today is, how-

Aqueduct, partial view, Cairo.

the Nile and ends at al-Sayyida 'A'isha Square. It has been demolished at intervals in order to allow streets and an underground-train line to pass through. A restoration project including the reconstruction of the water wheels and the demolished sections is currently underway to return it to its original state. Due to restoration work, visitors cannot go inside.

The project to build an aqueduct taking water from Fustat to the Citadel dates back to the time of Salah al-Din al-Ayyubi. Water was raised by a series of water wheels from one of the wells up to a canal at the top of the aqueduct, from where it flowed towards the Citadel. Thus, the Citadel was provided with sufficient water for drinking and irrigating the crops planted in the surrounding area.

When the Mamluks settled in the Citadel the aqueduct had to be extended to cope with the increase in inhabitants and soldiers residing therein. In 712/1312 Sultan al-Nasir Muhammad had another construction built to increase water supply to the city. He ordered an enormous tower with four water wheels to be built on the banks of the Nile approximately 1 km. to the north of the Salah al-Din well. The water wheels in this tower were to raise water to the new aqueduct, which on a slight slope ran eastwards to connect with the Salah al-Din aqueduct at a level with Salah Salim Street in the al-Sayyida Nafisa Quarter. Thus, al-Nasir Muhammad achieved his aim of providing water sufficient for soldiers, crop irrigation and animals. Furthermore, the increased flow of water allowed him to extend the Citadel to include the al-Ablaq Palace and his mosque (Itinerary I), among other buildings.

ever, the work of the Commission for the Conservation of Arab Monuments, as its inscription states, dated in 1367/1947. The nilometer is no longer in use.

G. G. R.

A wonderful view of the whole width of the Nile can be seen from the balcony of the al-Minesterli Palace next to the nilometer, on the southern tip of Roda Island.

IV.1.b **Aqueduct**

The Aqueduct, which measures 3 km. in length, begins at the water wheel towers (in the Fum al-Khalig area), on the Corniche of

The historian al-Maqrizi recounts how in 741/1340, al-Nasir Muhammad ordered a canal to be excavated, the course of which would flow from the banks of the river Nile inland to the Citadel. At this point the water was to be raised to the height of the aqueduct via a system of water wheels and wells. By reducing the distance the water had to travel, its flow would increase. Unfortunately, al-Nasir Muhammad died before work began.

The aqueduct was restored on several occasions. One of Sultan Farag Ibn Barquq's *amirs*, Yalbugha al-Salimi, undertook renovation work on it in 812/1409. Later, a large portion of this work collapsed and it was again reconstructed in the time of Qaytbay. In 912/1506, Sultan al-Ghuri ordered over half the aqueduct from the Nile to be rebuilt and other sections to be restored along with the water wheel tower. Between the two tall arches on either side of the tower, his name and arms can be seen.

With the arrival of the French expedition to Egypt, the aqueduct fell into disuse, and soldiers closed up some of the arches, which they turned into fortifications.

S. B.

IV.1.c Sabil and Kuttab of Sultan Qaytbay

The Sabil and Kuttab of Sultan Qaytbay is situated at the beginning of al-Saliba Street opening onto Citadel Square.
Opening times: from 08.00 to sunset.

*Sabil*s were the kind of building *amir*s and sultans had constructed during the Mamluk era as *waqf* foundations as a means of raising their social prestige. At the same time they fulfilled their duties as dictated by the *Qur'an* to help your neighbour and giving support to those in need.

The *sabil* served to supply water to passers-by and residents of the city. Their founders took particular care in selecting servants and workers free of intestinal illness and the *sabil* acquired enormous importance during the summer months when demand for water was greater.

In the majority of cases, the *sabil* comprised three floors. The underground section was a stone-built cistern for water storage, which had a hole in the upper part through which water was extracted. Water was distributed to the public through windows onto the street from the second level, which contained a *salsabil*

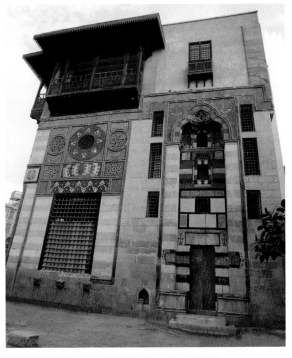

Sabil and Kuttab of Sultan Qaytbay, main façade, Cairo.

Sabil and Kuttab of Sultan Qaytbay, plan, Cairo.

Sabil and Kuttab of Sultan Qaytbay, corner column, detail, Cairo.

(marble fountain and panel over which the water flowed) to cool the water then offered to passers-by. The *kuttab* was located above this. It was a primary school and a school for memorising the *Qur'an* for children including orphans. It was, customary for the *sabil* to be annexed to architectural complexes as we have seen in examples of the Madrasa and Mosque of Sultan Qaytbay (II.1.a) and in the Khanqa of Farag Ibn Barquq (II.1.c).

This building is Qaytbay's most notable architectural achievement in Cairo and the first *sabil-kuttab* independent of any other building, a model which was to become popular among less well-off patrons, in particular in the late Ottoman period.

The building was constructed in 884/1479 with a square layout in the centre of four streets. The high narrow entrance portal is covered in *ablaq* stone work of red, black and white bands and crowned by the traditional tri-lobed arch, though here with its characteristic drip. The two half-fan vaults hold the central lobed semi-dome in the centre of the arch. The spandrels sport Qaytbay's coat of arms, which stand out on a bas-relief leaf-pattern background. Lower down on either side of the door is a foundation text carved in marble on a red background bearing the name of Sultan Qaytbay, one of the Mamluk Sultans to build the most *sabils* for the city.

The decoration on the façade of the building to the side of the main entrance is outstanding. The façade is crowned by the *kuttab* noted for its wooden balcony and ceiling with a cornice serving as both a sunshade and protection from the rain. Below the *kuttab* is the *sabil* window with its bronze grille through which the *sabil* was ventilated and water was passed to

156

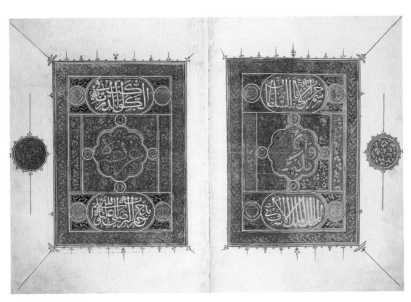

the public. The window is crowned by fine ornamentation comprising nine panels in three rows of three. The first and lower row of three panels contains the central lintel bearing interlaced triple leaves incrusted in black and white on a red background. On either side of the lintel are two small panels with leaf decoration in relief. The second panel contains the relieving arch constructed of interlocking black-and-white marble *voussoirs* of triple leaves. On either side, geometric latticework appears with blue-and-white earthenware incrustation on a red background. The third and largest row has a medallion in its centre and is surrounded by a leaf decoration in bas-relief. Smaller medallions are situated on either side with blue-and-white earthenware incrustation forming a geometric lattice decoration with a red hexagon in the centre. Above the corner column, in extraordinary detail, is a circular emblem bearing

leaf and geometric designs and the Sultan's epigraph which reads: "Glory to our master Sultan al-Malik al-Ashraf Abi al-Nasr Qaytbay, may his triumphs be glorious".

The magnificence of this ornamentation, uncommon in late Mamluk architecture, is explained by the notable location of the building. It stands in front of the Citadel and at the beginning of the procession to celebrate the flooding of the Nile, it being the first building seen from the outside. The design on the outside of the building divided into nine sections reminds us of the triptych on the double-page frontispiece of the manuscript made for Qaytbay (*Al-Kawakib al-Durriyya*) by al-Busiri and now conserved in Dublin. It copies the designs that were so freely transferred from one artistic medium (illumination) to another (architecture). A detailed comparison is not appropriate here, but it is interesting to note how the designs

157

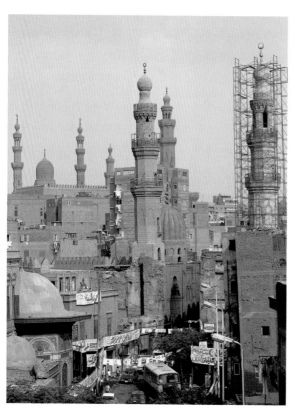

Mosque and Khanqa of Shaykhu, general view, Cairo.

Opening times: all day except during midday and afternoon prayers (12.00 and 15.00 in winter, 13.00 and 16.00 in summer). The madrasa is currently being restored and visitors are not allowed inside.

The *madrasa* was commissioned by Qanibay al-Muhammadi, one of Sultan Barquq's *amirs*. This *madrasa* belongs to the group of buildings known as "hanging" buildings due to the main entrance being above street level thus requiring a set of stairs to reach it.

The layout of the mosque comprises a *durqa'a* flanked by two *iwans*, the *qibla* to the south east and the other, of minimal proportions, to the north west. The mausoleum, which overlooks the street, is covered by a dome whose external decoration is similar to that of the Khanqa of Sultan Farag Ibn Barquq (II.1.c).

A. A.

IV.1.e **Mosque of Shaykhu**

The Mosque of Shaykhu is located on al-Saliba Street, opposite the khanqa of the same name.

Opening times: all day except during midday and afternoon prayers (12.00 and 15.00 in winter, 13.00 and 16.00 in summer).

Amir Shaykhu, one of Sultan al-Nasir Muhammad's *amirs*, held several posts before being made commander in chief of the palace. Then, on becoming head of the army he was made Great Amir only to be assassinated in 759/1357 by the Mamluks at the palace. In addition to the mosque he had built in 750/1349, he also commissioned the *khanqa* opposite and a *sabil* in al-Hattaba Street near the Citadel.

for buildings were initially sketched on paper, a transportable and cheap material before being crafted in metal with inlay or in paint and ink on paper, or carved in stone.

A. A.

IV.1.d **Madrasa of Qanibay al-Muhammadi** (option)

The Madrasa of Qanibay al-Muhammadi is on al-Saliba Street just after the previous monument.

Mosque of Shaykhu, plan, Cairo.

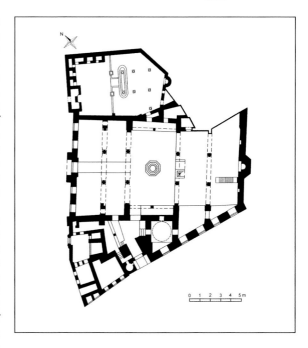

Located on a plot of land on a bend in the road, the architect took advantage of the crossroads with a secondary street to install the different components of the complex and to achieve a more regular layout for the mosque. The courtyard is rectangular with a fountain in its centre, *sadlas* on two of its facing sides and *iwans* on the other two sides. The *sadlas* are divided into two by a single column, while the *iwans* are separated by columns of two aisles that are arranged parallel to the *qibla* wall.

The most notable feature of this mosque is its stone *minbar*. The doorway is flanked by two twisted columns, above which the carved, stone capitals with the same arrow decorations as those on the second section of Qaytbay's minaret in the Al-Azhar Mosque (II.1.a). The lintel bears an inscription in *naskhi* script of Qur'anic verses and is crowned with three rows of *muqarnas* above which we see fleur-de-lys cresting. Of the ornamentation on the sides of the *minbar* only the banister decoration remains, divided into seven panels. Once again we see the arrow design on alternating panels with geometric designs in between. The upper part of the *minbar*, the seat from where the *imam* would preach to worshippers, is of wood, decorated in gold and topped with a twisted bulbiform finial.

The mosque was also used as a *madrasa*, for which Amir Shaykhu had rations of bread, meat, oil, soap and sweet foods assigned, and named several masters to teach the four legal rites, recitation of the Qur'an and the prophetic tradition (*hadith*).

A. A.

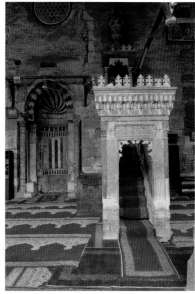

Mosque of Shaykhu, stone minbar and mihrab, Cairo.

159

*Khanqa and qubba of
Shaykhu, general view
of the two minarets,
Cairo.*

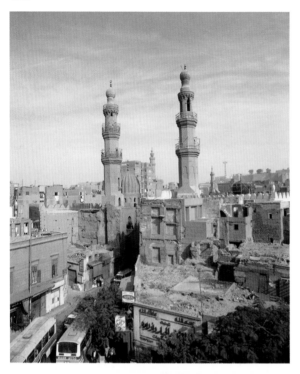

IV.1.f **Khanqa and Qubba of Shaykhu**

*This monument is opposite the Mosque of
Shaykhu.
Opening times: all day except during midday
and afternoon prayers (12 .00 and 15.00 in
winter, 13.00 and 16.00 in summer). This
monument is currently undergoing restoration
and visitors are not allowed inside.*

This *khanqa* was built in 756/1355 for the
teaching of the four doctrines, recitation
of the *Qur'an*, and the study of prophetic
tradition (*Hadith*). In order to meet the
running costs of the building, several *waqf*
foundations were set up. These resources
helped it gain importance. The *khanqa*
soon became a recognised seat of religious
learning. Many students came from
abroad that later became eminent acade-
mics. They received daily sustenance of
meat and bread and a monthly ration of
sweet food, oil and soap.

While the layout of the building appears
regular, the land it occupies is not. Lodg-
ings for the students are located on two
sides of the courtyard in the centre of
which is an octagonal fountain covered by
a dome. The prayer sanctuary is reached
through three arches separating it from the
south east side of the courtyard and com-
prises three aisles parallel to the *qibla*
wall. To its right is the *durqa'a*, with an *iwan* on
its south east and north west sides.

Despite the fact that in the mosque on the
other side of the street (constructed six
years earlier) a mausoleum had already
been built for the *amir*, the tomb of
Shaykhu is in the mausoleum here. It is
located on the left side of the sanctuary
and separated from it by a wooden screen.
The most outstanding part of this *khanqa*
is the coffering on the wooden ceiling

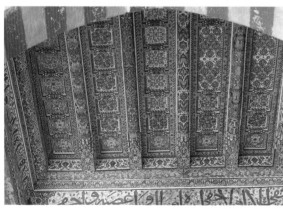

*Khanqa and qubba of
Shaykhu, sanctuary,
detail of ceiling
decoration, Cairo.*

covering the whole of the *qibla iwan*. The fine floral decoration combining gold, blue and brown shows extraordinary detail. The structure is in itself a perfectly formed combination of short beams and tie beams together forming simple coffers. The ends of the beams and the central part of the tie beams are carved in the form of *muqarnas* decoration. No two beams bear the same floral decoration, while the coffers, both square and rectangular, show the same basic design repeated with differing rhythms.

The minaret behind the main entrance has three sections. The first two are octagonal and the third is open (*gawsaq*) crowned by a series of *muqarnas* rows and a characteristic bulbiform finial. The architectural novelty of the minaret is however in the construction of the second section of the shaft in which red-and-white triangular shaped stones have been inserted giving the minaret an ornamental appearance of vertical zigzags. This style of decoration is characteristic of minarets in the era of al-Nasir Muhammad, whose own mosque in the Citadel has a minaret situated over the main entrance displaying similar vertical zigzags, though carved on the surface of the stone in high relief.

A. A.

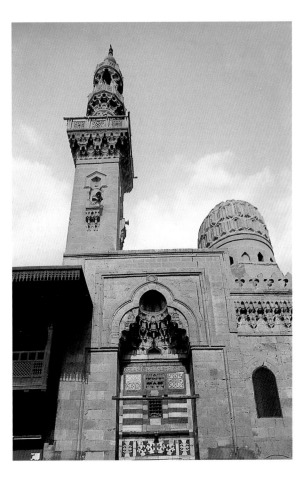

IV.1.g **Madrasa of Taghri Bardi**

The Madrasa of Taghri Bardi is on al-Saliba Street just past the Khanqa and Madrasa of Amir Shaykhu.
Opening times: all day except during midday and afternoon prayers (12.00 and 15.00 in winter, 13.00 and 16.00 in summer).

The *madrasa* was built in 844/1440 by

Amir Taghri Bardi, also known by the name of *al-mu'di* (the harmful) for his bad temper. He held a high position under Sultan Barsbay and became a general in the army that conquered Cyprus in 830/1426. Later, under Sultan Jaqmaq, he was named *dawadar* (Secretary of State), one of the seven most important posts in government.

Despite its apparently small surface area, the building contains a *madrasa*, mau-

Madrasa of Taghri Bardi, main façade, Cairo.

161

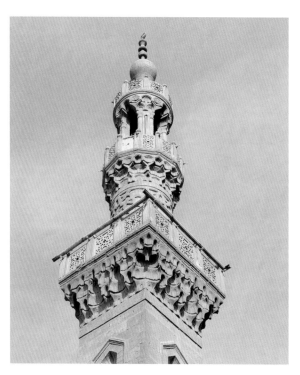

Madrasa of Taghri Bardi, minaret, detail, Cairo.

leaves resembling that of a doll. The second row is a simple *ablaq* composition with a small barred window in its centre, while the third is divided into three squares. The central square is ornamented with *muqarnas* and the two sides with leaf motifs, crowned with a *naskhi* inscription. The entrance is framed by a rectangular border rising above the cornice, in a similar fashion to that of the Mosque of al-Mu'ayyad Shaykh (II.1.i).

The mausoleum annexed to the *madrasa* is covered by a lengthened dome, the outer surface of which displays geometric figures in relief. The vertical nature of the pattern makes it appear disproportionately long.

The minaret has three sections, square-based, circular and *gawsaq*, separated by balconies supported on *muqarnas* rows and crowned with a by-then traditional bulbiform finial. The second section of the shaft testifies to the new stage in minaret decoration; it bears an eight-pointed-star lattice on its upper half.

A. A.

soleum, *sabil* and *kuttab*. The façade on al-Saliba Street bears evidence of the building's internal layout. The main entrance in the centre of the wall is flanked to the right by the wall of the *madrasa* and to the left by the *sabil* and *kuttab*.

The decoration above the main entrance is organised on three levels. A traditional tri-lobed arch, the vault of which is filled with *muqarnas* decoration, crowns the doorway. The first level contains the lintel and the relieving arch which together present an *ablaq* formation of *voussoirs* known as *al-'ara'is* (the dolls) and thought to be a new stage in the development of this kind of arch. Triangular pieces of marble fit together and the interlocking edges are cut in the shape of abstract

IV.1.h Madrasa of Sarghatmish

The Madrasa of Sarghatmish is located on al-Khudayri Street, and is positioned against the extension of the Mosque of Ahmad Ibn Tulun, in the area known as the Qal'a of al-Kabsh.

Opening times: all day except during midday and afternoon prayers (12.00 and 15.00 in winter, 13.00 and 16.00 in summer). This monument is currently under restoration and visitors are not allowed inside.

Amir Sarghatmish was a Mamluk bought for a considerable sum of money by al-Nasir Muhammad (one of the sultans

who acquired most slaves). Amir Sarghatmish was assigned the post of *gamadar*, to hold the mirror while the Sultan was dressing. During the reign of Sultan Hagui (r. 747/1346-748/1347) Sarghatmish quickly rose up through the ranks of *amirs* and on his promotion to the post of *ra's nuba kabir* (Commander in Chief of the Mamluks), he became one of the most influential *amirs*.

Under Sultan Salah al-Din Salah's reign (r. 752/1351-755/1354) he remained in government, but on the death of Amir Shaykhu found himself alone at the head of State matters. Sultan Hassan, on returning to power for a second time, feared Sarghatmish would undermine his reign as a result of the economic and political power he had acquired while in government. Sultan Hassan ordered the *amir*'s arrest and had him thrown into

prison in Alexandria where he died in 759/1358.

Historical sources record how Sarghatmish showed particular interest in Persian *ulemas* whom he treated with special care, respect and esteem. The great consideration and affinity he felt for them prompted him to dedicate a *madrasa* to them in which the doctrine of the four legal rites was taught. Special attention was paid to the *hanafi* school, given the large number of Persian *hanafi ulemas* were assigned to the school.

The *madrasa* was built in 757/1356 and like many others on a cruciform layout. It stands out, nevertheless, for other more unusual features.

Around the open central courtyard are four *iwans* with pointed arches and *mushahhar* masonry of white-and-red stone. Lodgings for students on five

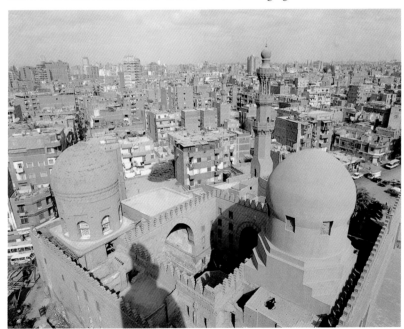

Madrasa of Sarghatmish, general view, Cairo.

*Madrasa of
Sarghatmish, plan,
Cairo.*

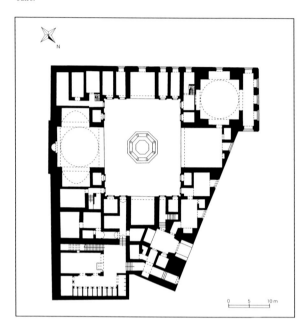

*Madrasa of
Sarghatmish, minaret,
Cairo.*

floors occupy all four sides of the court-
yard.

The sanctuary is characterised by its two
side *iwans* and by its elongated bulb-
shaped dome, typical of domes in
Samarkand in Iran. This is the oldest
dome built above the *mihrab* of a *madrasa*
in all the Islamic architecture of Egypt.
This type of stone dome first appeared
here in this *madrasa* and is noted for its
unusual structure: an inner dome and a
system of supports upholding the outer
dome hidden in the space between the
drum and outer dome. Such construc-
tions, never seen before in Egypt, were
introduced from Persia where the tradi-
tion of brick-built double domes dates
back to the 5th/11th century. The dome
covering Sarghatmish's tomb is similar to
that of the *mihrab*, though a little higher.
With the growing scarcity of land in
urban Cairo it was increasingly difficult
for patrons to find sizeable plots on which
to build their complexes, so they resort-
ed to constructing ever-higher buildings
to ensure they would be seen from all
over the city.

On either side of the *mihrab*, remains of
marble panelling can still be seen with
medallions surrounded by plant motifs a
testimony to its Iranian influence. Nine of
these panels displaying plant and animal
motifs, the latter in religious buildings,
have since been transferred to the Muse-
um of Islamic Art in Cairo (I.1.a; reg. no.
278).

The minaret, to the left of the traditional
monumental entrance soars majestically
above the *madrasa* with its three sections.
The uppermost section, the *gawsaq* is
raised on marble columns and crowned
with a series of *muqarnas* and a bulbiform
finial. Rising from a square base, the
lower and middle sections are octagonal

with alternating white-and-red stone bands (*mushahhar*). In the middle section, triangular stones appear to make a vertical chevron pattern, similar to the minaret at the *khanqa* of Amir Shaykhu. In the first section, the bands form horizontal lines two-thirds of the way up the shaft where triangular stones are inserted forming a series of pointed arches.

S. B.

IV.1.i Mosque of Ibn Tulun

The Mosque of Ibn Tulun is located on al-Khudayri Street, (continuation of al-Saliba Street), behind the Madrasa of Sarghatmish. The entrance is on a street perpendicular to al-Khudayri. On leaving the previous monument retrace your steps and take the first right.
Opening times: all day except during midday and afternoon prayers (12.00 and 15.00 in winter, 13.00 and 16.00 in summer). This monument is currently under restoration and visitors are not allowed inside.

This mosque is Egypt's third oldest after 'Amr Ibn al-'As and al-'Askar, the latter having now disappeared. It is the only remaining monument of the City of al-Qata'i' (the then capital of the Tulunid State) and believed to be among the oldest monuments in Egypt preserved in its original state.
The layout of the building closely follows the hypostyle model of the first congregational mosques with its central courtyard surrounded by four porticoes, the largest being that of the sanctuary. This comprises five aisles separated by pointed arches resting on brick pillars with colonettes. The three remaining porticoes

are each divided into two aisles. An open area known as "*al-ziyada*", or "the extension", surrounds the mosque on three sides. The government palace, which has now disappeared, was originally adjacent to the mosque.
Historical sources recount how Amir Lajin sought refuge from persecution in the Mosque of Ibn Tulun and vowed that should he survive and one day become Sultan, he would restore and rebuild the mosque. Lajin, who became lieutenant to Sultan Katbugha, ascended to the throne in 696/1296 during a period of econom-

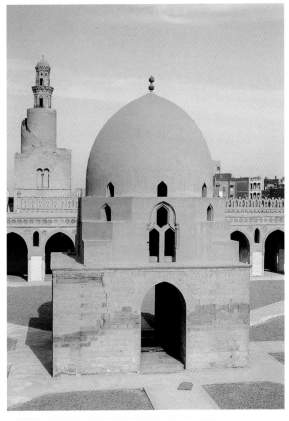

Mosque of Ibn Tulun, the ablutions fountain in the courtyard, Cairo.

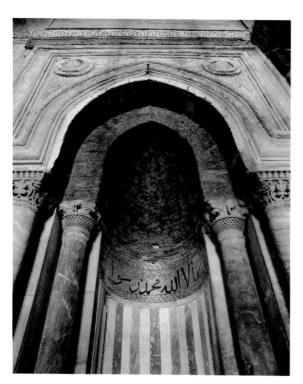

Mosque of Ibn Tulun, mihrab, Cairo.

around the outside. Lajin's improvements to the mosque carried out during the first part of the *Bahri* Mamluk period were faithful to the original style. He restored the damaged minaret and the horseshoe arch clearly influenced by Maghrebi style, which joins it to the mosque wall. The double window in the square base is a testimony to Andalusian influence. Two further octagonal sections rise above the cylindrical middle section of the minaret, both of which are open (*gawsaq*) and crowned by rows of *muqarnas*. Such a feature is considered a development of these ornamental elements, which had first appeared during the Mamluk period on the minaret of *zawiya* al-Hunud (al-Tabbana Street), dating back to 648/1296. The small ribbed dome on the minaret was of the type used at the beginning of the Mamluk period, the use of which was extended up until the reign of al-Nasir Muhammad.

The fountain in the centre of the courtyard was originally covered by a gold dome, which collapsed in 358/968. Nowadays it is covered by a construction added during Lajin's restorations in 696/1296. The present-day dome is supported by an octagonal drum, which in turn rests upon a square base with openings in each of its four sides. Inside the drum, or transition zone, the pendentives are formed of small superimposed and slightly concave arches, the precursor of the *muqarnas* that did not develop until later. Similar decoration can be found in the *qubba* of Tankizbugha (761/1359), in the Small Cemetery in Cairo.

On the outside of the drum there are four windows each comprising three keel arches recessed within a larger single pointed arch resting on small columns.

ic and political instability. Notwithstanding, he kept his promise and had the minaret, *mihrab* and central fountain in the courtyard of the mosque restored where, in earlier times, he had found shelter.

Among the features of this mosque, a synthesis of the most harmonious of Abbasid-period architecture is its spiral minaret, its inspiration clearly taken from Samarra (Iraq) where Ibn Tulun spent several years.

The free-standing minaret construction, set apart from the mosque, is situated on the north west side of the *ziyada*. The cylindrical shaft rises up from its square base and a spiral staircase winds itself

This design was first used in the Mamluk period in the mausoleum of Shajar al-Durr who was buried in 648/1250 (in al-Khalifa Street, behind the Mosque of Ibn Tulun).

In the sanctuary, Sultan Lajin had a magnificent wooden *minbar* added and other renovations carried out on the *mihrab*. Marble panelling, using thin vertical strips of the coloured stone, was carried out at the beginning of the period when this highly original decorative technique was becoming popular on Mamluk *mihrab*s. Gilt mosaics forming a frieze had first been employed in Egypt in the mausoleum of Shajar al-Durr. It was not until 50 years later that this technique was used in the Mosque of Ibn Tulun as a background to the *naskhi* script. This particular example displays a gilt mosaic of a tree with spreading branches.

Despite the interest the sultans and governors later showed in this mosque, it is above all due to Lajin's restoration work that the building is so well preserved today.

S. B.

From the top of the minaret (40 m. in height) there is a fantastic view of the City of Cairo. The ancient city of al-Qata'i' lies at its feet with Cairo extending to the north. The view stretches along al-Saliba Street, where a considerable number of its Mamluk monuments are included in this itinerary.

On leaving the Mosque of Ibn Tulun, a stop at the Bayt al-Kritliya, or the Gayer-Anderson Museum, is highly recommended. It is located to the south east adjacent to the mosque and gives an idea of what houses were like at the end of the Mamluk period and the beginning of the Ottoman era. The museum comprises two houses joined by two galleries or walkways on a level with their second floors. The walkways cross the side street linking the main street with the ziyada of the mosque, they were reconditioned by the English Major

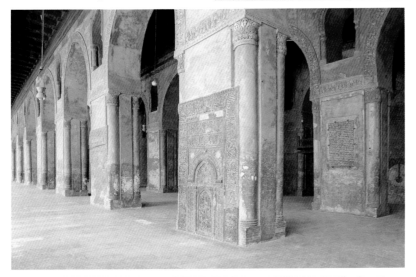

Mosque of Ibn Tulun,
sanctuary area, Cairo.

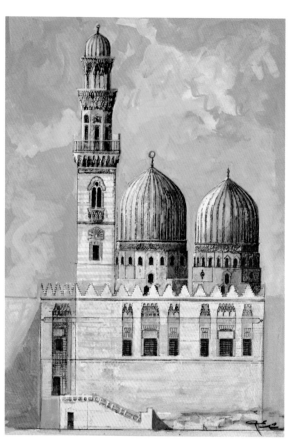

Madrasa and Mausoleums of Salar and Singar al-Gawli, façade, Cairo (painting by Mohammed Rushdy).

IV.1.j Madrasa and Mausoleums of Salar and Singar al-Gawli

This monument is located in 'Abd al-Majid al-Labban Street (before al-Saliba Street) in the al-Sayyida Zaynab Quarter.
Opening times: all day except during midday and afternoon prayers (12 .00 and 15.00 in winter, 13.00 and 16.00 in summer). This monument is currently under restoration and visitors are not allowed inside.

The construction of this monument, the last on our path following the route celebrating the flooding of the Nile, is attributed to two *amirs*, from the *Bahri* Mamluk era, Salar and Singar al-Gawli. Salar was bought by Qalawun and then proceeded to serve his sons Khalil and al-Nasir Muhammad. Singar was a Mamluk previously belonging to al-Gawli, one of Baybars' *amirs*, who came to serve Qalawun. Hence, Salar and Singar met while in the service of Qalawun and, according to the historian al-Maqrizi, they became close friends during this period.

The *madrasa* and two mausoleums, together covering a surface area of 780 sq. m., were built in 703/1303 on the side of a hill. The architect turned the steep land to his advantage by placing the building and its different quarters on several levels. The simple harmony of the façade hides the complex layout of the building's interior. The façade is believed to be the only one of its kind to have two *qubbas* adjacent to the minaret. The design of the minaret was also original for its time. It was the first time that the upper third section had appeared circular in form and with openings known as (*gawsaq*). Henceforth the structure became a significant feature of minarets

Gayer-Anderson, before the Second World War. The furniture and decorations belong to the 18th-and 19th-century Oriental style. Their main attraction lies in the variety of rooms they contain. Major Gayer-Anderson subsequently donated the houses to the Egyptian government for use as a museum bearing his name.

Opening times: from 09 .00 to sunset. On Fridays from 09.00 to 11:15 and from 13:30 to 16.00. There is an entrance fee.

firstly with ribbed tops (known as *mabakhir - mabkhara* in the singular) which were later to evolve into openings with columns.

The monumental entrance, raised some 3.5 m. above street level, is reached by a single set of steps. The vaulted *derka* leads to a long staircase with a small landing in the shape of a domed hall. This area is located in the centre of the complex and serves as access to the *khanqa* on one side and to the mausoleums on the other. To the left, a short passageway with a ribbed vault leads to the courtyard of the *khanqa* with its rooms on two floors for the Sufi students. This courtyard can also be reached from a side street to the south of the building, through a passageway and up a flight of stairs.

The *qibla iwan* on the east side of the courtyard has an unusually positioned *mihrab*. The location of the building and the layout of the prayer and study areas prevented the *mihrab* from facing south east. The problem was solved by setting the *mihrab* at an angle of forty-five degrees in the *qibla* wall.

The two mausoleums are reached from the landing via a much longer passageway with ribbed vaults, which end in a small burial hall covered by the first stone dome ever to be built in Cairo in the Mamluk period. Off to the right of the passageway the larger of the two burial halls is first encountered, the *qubba* of Amir Salar. Amir Singar al-Gawli's tomb is adjacent

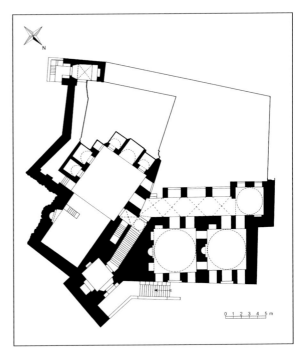

to this. Both *qubbas* are covered by brick-built ribbed domes that are finished in stucco.

Inside Amir Salar's mausoleum, the ornamentation on the fine marble of the *qibla* wall is of particular note, as are the carved wooden doors and the *muqarnas* of the dome. The decoration in Singar's burial chamber is more simplified.

A. A.

Madrasa and Mausoleums of Salar and Singar al-Gawli, plan, Cairo.

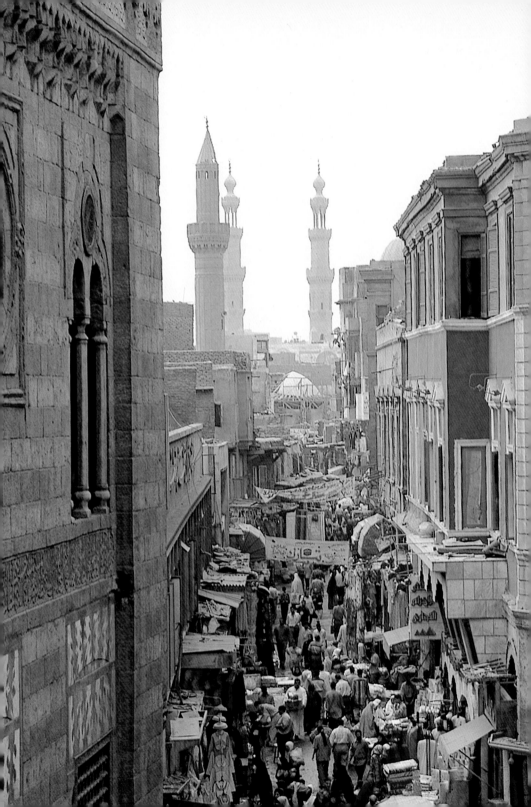

Markets

**Salah El-Bahnasi, Mohamed Hossam El-Din,
Medhat El-Manabbawi, Tarek Torky**

V.I CAIRO

Crafts and Trades

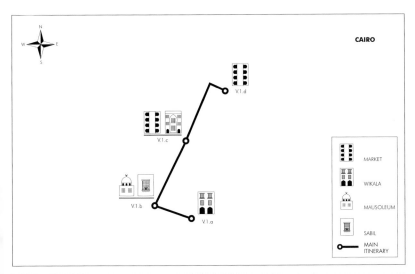

*Al-Ghuriya Market,
general view, Cairo.*

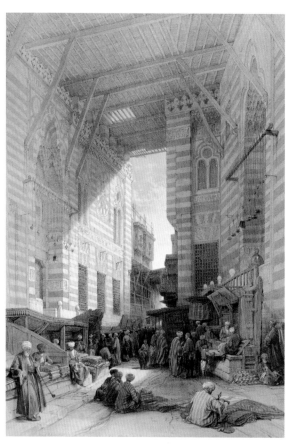

Complex of Sultan al-Ghuri, suq al-Ghuriya, Cairo (D. Roberts, 1996, courtesy of the American University of Cairo).

Mamluk period, remained so until the discovery of alternative sea routes by the Europeans an event which was to significantly alter trade relations with the East.

The Mamluk Sultans continued the work begun by the Ayyubids in the centre of the *medina*, in the Square named "Between two Palaces" after the palaces found there dating from the Fatimid era. Baybars al-Bunduqdari claimed parts of the Fatimid property for the Public treasury as well as a few buildings from descendants of the dynasty. One by one they were sold, and gradually religious and commercial buildings along with houses took their place.

The north-south artery of *al-Qahira* (al-Mu'izz li-Din Allah Street) between Bab al-Futuh to the north and Bab Zuwayla to the south quickly filled with shops and *wikala*s, spilling over into the local area. The area became a centre for trading activity in Egypt, where a diversity of domestic produce and imported products could be found.

The Mamluk Sultans were keen to promote such trading activity for the rapid and constant profits it generated, providing them with money to invest in their vast religious or social complexes, such as the Hospital of Qalawun (III.1.c), *madrasa*s, *sabil*s and *kuttab*s.

Trading establishments of various kinds appeared all over the city. Among them the *wikala*, characterised by the combination of store houses on the lower floor, shops opening onto the streets and above them, lodgings known as *rab'* mostly rented by middle-class citizens. The *khan* and the *funduq* were terms used respectively for shops along a street and adjacent stores in which to keep merchandise.

With the threat of Mongol invasion contained and the occupation of *al-Sham* by the Crusaders ended, the Mamluks were able to guarantee the stability of the eastern markets. Under such conditions, markets in Cairo enjoyed great prosperity and diversification, with Egypt becoming the centre through which trade between the East (India and China) and the West (Europe and North Africa) passed via the Red Sea. Thus, the city of Cairo, one of the most important trading centres in the region during the

Buildings such as the *qaysariyya* were also frequently found in the city. They consisted of a rectangular building usually with a roof and closed with doors and a central courtyard. The shops inside were reserved for the sale of more valuable products while those on the outside sold an assortment of goods.

Many similar establishments lined the main streets and squares of Cairo. Of these, the Armourer's *suq* (*al-Silah*), annexed to the Madrasa of Sultan Hassan, and Khan al-Khalili, built by Sultan al-Ghuri, are the best examples to have survived. In addition, the Goldsmiths *suq* (*al-Sagha*), perpendicular to al-Mu'izz li-Din Allah Street, displays a curious layout of three passageways with eight rows of shops.

The *suqs*, which spread across different streets, were grouped into specialist guilds according to their trade or merchandise. Among the different markets in Mamluk Cairo, the following were the most significant. Silk merchants' *suq*, which imported from China and Asia. The fur traders, who sold such products as grey squirrel, sable, ermine, beaver and so on. The cage bazaar, whose merchants paid rent to the Complex of Sultan Qalawun in return for placing their goods displayed in cages in front of the building. The *al-khal'iyin suq*, selling second-hand clothing and the damascene *suq*, where metalwork inlaid with silver, gold and precious gems was sold. There was also a *suq* selling chests and trunks for the storage of clothes. Likewise, some *wikala*s specialised in the storage and wholesale of goods from certain countries, as was the case of the *wikala* of Qusun, specialising in Syrian merchandise.

Control of the markets formed part of the religious obligations of *al-hisba*, the "com-

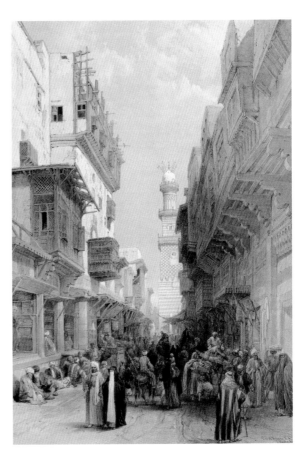

Shops along al-Mu'izz Street, Cairo (D. Roberts, 1996, courtesy of the American University of Cairo).

mending of good and the prohibition of evil". The sultan was duty bound to choose a candidate qualified for the task of *al-muhtasib* to fulfil these duties with the aid of his assistants.

The role of the *muhtasib* consisted of the regulation of weights and measures, overseeing the market, supervising hygiene, checking that goods were unadulterated, quality control of products and that prices applied were those set by the government. In Cairo the *muhtasib* had a group of helpers who carried out inspection

*Wikala of Sultan
al-Ghuri, general view
from inside, Cairo.*

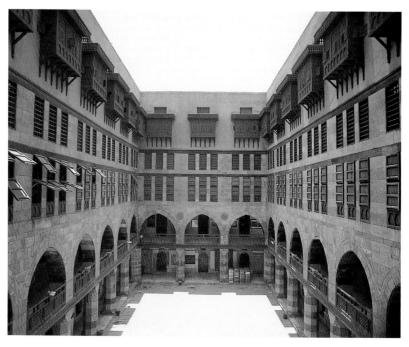

rounds on markets. The stability of the markets depended on the ease with which this important trade was allowed to develop. It is interesting to note that in 818/1415 Sultan al-Mu'ayyad Shaykh personally took on the role of *muhtasib* to ensure the correct application of prices and to combat the artificial inflation that the *amirs* were causing.

M. H. D.

IV.I **CAIRO**

V.1.a **Wikala of Sultan al-Ghuri**

This wikala *is located on al-Tablita Street*

which is parallel to al-Azhar Street. The Ministry of Culture has turned it into a centre for the promotion of traditional crafts and for training apprentices. There are also decorative arts workshops.
Opening times: from 08.00 to sunset, closed on Fridays. The wikala *is currently being restored and visitors are not allowed inside.*

The majority of middle-class Cairene society lived in rented accommodation blocks containing numerous apartments (*rab'*). These lodgings, which were rented on a monthly basis, were located over trade centres such as *wikalas* (effectively town *caravanserais*) or over market shops. Housing was generally located on two floors, the lower floor with latrines, water supply and an entrance hall or reception area. The bedrooms were on

the upper floor. Houses were not often equipped with kitchens and food was usually bought in the streets ready-cooked.

The *wikala* of Sultan al-Ghuri is a fine example of this arrangement of trading establishments and lodgings. It was built in 909/1503 as a market centre, residences for merchants and storehouses for merchandise. Sultan al-Ghuri invested income from the *wikala* in the construction of his complex 100 m. further up on either side of al-Mu'izz li-Din Allah Street.

One of the more unusual features of this *wikala* is its monumental entrance, which leads to a straight *derka*, and which enters directly into the rectangular courtyard. In addition to facilitating the transportation of goods from the storerooms to the market, this layout would have allowed passers-by to see the centre of the building with greater ease, thus attracting customers. The storerooms occupied the first two floors behind each of the four porticoes. The arcades separating the aisles were built with pointed arches resting on stone *mushahhar* pillars. Above the storage area were 29 rented lodgings situated on three floors around the central courtyard.

The delicate *mashrabiyya*s at the windows rest on wooden brackets decorated with *muqarnas* denoting the area set apart on the top floor for sleeping. The *mashrabiyya*s can be seen on both the interior and exterior walls, constituting the main decorative elements of this *wikala*.

Among the many *wikala*s dating back to the Mamluk and Ottoman periods, the *wikala* of al-Ghuri stands out for its well-preserved state and its original ornamentation.

S. B.

Wikala of Sultan al-Ghuri, mashrabiyya, Cairo.

Wikala of Sultan al-Ghuri, entrance, detail of the arch, Cairo.

V.1.b Complex of Sultan al-Ghuri (al-Ghuriya Market)

This large establishment is located on the cross-roads between al-Mu'izz li-Din Allah Street (al-Ghuriya) and al-Azhar Street, opposite the madrasa of the same name.

175

Complex of Sultan al-Ghuri, sabil, Cairo.

Complex of Sultan al-Ghuri, marble dado on the interior wall, Cairo.

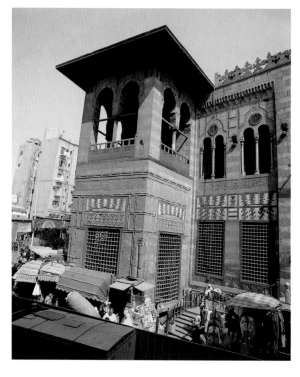

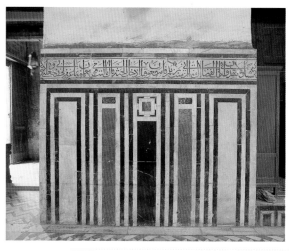

Opening times: from 08.00 to sunset.

With this complex combining a *sabil*, *kuttab* and the *madrasa* opposite (III.1.b), we have one of al-Ghuri's greatest contributions to the urban structure of the heart of Fatimid Cairo. The historian al-Maqrizi tells us that it was here that the al-Sharabshiyin *suq* was located specialising in the manufacture of felt hats, known as fez. It housed the shops of the *bazzazun* (textile merchants), founded as *waqfs* by Sultan al-Nasir Muhammad to finance the maintenance of the tomb of Yalbugha al-Turkmani, Amir and Governor of Alexandria in the name of Sultan Sha'ban. In this area, where there were three interconnected markets, the sale of spices, imported textiles and highly selective crafted products was concentrated: Al-Gudariya *suq*, al-Gamalun *suq*, which was closed at either end of the street by gates, and al-Bunduqaniyin *suq* selling dried fruits.

With the shops located on the ground floor of the *madrasa*, Sultan al-Ghuri was to extend the commercial scope of the market by providing four communication passageways between the various market streets. The area was known as al-Ghuriya Market, and still today, an enormous variety of clothing and textiles is sold there. Built in 909/1503 at the same time as the *madrasa*, he had a small public square, of only 13 m. across, constructed between the two. Throughout the centuries and to our day this little square has always had a special place in the historical centre of Cairo. Sultan al-Ghuri proved keen to promote commercial activity in the area and to contribute to the urban layout of the city.

Entrance to the *sabil* is on al-Azhar Street while the traditional monumental

entrance to the *qubba* is on al-Mu'izz li-Din Allah Street. The Sultan was not buried here in the mausoleum for he died in 922/1516 in the Battle of Marj Dabiq, and his body was never recovered. Decoration in the mausoleum begins with a coloured marble frieze beside the stairs that ascend to the main entrance. The door is faced in plain bronze and opens into the *derka* with its coloured marble floor and ceiling painted in gold. The *derka* is located between the mausoleum and the small *khanqa* providing access to both. The *maq'ad*, where the sultan retired to meditate, is behind the *derka*.

The panelling around the *qubba* comprises vertical panels of different coloured marble while the square-based dome of the *qubba* is decorated with a marble frieze bearing *Kufic* inscriptions. The wall area between the frieze and the pendentives is decorated with *muqarnas* and covered with floral motifs. The dome collapsed in 1908 and the sacred relics, which had been kept in this mausoleum, were transferred to the sanctuary of the Mosque of al-Husayn, near the Mosque of al-Azhar.

The *sabil* floor displays an intricate and perfectly finished pattern of coloured marble while the ceiling is decorated with a gold design. In keeping with tradition the *kuttab*, where orphans received schooling, is located above the *sabil* along with other rooms of a plainer nature.

M. M.

V.1.c Madrasa of Sultan Barsbay and Market of al-'Attarin

The Madrasa of Sultan Barsbay is located in

al-Mu'izz li-Din Allah Street on the other side of al-Azhar Street, on the corner with Gawhar al-Qa'id (al-Musqi).

Opening times: all day except during midday and afternoon prayers (12.00 and 15.00 in winter, 13.00 and 16.00 in summer).

Madrasa of Sultan al-Ghuri, ground floor shops, Cairo.
1. Al-Mu'izz Street
2. Al-Gamalun Street.
3. Al-Sharabshiyin Street.

Sultan Barsbay, like his predecessors, was of Circassian origin. He conquered Cyprus in 830/1426, and in addition to the large sums of money he exacted on the island in return for freeing King Janus, he introduced an annual tribute (*guizya*) thus imposing vassalage on the island. Always having attached great importance to money, Sultan Barsbay was constantly looking for ways to increase his income.

This *madrasa*, which overlooks al-'Attarin *suq* Street, also houses a mosque. It was built on land occupied by shops, and above them rented lodgings known as *rab'*. The *suq* brought together a plethora of traders dealing in Eastern perfumes and aromas including spices and amber. Sultan Barsbay kept a tight control over the *suq* investing its earnings in his buildings and military campaigns.

Madrasa of Sultan
Barsbay, general view,
Cairo.

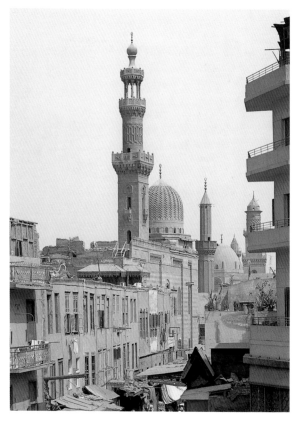

The general layout of the *madrasa* is no different than that of other *madrasas* of the Mamluk period. It is built on a cruciform plan, with the four *iwans* around the central open *durqaʿa* forming the arms of the cross. Behind the mausoleum and to one side of the sanctuary is a room reserved for the caretakers of the building. The *al-faqih* however had a room behind the *sabil*, above which the *kuttab* was located while the students' rooms were on the upper floor.

The whole building was built with the *mushahhar* masonry technique, such that the alternating red-and-white horizontal bands of stone along the length of the façade reduced the feeling of vertigo often caused by the height of these buildings. It is undoubtedly one of the most carefully studied techniques of Mamluk architecture which sought to counterbalance the effects of vertigo these buildings encouraged, and to weave them into the fabric of the densely built residential areas.

Beside the *mihrab*, decorated with marble panels and mosaics, is the slender *minbar* made of wood with finely turned interlocking pieces inlaid with ivory and mother of pearl in a similar style to the *Qurʾan* lectern.

M. M.

Sultan Barsbay chose a preacher to give the first Friday sermon on the 7th *jumada* I^{st} 827/7 April 1424. By then, only the main *iwan* had been built with the *qibla* wall; the building would not be finished until 829/1425.

Among the constructions known as "hanging buildings" for their raised entrances reached by a flight of stairs, in this particular building the difference in height from street level and the *madrasa* entrance has been utilised on the south side where six shops were once located.

V.1.d Khan al-Khalili and Market of al-Sagha

This complex of old and new buildings belonging to numerous owners is found on the other side of Gawhar al-Siqilli Street. On leaving the previous monument, go down this street until you find the entrance on the left.

On founding the city of Cairo, Gawhar al-Siqilli had the Great Eastern Palace

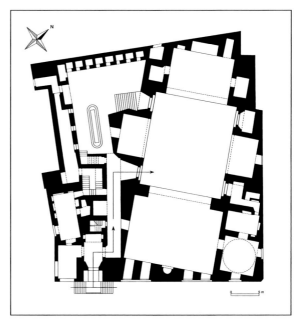

built, and behind it, a mausoleum known as *turbet al-za'afran* (saffron tomb), in which the mortal remains of the Fatimid Caliphs rested.

In the second half of the 8th / 14th century, Amir Jaharkas al-Khalili had his *khan* built on the same site, the bones were transferred in baskets to a rubbish dump on a hill outside the city. Al-Maqrizi recounts how Amir Jaharkas al-Khalili justified this act with a *fatwa* (a decision on a point of law) declaring that the *Shi'ites*, heretics in the eyes of the Muslim faith, had no right to remain in their tombs. Al-Maqrizi lived through the transition from the *Bahri* Mamluks to the Circassian Mamluks. He interprets the assassination of the *amir* (in the Battle of al-Nasiri near Damascus in 791/1389) and the fact that his naked body was subsequently left to rot, as a punishment from God for the desecration of the tomb of the Imams and their descendants.

There are no remains of the original building but for the name Khan al-Khalili that the *suq* that was preserved in memory of its founder, Jaharkas al-Khalili, *amir* of the stables, in the service of Sultan Barquq.

In 917/1511, Sultan al-Ghuri ordered the *khan* of Jaharkas al-Khalili to be pulled down and replaced by warehouses, shops, rented accommodation (*rab'*) and *wikalas*. There were three main entrances to the area set out on a grid of streets, each a monumental gateway, a copy of the majestic entrances traditionally associated with mosques, *madrasa*s and *khanqa*s. Two gateways, near the al-Husayni sanctuary face each other and open with an enormous pointed arch crowned by another tri-lobed arch filled with fine *muqarnas*. The *voussoirs* of the pointed arch are also decorated with *muqarnas* and the

*Madrasa of Sultan
Barsbay, wooden
minbar, detail of
the decoration, Cairo.*

spandrels with floral motifs with the Sultan's epigraph in the centre. Above the frame, a *naskhi* inscription band reads: "al-Malik al-Ashraf Abi al-Nasr Qansuh al-Ghuri ordered this sacred place to be built, glory be to his victory".

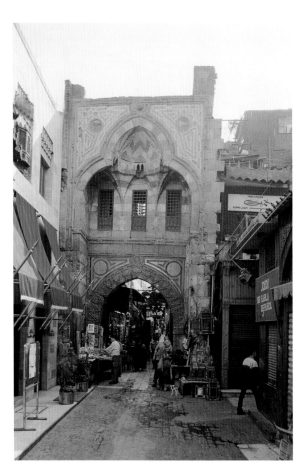

Khan al-Khalili, Bab al-Badistan, main view, Cairo.

may his triumphs be glorious". The tri-lobed arch is built of *mushahhar* stone, while the *voussoirs* of the pointed arch display an original geometric design in a succession of triangles.

M. M.

Market of al-Sagha

Al-Maqrizi describes the location of al-Sagha (goldsmiths') *suq* in the street between the two Fatimid Palaces as follows: "this place is located in the direction of the *madrasa* of al-Salihiyya in a line between two palaces".

In the Fatimid era, the kitchens of the Great Eastern Palace occupied this site from where, during the month of *Ramadan*, more than 1000 pots of food were left each day to be shared among the poor. The gateway to the palace, located on the south west corner, was used exclusively for the delivery of meat and other victuals and held onto the name Bab al-Zuhuma, due to the unpleasant smell of fat (*zuhm*) which the site gave off. It is the same gateway that was destroyed in order to build the hall (*qa'a*) of the Hanbali shaykh between the years 641/1243 and 647/1249 of the al-Salihiyya Madrasa. It was the first of its kind in Cairo to bring together the teaching of the four legal rites.

At the beginning of the *Bahri* Mamluk era, Sultan Barakat Khan (r. 676/1277-678/1279) son of Baybars al-Bunduqdari, founded the al-Sagha *suq* to support the *al-faqihs* and *Qur'an* reciters of the Madrasa of al-Salihiyya.

Goldsmiths worked inside the market selling all kinds of artefacts and jewellery made of precious metals. The market also

The third gateway, known as Bab al-Badistan, is found to the far west of the street entering the market area from the al-Husayni sanctuary. It follows the same construction pattern as the former two (a pointed arch within a tri-lobed arch), but differs in its decoration. The spandrels are filled with geometric designs in marble surrounding the circular epigraph of the Sultan: "Glory be to our lord Sultan al-Malik al-Ashraf Abi al-Nasr Qansuh al-Ghuri,

180

housed the operations of moneychangers. Located at the very backbone of international trade in Mamluk Egypt, the jewellery market was based on a structure of narrow streets and passageways and had several entrances. The main entrance was opposite the Madrasa of al-Salihiyya and many of the shops belonged to Armenians, Copts and Jews, the latter group installing themselves in an area (*harat al-yahud*) to the west of the *suq*.

M. M.

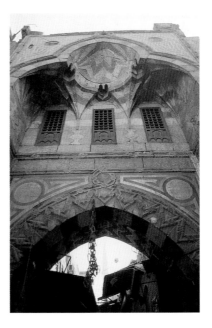

Khan al-Khalili, Bab al-Badistan, tri-lobed arch, detail, Cairo.

Khan al-Khalili, Bab al-Badistan, pointed arch, detail of spandrels displaying Sultan's Arms, Cairo.

CRAFTS AND TRADES

Salah El-Bahnasi, Tarek Torky

Builders, from Description de L'Égypte.

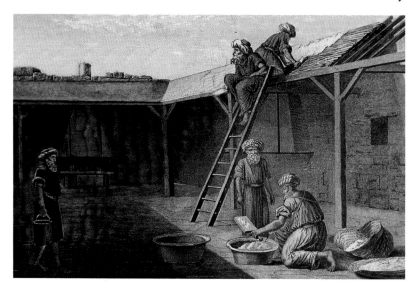

The Mamluk era was a period of great economic prosperity, which resulted in the expansion of markets and the development of different industries and trades.

Those related to architecture are the most important ones, which have been maintained up to the present day. The great building activity of the sultans and emirs required different groups of workmen who carried out all sorts of work to do with construction they made Cairo one of the, richest in mosques, *madrasas*, *khanqas*, mausoleums and *wikalas*. All the trades connected with building took their names from the material they specialised in: *al-haggarin* (stone-layers), *al-tabba'in* (those who covered the walls with clay), *al-mubayaddin* (whitewashers), *al-gabbasin* (plasterers), *al-gayyarin* (limestone workers), *al-naggarin* (carpenters), *al-murakhamin* (marble workers), *al-dahhanin* (painters), *al-haddadin* (smiths); or from the type of work they did, such as *al-banna'in* (brick-layers), *al-qatta'in* (stone-cutters), *al-saqqalin* (marble polishers), and so on.

On the other hand, the design and realisation of the building projects was divided between the *al-mu'allim*, or architect, who designed them and chose the materials, and the *al-mushrif* or quantity surveyor, who supervised the work. This division can be seen for example in the case of Muhammad Ibn Bilik al-Muhsini, *al-mushrif* who controlled the building of the mosque and *madrasa* of the Sultan Hasan (I.1.g); in that of Ibn al Suyufi, the chief architect of the court of al-Nasir Muhammad, who designed the first stone minaret, or in that of Ibn al-Tuluni, *mu'allim al-mu'allimin* (*chief architect*) of the court of the Sultan Barquq.

In the sphere of the textile industry we find the silk workers, whose trades were divided into different specialities such as *al-ha'ik* (tailor), *al-qabil* (weaver) or *al-hariri* (employed to spin and weave

silk). There were also the corporations of the *raffa'in* or stitchers; of the *rassamin* or artists who decorated the cloth with paint or with the overlaying of cloth stitched to form different patterns; or the *al-farra'in*, the skin workers who lined and decorated garments with fur. There were also places to wash and iron clothes, and a dye works.

The trades related to the metal industry were very important. *Al-nahhasin*, the specialised copper workers still carry on their trade in the same stretch of al-Mu'izz Street, near the complex of the sultan Qalawun, and the *khanqa* and *madrasa* of the sultan Barquq (III.1.c and III.1.d). *Al-kaftiyin*, the damascene craftsmen who inlaid metals with gold and silver, have their workshops today in a street parallel and to the west of al-Mu'izz. The name of the trade was normally used both for the profession itself and for the market where the product was sold, or for the area where the activity was carried out. Copper inlaid with precious metals was normally used in the manufacture of luxury objects, which reflected the opulence of the Mamluk court. Many articles have survived which include in their decoration the names of the sultans and emirs for whom they were made. There is no doubt that Mamluk Egypt was an important centre for the production of these types of objects which included doors, lamps, tables, chests, pen cases, basins, candelabra, astrolabes, swords etc. Egyptian damascene was so sought after that foreign merchants ordered objects to export to the East and the West. An example of this is the basin from the middle of the 8th/14th century, preserved in the Louvre Museum in Paris which is inscribed with the name of the King of Cyprus, Hugo IV of Lusignan (r. 1324-1359).

Another example is the ewer made for the Yemeni Sultan Afdal Dirgam al-Din al-'Abbas (r. 765/1363-779/1377), conserved in the Bargello Museum in Florence.

The Mamluk artists showed great skill in the manufacture of all sorts of glass objects for different uses: perfume flasks, vases, drinking glasses, bowls, basins, lamps or bottles in which the techniques of enamelling and gilding predominate. The production of these was destined for both the domestic and export markets.

Carpenter, from Description de L'Égypte.

The art of woodworking reached its height in Mamluk Egypt. The sculptors and carvers of this great age of artistic development have left us *minbar*s, tables, dais, *machrabiyya*s, ceilings, doors and chests where the refined decoration is even more fascinating close up than seen from a distance. Coloured woods, inlaid with ivory, bone or ebony composes a harmonious decoration, which is most often geometric, in an infinite variety of designs which made their artists famous. Like all the members of their guild they enjoyed a highly considered social status. The particular type of sculpture in wood, the *machrabiyya*, made of small pieces of turned wood assembled into panels with geometric or floral motives or inscriptions of exquisite delicacy, achieved very sophisticated levels. The wooden latticed screens, characteristic of the Mamluk period, were placed around the tombs of the sultans, between the patios of some mosques and the prayer area, but above all in the windows of the buildings, so that the street scene below could be observed unseen and to allow good ventilation and to keep the heat of the sun out, especially in summer.

The most important public service in normal daily life was the water supply, which was guaranteed by the water carriers. These carriers supplied water in houses and shops. There were also some who sold water in the streets from skins to the passers by for a few coins and the workers in the *sabil*s, such as the *muzammalati*, who supervised the purity of the water.

Also well known were the trades of bread maker and baker, which were fundamental since the people sent the dough already prepared to the bakers' ovens to bake it. There were also the sugar cooks who were employees of the sugar works. All these tradesmen were subject to the controls of the *muhtasib*, both in questions of hygiene – nobody who had an infec-

Weaver, from Description de L'Égypte.

tious disease was allowed to work in these areas — and also in moral questions and the application of quality control established over the manufacture of these products. The system of the *hisba* is considered to be the most important of those known in the Muslim world. A judicial agent or *al-faqih* was named for this post and the responsibility he and his assistants had was to patrol the *suqs*, bakeries, restaurants, *sabils* and *hammams* to guarantee that hygiene regulations were being observed, to control the weights and measures, and to avoid fraud.

The majority of these trades were concentrated in the city of Cairo and the artisans reached a remarkable skill in its development. To a large extent this was because of the role played by the organisation of the trade guilds. Each trade was organised into a professional body, headed by a *chaykh*, who was elected from among the most experienced master craftsmen and endowed with moral and religious authority. It was he who watched over the smooth running of the internal organisa-

Pen holder of brass damascened with copper, gold and silver, Museum of Islamic Art (reg. n° 15132), Cairo.

tion, the interests of each of its members and who gave artistic guidance as appropriate. Before reaching the status of fully-fledged artisan the apprentice had to pass through different stages of training and several tests. After that, he received from the *chaykh* of the guild the document which validated his knowledge of his trade; the *chaykh* named him master craftsman and thus he became a member of the corresponding guild. On the other hand, each trade had its own emblem and drums, which were used when they took part in the sultan's processions and other celebrations.

Alexandria: Gateway to the West

Mohamed Abdel Aziz, Tarek Torky

Centre of the Spice Trade between East and West

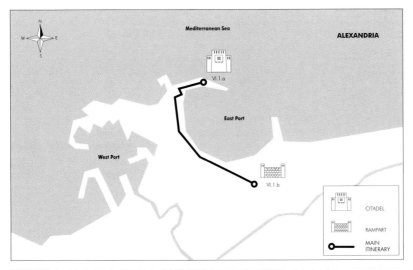

Port of Alexandria (D. Roberts, 1996, courtesy of the American University, Cairo).

187

Known as the "Bride of the Mediterranean", the city of Alexandria is 220 km. to the north west of Cairo. The city can be reached either by bus (just over 3 hours) along the desert road, by train (two and a half hours) or by car. Take Shari' al-Ahram (Pyramid Avenue) out of Cairo on the edge of El Giza and from there, past the necropolis of Abu Rawash, the main road passes through agricultural land. Continue towards the coast and enter Alexandria from the west after driving around Lake Maryut.

The City of Alexandria is situated on the eastern edge of the Nile delta. The city considered one of Egypt's major seaports keeps watch over the Mediterranean.

Following the conquest of Egypt in 332 BC, Alexander the Great founded the city on the site of the town named *Raquda* (Rakotis), where a community of fishermen lived alongside a military garrison. The architect Dinocrates was given the task of planning the city, the urban layout of which he based on a Greek model. The city's rectangular area measured 3 km. in length and 1 km. in width. It was based on a grid structure of eight by eight streets, enclosed by city walls built of stone, which over the centuries have successively been restored and reconstructed. The historian Yaqut al-Hamawi records in his work *Mu'jam al-buldan*, that Alexander the Great, King of Macedonia, gave his name to some 13 cities founded by him. Although in later times (by the 7th/13th century) it was only the great Egyptian city which was to hold on to his name.

With the death of Alexander, his General Ptolemy I founded the Ptolemaic dynasty and work began on the construction of a lighthouse on the Island of Pharos to guide ships in to her harbour. It is thought to have been joined to the mainland by a quay. Work finished on the lighthouse between 280 and 279 BC during the reign of Ptolemy II Philadelphos (r. 285-246 BC). The Museum was founded in the Royal Quarter along with the House of Science frequented by poets, philosophers and the most illustrious of learned men from the Hellenic world.

The Ptolemies continued to govern Egypt until she fell to the Romans under Emperor Augustus in 30 BC in the Battle of Actium, which resulted in her becoming a territory annexed to Rome.

In around AD 40 the evangelisation of the city began and by the 2nd century Christianity had gained such a following that Alexandria became a major religious centre wherein many churches were built; among them, the Church of Saint Mark the Evangelist and the Church of Saint Ignatius.

The century that followed was marked by the persecution of followers of the new religion and Alexandria fell into a period of decline, which was to end with the taking and pillaging of the city by Dioclesianus in the year 295. By the end of the following century, the population had recovered but the city continued to be the scene of frequent acts of violence causing the destruction of a considerable part of the monumental heritage from that era.

In 21/642 Alexandria was the capital of Egypt. However, following the protracted siege and conquest of the city by the Arabs in that year the capital was transferred to Fustat, founded by the Arabs as the first Islamic capital of Egypt. Nevertheless, the Arabs greatly admired Alexandria and within the original urban area of Alexandria, numerous Arab tribes settled, bringing with them an increase in building activity city and in particular

in the construction of mosques. The new Governor of Alexandria undertook the task of fortifying the coasts exposed to attack from the sea and 'Abd Allah Ibn Abi al-Sarh, the second Arab Governor of Egypt, had a shipyard built there.

In the Abbasid era a new enclosure was built to protect the inhabited areas of the city where her walls had previously stood, with four gates located on the original axis of the city. To the east, the Rosetta Gate; to the west, the Cemetery Gate; to the south, Bab Sidra and to the north, Bab al-Bahr or the Gate of the Sea.

During the Fatimid era (358/969-569/1171) Alexandria regained her former glory playing a role in many of the political events in Egypt, primarily recognised as a base for the Fatimid Caliphate's fleet of ships.

In 404/1013, on the orders of al-Hakim bi-Amr Allah, her canal was dredged to help navigation between the city and the Nile, an event that served to strengthen ties with other provinces in the country.

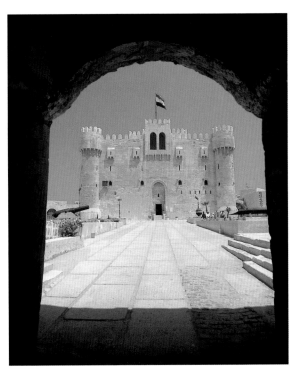

The Citadel of Qaytbay, main tower, Alexandria.

Among the most famous mosques of the era is the Mosque of al-'Attarin. Due to the fact her inhabitants were followers of the *Sunni* doctrine, Alexandria was the first city to stop preaching the Friday sermon in the name of the Fatimid Caliph. From the end of this period, several *madrasa*s were built in order to put an end to the *Shi'ite* doctrine and to promote *Sunni* principles. Among the schools, the most noted are the al-Sufiyya Madrasa (or Madrasa of the Sufis) and the al-Salafiyya Madrasa (or Madrasa of the Precedence).

Historical sources recount how on Salah Al-Din al-Ayubbi's visit to Alexandria in 572/1176, he showed great interest in her defence system, in the renovation of

her fleet, and that he personally took part in the restoration of her city walls. During the Ayyubid period (569/1171-648/1250) Alexandria became the centre of world trade where products from the East were unloaded, among which spices and perfumes were highly valued. The 7th-century Jewish traveller from Spain, Ibn Jubayr (Benjamin of Tudela), recorded 28 cities or countries as having trading relations with Alexandria, each of which had a *funduq* available in the city for its citizens to store their wares and to lodge. In 569/1173, however, the city again faced invasion, this time by the King of Sicily, an attempt conspired along with the Franks and the *Hashashin* Ismailis, to retake the city for the

189

Old City, ruins of the west wall, Alexandria.

al-Bunduqdari (r. 658/1260-676/1277) is thought to be the first sultan to pay particular attention to the port of Alexandria. He ordered its walls to be reconstructed and a port built in Rosetta, which would also serve as an observation post from which to guard and control the coast. Sultan Baybars al-Bunduqdari undertook the renewal of the fleet based there, equipping it with warships and ordering that all the trees necessary for their construction should be felled.

Following the Cypriot attack of 767/1365, the Mamluk Sultans reinforced fortifications in Alexandria to dissuade the Crusaders, who had already made two failed attempts on Damietta during the reign of the Sultans al-Kamil and al-Salih Najm al-Din Ayyub.

Sultan al-Nasir Muhammad had the Alexandria canal re-dredged and widened from its starting point at the city of Fuwa where the river forks to the city. This event had a significant effect in increasing trade during the Mamluk era. In addition, Sultan al-Nasir had the lighthouse of Alexandria rebuilt following considerable damage caused by the 702/1302 earthquake.

We know from historical sources that the city largely held onto its ancient urban structure in the second half of the 8th/14th century. The main transport artery (nowadays Gamal 'Abd al-Naser Street) crossed the city from east to west from the Rosetta Gate to the Cemetery Gate. Another main artery crossed the city from north to south and linked the Gate of the Sea to Sidra Gate. It is also interesting to note that the Alexandria canal was divided into a network of smaller underground channels carrying water to houses and gardens. Outside the Gate of the Sea, there was an area of

Fatimid State, a plot that nevertheless failed.

With the *Bahri* and *Burgui* Mamluks Alexandria saw her activity reach its zenith, and its greatest period of wealth under Islamic rule. The city became one of Egypt's most important seaports and the greatest trading centre in the Islamic world of its time. Such events coincided with the loss of protagonism of the port of Damietta. This was due in part to the continuous attacks on the city by Crusaders but was also partly due to the difficulty of navigating its river, the mouth of which had become blocked causing many merchants to abandon this route.

In spite of the problems threatening to undermine his government, Sultan Baybars

190

open level ground, stretching as far as the ancient lighthouse, where the Citadel of Qaytbay was later built. Known as "the square", it provided a field in which the sultans set up camp and played ball games with the *amirs*, evidence of which we have from Qaytbay and Al-Ghuri during their travels to the city. When sultans visited Alexandria, the city was decked out in their honour, lamps hung from the battlements of the city wall, flags were hoisted and bells and trumpets sounded from the towers. Alexandria's prosperity depended largely on navigating the channel connecting the city with the Nile. The ability to transport goods between the river and the port at any time of year was absolutely essential for the Mamluk economy, which relied heavily on the trade between the Red Sea and the Mediterranean. All manner of goods from East and West were bought and sold in the port markets, many of which specialised in spices, pepper, coral, slaves, linen, silk, cotton and much more. These products were subject to customs tariffs, taxes and fees, which filled the State coffers with large sums of money. Domestic agricultural produce such as cereals and wax, or industrial goods such as sugar, and handcrafted products such as glassware, were exported through her port. The famous cloths of Alexandria, sought after in both Eastern and Western high society, were manufactured in her workshops, which could be counted in thousands. Every traveller who stopped in Alexandria marvelled at the bustling activity and great wealth of her inhabitants. For the famed traveller Ibn Battuta, Alexandria was one of the most important ports in the world.

On the death of Sultan Qaytbay, which coincided with the Portuguese discovery of the sea route East via the Cape of Good Hope, and their resultant domination of trade with the Orient, the City of Alexandria began to fall into decline. Trade subsequently stopped causing depression of the Egyptian economy and the eventual fall of the Mamluks. In addition to this the Ottoman conquest of Egypt caused Alexandria to lose her position as a major trading centre and with it the contact she had maintained with other countries, her hitherto trading partners, and the ports of Damietta and Rosetta eclipsed that of Alexandria. The ports of Syria and the Ottoman State were likewise affected. Of the Ottoman era in Alexandria, only a few vestiges remain: some small buildings such as the Mosque of Ibrahim Tarbana and the Mosque of 'Abd al-Baqi Yurbagui, built in 1097/1685 and 1171/1758, respectively.

VI.I ALEXANDRIA

VI.1.a The Citadel of Qaytbay

The Citadel is located in an area known as al-Anfushi (Eastern Port), to the far west of the promenade along the seafront in Alexandria. There is a cafeteria and public conveniences in the Citadel.
Opening times: 09.00 to 15.00 in winter, 09.00 to 17.00 in summer. Although the building is currently under restoration, visitors are allowed inside.

As its name indicates the Citadel in Alexandria was commissioned by Sultan Qaytbay who came to power in 872/1467. On vis-

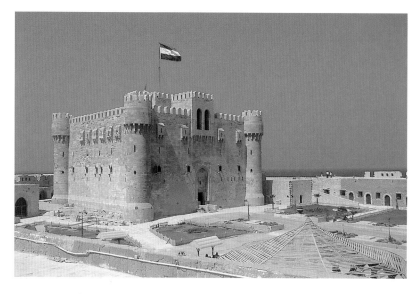

The Citadel of Qaytbay, main burg, view from the parapet, Alexandria.

The Citadel of Qaytbay, main burg, detail of entrance arch, Alexandria.

iting the city and ruins of her ancient lighthouse in 882/1477, he ordered a *burg* to be built on the site of its foundations and set up several *waqf*s to finance its construction. The work took two years to complete costing over 100,000 dinars. Ibn Iyas recounts how it was equipped with a congregational mosque, bakery, oven and armouries.

The Citadel was built on land of an area larger than two *faddan*s (over 8,400 sq. m.), and its walls constructed of huge blocks of stone giving it the appearance of a beautiful yet solid construction in keeping with its role of an impregnable fortress. Comprising two enclosures and the *burg* to the north east of the great courtyard, the outer wall of the Citadel surrounds the enclosure on all four sides. The eastern stretch of wall, 2 m. thick and 8 m. high, on the seaboard side has no towers, whereas the western face has three semi-circular towers along its length. This western face is the oldest and thickest and palm and other tree trunks can be seen inserted in its length. The south wall has three towers along its length facing the east gate. In its centre is the present-day main gate to the Citadel. The north stretch of wall overlooks the sea and is built on two levels. The lower part, a long covered passageway stretching the length of the wall, is divided into

The Citadel of
Qaytbay, plan,
Alexandria.

The Citadel of
Qaytbay, main burg,
passageway to the
mosque, Alexandria.

several square sections each with an arched opening into which cannons were placed. The upper level is a parapet walk with narrow openings which is now mostly in ruins.

The inner wall surrounds the Citadel courtyard on three sides (east, west and south) and the distance between the inner and outer walls varies between 5 and 10 m. Set into the thick wall are small rooms which served as barracks for the soldiers. In the centre of the length of wall is the second gateway to the Citadel (opposite the outer wall gateway). Above the entrance a marble plaque bears the decree issued by Sultan al-Ghuri in 907/1501 prohibiting the removal of arms, rifles or gunpowder from the Citadel and that anyone found guilty of doing so would be hung from the *burg* gate. Sultan al-Ghuri had the Citadel equipped with facilities for arms and chain-mail manufacture and increased the number of soldiers stationed there.

To the north east of the Citadel courtyard and built on the foundations of the ancient lighthouse, is the *burg*. It has a square base with sides of 30 m. measuring 17 m. in height and was built on three levels. The walls are crowned with battlements and each of the corners is reinforced with round towers. A machicolation is located above the gate, supported on square brackets with loopholes in the floor through which the entrance gate was defended.

The Citadel mosque occupied over half of the ground floor. The mosque comprised a square courtyard with four *iwan*s and its floor was decorated with a marble mosaic of various colours in geometric shapes. By descriptions which have come down to us from travellers, we know that the minaret, now gone, was located in the

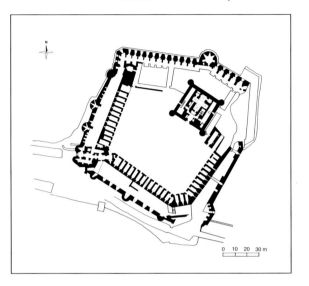

193

upper part of the *burg* and that it was constructed in keeping with the predominant style of the Qaytbay era. The second floor has several small rooms interconnected by corridors, while the third floor has one large room located in the centre of the south end. The latter is mentioned by the Ibn Iyas as *al-maq'ad*, or a reception hall. This *burg* is similar to that in the Citadel of Qaytbay in Rosetta (VII.1.a) and to the one in Ra's al-Nahr in Tripoli, Syria. Sultan Qaytbay had them all built over a similar period, though the latter on a smaller scale.

From the top of the Citadel towers there is a fantastic view of the Alexandria promenade, East Port and al-Raml Square.

VI.1.b The Walls and Towers of the Old City

Walls of the Old City and Towers, ruins of the west stretch of wall and rectangular tower, Alexandria.

The stone walls around the city of Alexandria were still standing in 1234/1818. There were two walls one

194

inside the other and separated by a distance of between 10 and 12.5 m; the outer wall was 10 m. high with two towers along its length. The inner wall was higher and 6.5 m. thick.

Al-Nuwiri al-Skandari described Sultan Sha'ban's visit to Alexandria in 746/1345 and in his writings records each of the city gates as having three iron doors: such a feature is similar in design to the Cordoba Gate in Seville, Spain. From his account we also understand that the north stretch of wall between the Sea Gate and the Green Gate (or Cemetery Gate) was a double wall and followed the predominant models of Byzantine constructions and those of military architecture in al-Andalus, Spain.

Restored and rebuilt on several occasions throughout history, the Mamluk Sultans took care to preserve the wall as best they could to defend the city. In 659/1260 Sultan Baybars, fearful of invasion from the sea, ordered the walls to be strengthened. The city walls were rebuilt while al-Nasir Muhammad was in power following the earthquake of 702/1302, which according to al-Maqrizi destroyed 46 buttresses and 17 towers. Ibn Battuta vouched for the indomitable strength of the walls of Alexandria on his visit in 725/1324. Later, Sultan al-Ghuri directed part of the money collected through taxes to the restoration of the walls, a task included in his programme of strengthening and reorganising the fortresses of the Mamluk territory. In addition to the four main gateways from the Abbasid era (Gate of the Sea, Rosetta Gate, Sidra Gate and the Cemetery Gate), according to most historians another four gates were opened in the city walls in the Mamluk era, at the beginning of Baybars' reign.

East Wall and Towers

Walk along the Corniche from the Citadel and turn right into Nabi Daniel Street. From there, go down Gamal 'Abd al-Naser Street, on the left, and continue as far as the crossroads with Shahid Salah Mustafa.

The Rosetta Gate was located on this stretch of wall where Gamal 'Abd al-Naser Street and Shahid Salah Mustafa Street meet. It was the main gateway to the city through which sultans passed on visiting the port of Alexandria. The Rosetta Gate was used also by people coming from the capital, hence its popular name, the Cairo Gateway. During the Cypriot siege of 767/1365, this gateway was the scene of the flight of many of her inhabitants from the city. Her people also set fire to the gateways to prevent the enemy from hiding within her walls, and to secure access for Mamluk troops coming from Cairo to liberate the city.

In 1882 the Rosetta Gate was left to fall into ruins and within three years it had disappeared completely. Nevertheless, two traces of the east walls can still be seen in the area of the waterfall gardens. One such example can be found to the north of the Rosetta Gate site; two towers can be made out, one semi-circular and the other rectangular. The rusticated stones are worth noting as they were widely used during the Ayyubid era, and closely resemble those used on the Salah al-Din city walls in Cairo. These stones were also used on a number of towers in the Citadel in Cairo. The second vestige

Walls and Towers of the Old City, ruins of the south stretch of wall and its west tower, Alexandria.

of the original wall is found among modern buildings to the south of the waterfalls.

South Wall and Towers

Take al-Sutar Street in the area of the waterfall gardens. Nowadays, the tower is located within the Stadium of Alexandria.

There were two gates along this stretch of wall: Bab Sidra and Bab al-Zahri. Of the former, only the name remains, inherited by the street where it once stood. Of the latter, a section of the tower stands inside the sports stadium of Alexandria. In the circular tower, loopholes can be seen through which the enemy were fired upon below. This building is one of the few Islamic monuments remaining in Alexandria.

195

CENTRE OF THE SPICE TRADE BETWEEN EAST AND WEST

Tarek Torky

With the Arab Conquest of Alexandria completed, the city held onto her position as a major Mediterranean port on the main East-West trade route. Her strategic geographic location on the Mediterranean sea on the one hand, and the canal connecting the city to the Nile on the other, allowed Alexandria to maintain her position as a centre for trade throughout the Abbasid period, in spite of Baghdad's dominant trade position throughout the Islamic world.

The Mamluk Sultans encouraged foreign traders to come to Alexandria to trade at the *funduqs* set up by different European peoples. When Acre fell to the Mamluks in 690/1291 the papacy tried to intervene in the religious affairs of European countries preventing them from trading with Egypt. The papacy put an economic blockade on the Egyptian coasts and declared trade between Egypt and the West illegal. To compensate, relations between the Europeans and the Mongols were promoted, the trading route through the Red Sea replaced by a route through the Persian Gulf and additional trading routes established through central Asia. Such attempts were, however, fruitless and the Italian Republics and other European States which had already established trading agreements with Mamluk Egypt, witnessed Egypt's ability to maintain her independence and resist the Crusaders' repeated and failed attacks. Furthermore, the European States saw that the Egyptian route through Alexandria was indispensable and channelled all their efforts into gaining favour with her sultans. They signed profitable trade agreements with Egypt and took great care to be represented in Alexandria by Consuls who defended their commercial interests. Several *funduqs* were built in the port,

mostly near the Gateway of the Sea, and were reserved for the traders of each country.

Envoys were sent to Alexandria by the Kings of Aragon, Castile and France, the Dukes of Genoa and Venice, the Emperor of Byzantium, the Kings of Bulgaria and of the River Volga (main artery of Russian navigation) and by the Ottoman and Iranian courts.

The Genoese and Venetian merchants in Alexandria brought in essential products for the Egyptians; wood, cloth, animal skins, iron, tin, copper, oil, soap, leather and wax. In exchange, they exported from Egypt incense and spices such as pepper, ginger, cinnamon, nutmeg and clove, all of which were originally imported from India, Yemen and Somalia. Ceramics from China and pearls from the Persian Gulf were also re-exported along with materials for curing leather, dyes, sugar, paint, resin, cotton, linen and silk, Egyptian alum, perfumes and medicinal plants. Each major product had its specialist market; the spice and pepper markets were centred in the al-'Attarin market place.

Alexandria was one of the most important centres for the export of spice, on which the majority of trade between Egypt and Christian Europe was based, providing a vast income for the State coffers. The Mamluk Sultans relied on this trade to increase the sources of funds for the State. With a monopoly established on the spice trade and that of other products such as sugar and timber, their income increased yet further.

This monopoly reached its height with Sultan Barsbay, who, in 832/1428 issued a decree prohibiting the purchase of spices from any other marketplace outside the Sultan's own stores. He subject-

ed imports and exports to exorbitant taxes and declared the port of Alexandria exclusive to the spice trade. Such were the price increases on some products from the East such as spices and silk, that the foreign traders took offence. In 836/1432 Venetian representatives in Alexandria met Sultan Barsbay threatening to end relations with Egypt. They even sent their fleets to Alexandria to repatriate their traders, but on seeing such a reaction Barsbay came to his senses and agreed to better conditions for the International Spice Trade, though keeping his monopoly on pepper.

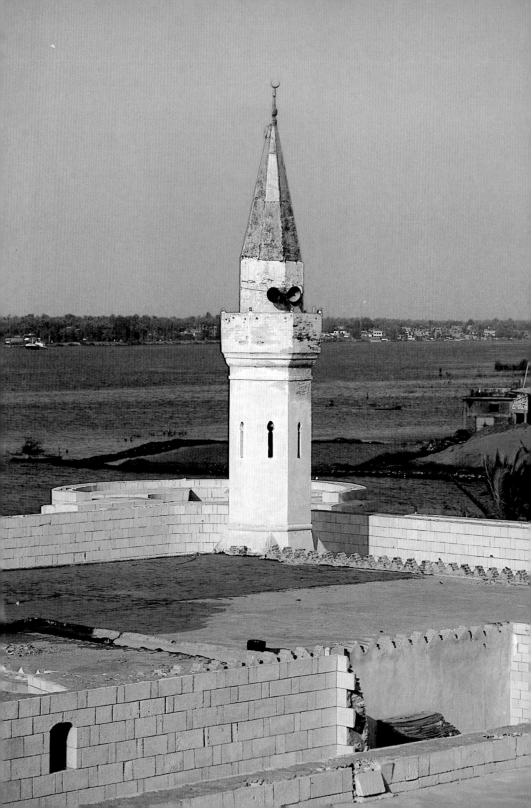

Rosetta: Trading Centre of the Delta

Mohamed Abdel Aziz

VII.1 ROSETTA
 VII.1.a The Citadel of Qaytbay
 VII.1.b Mosque of al-Mahalli

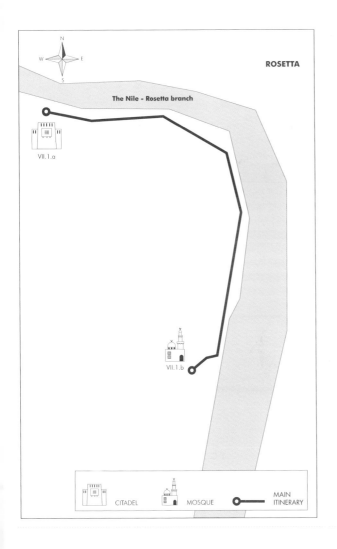

The Citadel of Qaytbay, minaret, Rosetta.

199

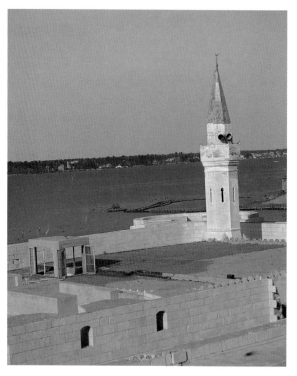

The Citadel of Qaytbay and the widest stretch of the Rosetta arm of the Nile before it meets the Mediterranean, Rosetta.

The City of Rosetta, (Rashid in Arabic), is situated on the far east of the Bay of Abu Qir, some 65 km. to the east of Alexandria. Buses leave every day for Rosetta from Midan al-Gumhuriyya (Republic Square) near the Roman theatre of Alexandria. Ask for the return bus times before leaving Alexandria.

If travelling by car, leave Alexandria through the area known as al-Muntazah. On leaving the al-Ma'mura area, at the crossroads with Abu Qir (a small fishing town), turn right along the main road to Ma'diya near Lake Idku. On leaving the town of Idku, follow the road as far as the first junction and turn left onto the main road to Rosetta. The journey takes about an hour. On arriving in the city, there is a social club on the banks of the Nile,

with a cafeteria, restaurant and public conveniences.

The Egyptian authorities responsible for heritage have taken great care in restoring and preserving the main historical monuments of this city. A craft centre has also been built to recover and promote the skills that brought the city its fame; such as wood-turning, joinery, inlay work, carving, marquetry and casting.

The city of Rosetta was one of Egypt's ancient ports, known to the Greek geographer and historian Strabo as Bolbitine, for it was located at the mouth of the west branch of the Nile of the same name. According to other historical sources, the Coptic name of Rosetta was Rashid, a word that derives from the Pharaonic name of "Rajbatu" meaning "the masses" or "the ordinary people". The Europeans, however, knew it as Rosetta or "Rosette" from the Latin for rose, due to the large number of gardens and palm trees there. Historians recount how her inhabitants fought King Menes on his march to unify the north and how one of the country's first kings of the 19th Pharaonic dynasty had the city fortified. During the 26th Pharaonic dynasty, it was a highly successful market town, renowned for its manufacture of war chariots. The temple of Bolbatinium was built during the Ptolemaic era. Of other historical periods some Ionic and Corinthian capitals and columns remain, later re-used in the construction of a number of public and private buildings.

Following the conquest of Alexandria in 21/642, 'Amr Ibn al-'As led the conversion of Rosetta to Islam. He signed a peace treaty with the city's Coptic governor to allow churches to continue to function for those who still professed Christianity.

Historical accounts show that in 256/870 (Abbasid era) Rosetta was transferred to its present-day location north of the original town of Rosetta, where Caliph al-Mutawakkil 'Ala Allah had ordered new forts to be built to defend Egyptian ports facing attack from the Byzantines.

The Egyptian historian Ibn Duqmaq (d.809/1406) has left us with a description of the city as it was at the end of the 8th/14th century. "The secure port of Rosetta is a work of the faithful, at a juncture between two seas [the River Nile and the Mediterranean Sea], with a mosque, *hammam* and local *amir*, it is a pious town in which numerous festivities are celebrated". He also mentions the lighthouse which had been restored by Sultan Baybars al-Bunduqdari, and below it, a tower built on the banks of the Nile constructed by Salah al-Din Ibn 'Aram, in the 8th/14th century. In 876/1472, Sultan Qaytbay had a *burg* built which can still be seen today.

According to Ibn Iyas, Sultan Qaytbay had the walls around the city built to defend it from attacks and an enormous iron chain placed across the mouth of the river to stop enemy ships entering. The installation of the defence system was carried out under the supervision of Amir Yashbak al-Dawadar. At the beginning of the 10th/16th century, Sultan al-Ghuri ordered another wall to be built with defensive towers.

During the Mamluk era, Rosetta became one of Egypt's major ports, her importance overtaking that of the larger city of Alexandria. Historical records indicate that ships left her port for both distant lands and on military expeditions. Amir Nasir al-Din Bek Ibn 'Ali Bek Ibn Qurman, is recorded as being set free and leaving for his homeland in Asia Minor on a ship from Rosetta. Rosetta took part in Sultan Barsbay's naval campaigns that ended with the invasion of Cyprus, subjecting it to Mamluk rule in 829/1426. During the reign of Sultan Jaqmaq, the city did however face attacks from the Knights Hospitallers who came in four ships in 842/1439 from the Island of Rhodes.

The French traveller Gilbert de Lanoy who visited Egypt in 826/1422, described Rosetta as a large hamlet built of adobe and located 5 miles (7.5 km.) from the mouth of the Nile. He also mentions the Green Island in the sea at the mouth of the Nile and records the presence of a seaport.

Hence, Rosetta is assumed to have been a town with a defensive purpose, as the Arab geographers described it, calling it *thagr*, or frontier post. Many of its most noted citizens were *murabitin*, or warrior

Mosque of al-Mahalli, capital in the qibla aisle and part of mausoleum façade, Rosetta.

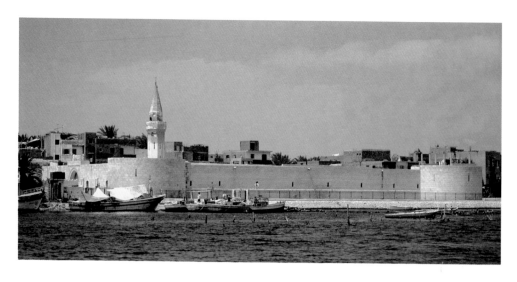

The Citadel of Qaytbay, general view from the Nile, Rosetta.

monks, and the majority of its inhabitants were fishermen.

With the discovery of the sea route round the Cape of Good Hope in the 9th/15th century, trade routes diverted around South Africa and Rosetta declined in importance. Nevertheless, the town maintained its role as a trade centre and one of the largest rice stores in the country. From the 10th/16th century, Rosetta reached her height of development when Egypt became one of the provinces of the Ottoman Empire. *Funduqs*, *qaysariyyas*, *wikalas* and lodgings were built. The Ottomans concentrated their attention on the port of Rosetta more than on any other of the Egyptian ports. They turned it into an international trade centre, making the most of its proximity to Istanbul and the other countries bordering the Aegean Sea that made up the Ottoman Empire. Ships left Rosetta loaded with rice, cloth, wheat and salt, and returned laden with timber, soap and tobacco.

It was, however, the French expedition that brought Rosetta its universal fame. With the French occupation of the city in 1798, a garrison governed by General Menou was installed there. On converting to Islam he married Zubayda, the daughter of al-Bawab a wealthy merchant, and lived in a house known as al-Mizuni, one of the ancient houses still preserved today bearing testimony to the period. The French undertook to rehabilitate the Citadel of Qaytbay and during the restoration work of one of its walls, came across the famous stone which has become part of the history of archaeology. Known as the "Rosetta stone" it provided the key to deciphering Ancient Egyptian hieroglyphics.

With the English expedition thwarted by her inhabitants in 1807, Muhammad Ali strengthened the fortifications of Rosetta, a city second only to Cairo with regard to the importance of its Islamic monuments. The widely used building system of red-and-black brick facing with white

mortar pointing is called *al-mangur* and gives Rosetta a picturesque appearance. A great variety of fine motifs used in carpentry are found in the *mashrabiyyas* in the windows. The terracotta brick mosaics in the spandrels and tie bars over doors enhance the artistic look of the city.

VII.I **ROSETTA**

VII.1.a **The Citadel of Qaytbay**

The Citadel or burg of Qaytbay is located 6 km. to the north of Rosetta on the west bank of the arm of the River Nile.
The Organisation of Egyptian Monuments reconditioned the Citadel in 1985. The wall was rebuilt, until then in ruins, as were the towers. The northeast tower was reconstructed from its foundations, which were uncovered during an archaeological dig, and the main tower was rebuilt based on the structure of those still standing. Restoration work was carried out with features of both the Mamluk and the French periods in mind; the facing of the towers carried out by the French was maintained, considered a significant feature of its architectural style.
Opening times: from 08.00 to sunset.

Sultan Qaytbay had a Citadel built to defend Egypt from attacks mounted at sea. Hence the strategic location at the mouth of the Nile arm which meets the Mediterranean in Rosetta. Building work began in 876/1472 and took seven years to complete. Stones were brought from ancient Bolbitine and combined with bricks made in Rosetta.
Its overall plan is similar to that of the main *burg* in the Citadel of Alexandria with circular pillars of granite inserted

horizontally through the length of its walls, also similar to those used in the main *burg* of the Citadel of Qaytbay, Alexandria. During the French occupation, the Citadel was christened with the name Saint Julian, and the south west and north west towers were renovated with brick facing manufactured in Rosetta.
It is rectangular in shape, its corners reinforced with towers and the main gate located in the centre of the south wall. In the middle of the inner enclosure is the main *burg* comprising a mosque, (of more recent construction on the site of the previous one), stores and a large cistern dating back to the Mamluk period. The stairs leading to the upper floor of this main *burg* can still be seen next to the mosque, while the upper section itself has long since disappeared.
As a result of the restoration work carried out in 1214/1799, Bouchard, one of the officers of the French expedition in charge of the building work, found the famous Rosetta stone. Now one of the most important artefacts housed in the

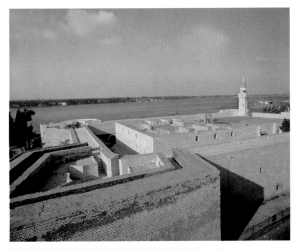

The Citadel of Qaytbay, upper section of wall, Rosetta.

The Citadel of Qaytbay, interior passageway, Rosetta.

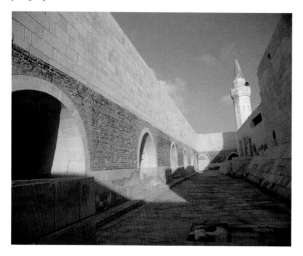

to decipher the ancient writings and discover a considerable number of secrets about ancient Egyptian civilisation.

From the top of the Citadel there is a clear and wonderful view across the mouth of the Nile some 2 km. away as it flows into the Mediterranean Sea. This point may also be reached by car, by travelling northwards, and then walking along the beach a short way as far as this fascinating location where the Rosetta arm of the Nile meets the Mediterranean.

VII.1.b **Mosque of al-Mahalli**

The Mosque of al-Mahalli is located in the centre of the City of Rosetta, near the grocery market.
Opening times: all day except during morning and afternoon prayers (12.00 and 15.00 in winter, 13.00 and 16.00 in summer).

'Ali al-Mahalli, who died in Rosetta in 901/1495, founded this mosque which was later restored in the Ottoman era in 1134/1722. Its foundation is mentioned in the *waqf* deed dated 990/1582.
Its irregular layout comprises a central courtyard surrounded by arcades, a total of 99 columns each of a different shape upholding the ceiling. It was here that classes were imparted. This mosque plan is representative of the model adopted in the city where the location of the four *iwans* around a central courtyard was substituted by a single hypostyle hall.
The building can be entered through six entrances, each one crowned with a triple arch and decorated using the particular building technique known as *al-mangur*; the decorative motifs are different on each entrance.

Mosque of al-Mahalli, the door to the mausoleum, Rosetta.

British Museum, London, the black basalt stone bearing a long trilingual inscription (hieroglyphic, demotic and Greek) helped the French expert François Champollion

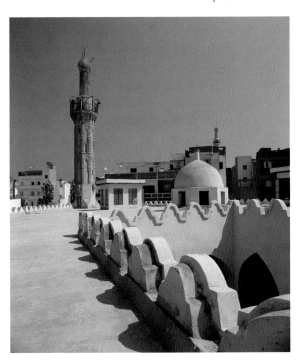

*Mosque of al-Mahalli,
dome and minaret,
Rosetta.*

*Mosque of al-Mahalli,
plan, Rosetta.*

The western edge of the mosque contains the area set apart for ablutions, its portico is supported by 14 columns. In the centre of the mosque is the tomb of *shaykh* 'Ali al-Mahalli, around which a *maqsura* is placed. On the door an inscription reads: "There is no God but Allah and Muhammad is his messenger, victory belongs to God and his triumph is nigh; 6th *Sha'ban* 1283/14 December 1866". 'Ali Bek Tabaq, "mayor" of Rosetta in the second half of the 13th/19th century, acquired two *wikalas* on the north side of the mosque, which were added to the building as an extension. Ali Mubarak, Minister of Education in the time of the Khedive Isma'il, poured praise on the mosque, claiming that its size and the number of columns placed it on a level with the Mosque of al-Azhar in Cairo.

It is worthwhile taking a boat from the Nile bank south to the hilltop Mosque of shaykh Abu Mandur on the right bank of the river. Archaeological finds on the hill have included successive levels dating back to various periods; some as far back as the Pharaonic periods and others to different Islamic eras. A museum store is currently being built in which to house and display finds from this site.

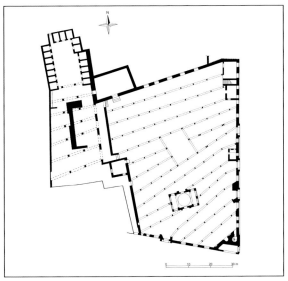

205

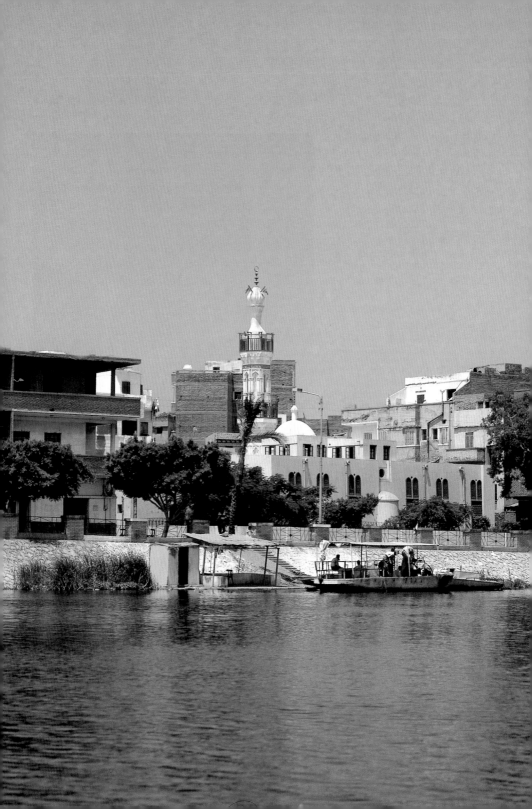

Fuwa: Rice Province on the Banks of the Nile

Mohamed Abdel Aziz

VIII.I FUWA

Kilim-making in Fuwa

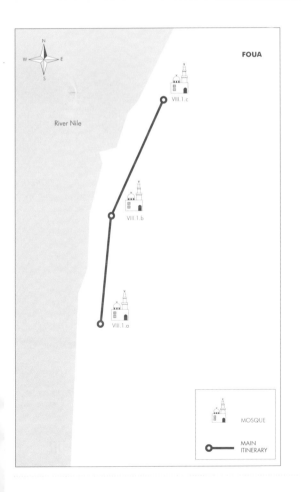

Mosque of Abu al-Makarim, general view from the Nile, Fuwa.

View of the city with the Mosque of Hassan Nasr Allah and the Rosetta arm of the Nile, Fuwa.

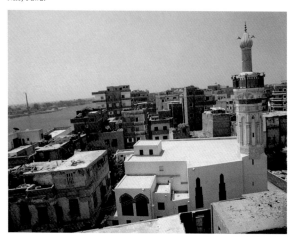

Mosque of Abu al-Makarim, general view from the Nile, Fuwa.

Both locally and internationally, the town of Fuwa was an important centre of rug and kilim production. Fuwa is situated 105 km. from Alexandria on the east bank of the Rosetta arm of the Nile and can be reached by car from Alexandria, passing by the towns of Daman-hur and Dusuq. At the beginning of the 1990s many of its monuments were renovated and a project is currently being carried out to restore the city's heritage completely, soon to be included in the group of protected archaeological sites of Egypt.

Fuwa is located to the north of the Kafr al-Shaykh province, in the centre of the Delta on a bend in the river on the east bank of the Rosetta arm of the Nile. This geographical location saved the city from devastating epidemics in 775/1373 and 873/1467, caused by the Nile bursting its banks and also from floods affecting the coastal cities of Rosetta and Alexandria.

Historical sources refer to the city as Poei, locating it near the site of the City of Metelis, a name dating back to Pharaonic times. Fuwa began to acquire regional importance when Christianity arrived in the area, and with it, the city became an Episcopal Seat. It was later mentioned in accounts of the Arab conquest of Egypt and in a letter 'Amr Ibn al-'As wrote to Caliph 'Umar Ibn al-Khattab informing him of the conquest of Maryut (Mareotis), Alexandria, Rosetta, Fuwa, Damanhur, Beheira and Damietta.

From the beginning of the 5th/11th century, Fuwa was the main city in the region of al-Muzahamatin, nowadays the province of Kafr al-Shaykh, covering the area between the region of al-Beheira and al-Gharbiyya. Along with al-Muza-hamatin, Fuwa made up one of the *iqta'at* (singular *iqta'*), or land endowments given by Salah al-Din al-Ayyubi to his nephew al-Muzaffar Taqi al-Din and the town formed the second line of defence for Alexandria, Rosetta and Damietta on the coast.

In 600/1203 it was attacked by the Cru-saders, who for five days ransacked the city taking as much booty as they could carry back to Rosetta. In the Mamluk era, the Alexandrian canal was dredged twice, first by Sultan al-Nasir Muhammad and later by Sultan Barsbay, facilitating the

development of agriculture and trade. Fuwa became an important trade centre and many European ships docked in her port on their way East through the Alexandrian canal. The French traveller Pilon testifies to the 9th/15th century commercial development of Fuwa noting that, like Alexandria, there were many European Consuls there.

The port of Fuwa is quoted in a document, dated 680/1281, in which Sultan Qalawun cleverly obtained a 10-year peace treaty signed by the Crusaders. The purpose was to counterbalance the attempted union between the Mongols and Christians, the increasing threat of which would have endangered the unity of the Mamluk territories.

In addition, documents of the canonical court of Fuwa (*al-Mahkama al-Shar'iya*) also identify the presence of a dock, in the vicinity of the Mosque of Abu al-Naga, on the banks of the Nile, most likely to have formed part of the town's ancient port.

Sultan Salim I's visit to Alexandria in 923/1517 included a visit to Fuwa, which left the sultan amazed by its wealth. During the Ottoman era a large number of *khans* were built, a clear sign of the stability of its commercial activity. At the beginning of the 13th/19th century, Muhammad 'Ali showed interest in the city and ordered the Alexandrian canal to be dredged once again, changing its name to the al-Mahmudiyya canal. During the reign of Muhammad 'Ali, Fuwa became one of Egypt's most important centres of industry. Fez factories and spinning mills were set up there to meet the demands of the Egyptian army.

With the creation of the Rice Province in the west of the country in 1242/1826, Fuwa stood as its capital. In 1288/1871,

it was named Centre of the Rice Region, and later in 1896, received the title of City of Fuwa. Fuwa holds third place in the ranking of Egyptian cities with the most Islamic monuments.

VIII.I **FUWA**

VIII.1.a **Mosque of al-Qina'i**

The mosque is situated near the banks of the River Nile, between al-Tilal Square to the west and the Nile to the east.

Opening times: all day except during midday and afternoon prayers (12.00 and 15.00 in winter, 13.00 and 16.00 in summer).

The Mosque of al-Qina'i is attributed to the affiliation between Sidi 'Abd al-Rahim al-Qina'i, descendant of the Prophet

Mosque of al-Qina'i, side of the minbar, Fuwa.

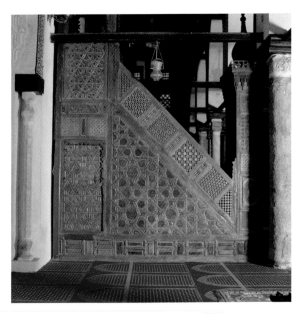

*Mosque of al-Qina'i,
plan, Fuwa.*

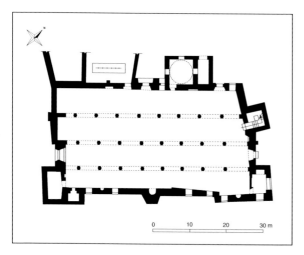

*Mosque of al-Qina'i,
sanctuary, capital
used as column base,
Fuwa.*

stayed for two years before returning to his hometown to be named *shaykh* of the main mosque in which he taught. As a child, he had been educated in this same mosque by his father. On his way to Mecca to fulfil his religious duties of pilgrimage, Sidi 'Abd al-Rahim al-Qina'i visited Cairo and Alexandria. On his return, he went to Qus (southern Egypt), which at the time of the Mamluk Sultans was a major commercial store in Upper Egypt and the crossroads for caravan routes coming from the Red Sea. From there he chose the city of Qina', located just over 20 km. to the north of Qus, and inherited its name staying there for a further two years dedicated to prayer and in exercises of spiritual perfection. At the end of the two years he was named *shaykh* of the city.

His stay in Fuwa was inspired by his visit to his one-time master Sidi Salam Abi al-Nagah, of Moroccan origin and who was later buried in the mausoleum of the same name. In Fuwa, al-Qina'i also committed himself to retreat and meditation on the site where the mosque, to which his name is given, was eventually built in the 9th/15th century. Sidi 'Abd al-Rahim al-Qina'i subsequently returned to Qina' where he died in 593/1196.

The mosque was restored in 1133/1721. It is constructed on a rectangular layout with sides of irregular lengths. The inside can be reached through doorways on three sides while the north west wall is the main wall containing the *qubba* and the minaret. Inside the north entrance and to the left is a stone plaque with a *naskhi*-style inscription dating back to the era of Sultan Barquq.

The prayer hall is divided into four aisles, parallel to the *qibla* wall, separated by three rows of columns numbering 24 in

Muhammad, and his cousin and son-in-law 'Ali Ibn Abi Talib, the last of the Orthodox Caliphs. He was born in 521/1127, in the city of Targa, in Ceuta. He travelled to Damascus, where he

total. It is the largest of the monumental mosques in the City of Fuwa. It is also worth noting the eight marble and granite columns overlooking the courtyard that support pointed arches rising from imposts. One of the columns shows hieroglyphics testifying to the fact that the columns were taken from other earlier buildings.

Of the three *mihrab*s in the *qibla* wall, the central one is the largest. Beside it is a plaque with *naskhi*-style inscriptions that bears the name of Sultan al-Ghuri.

The arch frame around the *mihrab* displays red and black geometric decoration using the traditional local technique of *al-mangur*. This design is created by placing red and black bricks (burnt brick) alternately with white-mortar pointing.

The real work of art in this mosque is the *minbar*, one of the most beautiful of its kind, heritage of the mosques of Fuwa. It is decorated using inlaid wood and small turned pieces that fit together to form star shapes. One side of the *minbar* bears an inscription of the name Muhammad 'Umar al-Naggar al-Qa'idi al-Fuwi, craftsman of the *minbar*.

The minaret, which can be reached through the second north aisle, is over 33 m. high, the highest minaret in Fuwa. It is likely that as well as its religious role it also served as a lighthouse due to its location in the ancient city port. The sundial on the building was used to determine the correct hours of prayer.

VIII.1.b Mosque of Hassan Nasr Allah

The Mosque of Hassan Nasr Allah is on the street of the same name near the River Nile. Opening times: all day except during midday and afternoon prayers (12.00 and 15.00 in winter, 13.00 and 16.00 in summer).

Badr al-Din Hassan Nasr Allah, a native of Fuwa, travelled to Cairo to finish his studies in the Madrasa of Sultan Hassan (I.1.g). One of the few Egyptian natives to hold a high position in the Mamluk era, from *muhtasib* of the Cairene markets to *vizier* under Sultan Barquq, he rose to the position of *ustadar* under the reign of Sultan al-Mu'ayyad Shaykh in 822/1420. As

Mosque of Hassan Nasr Allah, entrance façade and minaret, Fuwa.

Mosque of Hassan Nasr Allah, one of the three decrees on a marble plaque on the qibla wall, Fuwa.

ustadar, he was responsible for the private affairs of the Sultan, and in particular for his property and treasury. In 842/1440 during Sultan Jaqmaq's reign, he was dismissed and his wealth (lands and palaces) confiscated. Four years later he died and was buried in his mausoleum in the North or Mamluk Cemetery, Cairo.

The mosque he founded which inherited his name, Hassan Nasr Allah, was built in the 9th/15th century. Only the minaret and the three decrees written in *naskhi* script on marble plaques located on the *qibla* wall remain from the Mamluk period. They refer to tax exemption, one from Sultan al-Mu'ayyad Shaykh, and the other two from Sultan Barquq. In 1115/1703, the Ottoman Amir 'Ali Suleyman, a tax collector in Fuwa, had the mosque restored.

The main entrance to the mosque is on the north west side, crowned by three pointed arches, a traditional design of the Nile Delta. The central arch, a blind arch, is set back into the wall above the door lintel, and placed over the other two with a hanging column between them, constructed using the *al-mangur* technique.

Both the main entrance façade and the spandrels of the triple arch are decorated using the same technique: red and black bricks with white mortar pointing. Its original decoration places this mosque façade among the most characteristic of Fuwa. The ceiling is noted for its fine wooden beams decorated in black and red.

Of the three *mihrabs* in the *qibla* wall, the central one is the largest. The wooden *minbar* is decorated with ivory and mother-of-pearl inlay and displays a geometric eight-pointed-star shape in the centre of its sides. The banister is made of small turned wooden pieces that fit together to make small screen panels.

In the north east of the mosque is a wooden *maqsura*, with different motifs carved on its three sides. The door bears the carpenter's name, Sayyid 'Abd al-Karim al-Fuwi, and 1287/1870, the date of construction.

VIII.1.c Mosque of Abu al-Makarim

This mosque is found on Abu al-Makarim Street with its rear wall overlooking the Nile. Opening times: all day except during midday and afternoon prayers (12.00 and 15.00 in winter, 13.00 and 16.00 in summer).

This mosque is named after its founder Sidi Muhammad Zahir Abi al-Makarim, who died in 980/1571. The building is mentioned in the documents of the canonical court (*al-Mahakim al-Char'iya*) where

records account for an oratory, cells, the imam's lodgings and a water wheel with a channel to the ablutions area. Carved on the wooden lintel above the main door to the mosque is the date of its restoration; the month of *sha'ban* 1267/1850.

This building, built on an irregular rectangle, is one of the most famous in Fuwa. The prayer hall is divided into five aisles parallel to the *qibla* wall separated by arcades each containing six marble and granite columns, supporting pointed arches. There are three *mihrabs* in the *qibla* wall, the deepest being the central one, whose spandrels bear geometric decoration using *al-mangur*.

The *minbar* also displays geometric decoration while the square, wooden *maqsura* is covered by a dome resting on arches.

The main façade is oriented north east and has three entrances also decorated using the *al-mangur* technique. The main entrance is in its centre and is the highest of the three with its arch frame rising above the cornice.

The minaret measures 23 m. in height and is located between the central and north doors. Access to the minaret is gained from within the mosque. The minaret style is of the type built in the post-Mamluk period, widely used in mosques in the region throughout the Ottoman period.

Mosque of Abu al-Makarim, general view, Fuwa.

Cross the small square in front of the mosque to visit al-Rub' al-Khattabiyya, where artisans continue to hand-weave rugs and kilims, a skill which brought the city its fame.

The building is a living example of the style of architecture popular during the Mamluk era and later under Ottoman rule.

KILIM-MAKING IN FUWA

Salah El-Bahnasi

Kilim-making in Fuwa

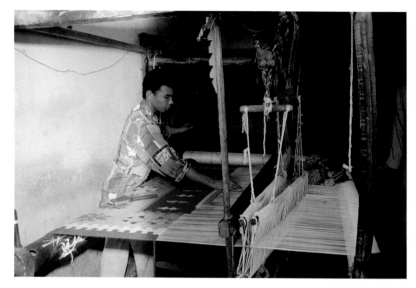

The origins of the name Fuwa come from the plant known as Madder (*rubia tinctorum*). It grows in abundance around the town and its roots produce a red colour used to dye cloth and to prepare a red-coloured substance commonly used in dry cleaning.

The cloth and kilim industry, well supported in Mamluk times, saw rapid development during the time of Muhammad Ali when the city became the most important industrial centre in the country. The importance of this industry is reflected in the design of houses, in which the first floor is reserved for looms on which kilims were handcrafted.

The word kilim, of Turkish origin, is used for carpets made using the same technique as the *al-qabbati* or tapestry, the decoration of which uses a weft not occupying the full width of the cloth.

The French traveller Pilon, who visited Fuwa in the 9th/15th century, described the city in detail and noted that apart from its extraordinary buildings, the bustling commercial activity placed the city among the most important in Egypt, in fact second only to Cairo. Some of the products manufactured in the linen factory of Fuwa were exported to Europe via the Island of Malta, and it is for this reason that the factory door is still popularly known as the "Door of Malta".

The fact that kilims were cheap to produce greatly influenced their popularity. In general, they were made from materials abundant in the area. One example was wool, the major component, which came mainly from animals such as sheep, but also from goats and even camels. Their natural colours were maintained without the use of artificial dyes; black, white, brown, beige or grey. Nevertheless, natural dyes extracted from plants were used such as red from the roots of the madder plant, yellow from turmeric, onion colour from the root vegetable and violet extracted from pomegranate skins.

The variety of kilim decoration in Fuwa produced many different models, the following are among the most notable:

The **gobelin kilim** is characterised by the illustrative scenes taken mostly from the Egyptian historical legacy and surroundings. Some portrayed landscapes interspersed with Islamic or ancient Egyptian monuments as well as panoramic views of Egyptian towns. This type of kilim required enormous technical expertise, as such illustrations were created using different coloured threads to produce magnificent scenes rivalling those painted on canvas or walls. The use of the word gobelin is interesting as it comes from the French tapestry manufacturer "Gobelins" famous in the 17th century during the reign of Louis XIV. Gobelins made tapestries using the same process as *al-qabbati* which were characterised by the woven illustrations they bore, similar in appearance to Aubusson textiles.

The **double kilim** stands out for its thickness and size. Larger than the goblin kilim, its decoration generally involves geometric shapes, medallions in lines, or framed geometric figures.

The **manawishi kilim** is characterised by its pale colours, trimming of geometric figures, and alternating triangles of different colours. The centre bears no decoration, but its speckled appearance comes from the natural variation in the colour of the threads used.

Kilim makers in Fuwa contributed considerably to the development of the industry and to the designs produced with the simple decoration of geometric figures and plant motifs. Despite the rough traditional tools, Fuwa kilim weavers acquired considerable skill and created a variety of landscape scenes of exquisite detail and quality.

GLOSSARY

Ablaq	(From the Turkish *iplik*, "rope" or "thread".) Building technique consisting of alternating courses of black-and-white masonry.
Al-Sham	Originally, territories including Syria, the Lebanon, Palestine and Jordan; nowadays Syria.
Amir	Governor, Prince, dignitary.
Amir akhur	Amir responsible for Sultan's stables, camels and postal service
Amir al-silah	Amir responsible for arms.
Amir kabir	Great Amir.
Atabek	Commander in Chief of armies.
Bahri	Relative to the Nile (*al-Bahr*). The name *Bahri* Mamluk derives from their barracks located on Roda Island, in the Nile.
Burg	Fort, bastion. Tower, sometimes surrounded by an outer wall.
Caravanserai	Hostel along main travelling routes to accommodate travellers and safeguard their goods.
Dawadar	Post occupied by secretary of State.
Derka	Small square or rectangular transition zone between the main entrance and rooms of a building. Hall.
Dikkat al-muballigh	Platform from which prayers of the day were repeated for all worshippers to hear.
Durqa'a	Central area in mosques and *madrasa*s, from which remaining rooms are reached. Usually surrounded by two or four *iwan*s, and covered by a wooden ceiling with openings for light and ventilation.
Fatwa	Decree, legal adviser's reply to a consultation on religious law.
Funduq	In Northern Africa, a hostel for merchants and their pack animals; store for merchandise and a commercial centre, equivalent of a *caravanserai* or *khan* in Oriental Islam.
Gawsaq	Finial or upper section of a minaret, open on all sides that towards the end of the 7th/13th century appeared with brick pillars and from 739/1340 onwards, with arches supported on columns.
Hadith	(Lit. "sayings".) Tradition related to acts, sayings and attitudes of the Prophet Muhammad and his companions.
Hammam	Public or private bathhouse.

Hanafi	One of four *Sunni* legal schools (Orthodox Islam). Abu Hanifa al-Nu'man (79/699-149/767) began the school, which became the chosen school of the Ottomans, who "exported" it to their provinces.
Hanbali	One of the four *Sunni* legal schools (Orthodox Islam).
Hashashin	(Sing. *hashash*, from the Arabic *hashish*, "grass"). Follower of Syrian *Ismaili* sect.
Hisba	Prefecture of markets. Post held by *muhtasib*.
Hijab	Veil, fine curtain.
Iqta'	Donation of Property.
Ismaili	Member of the dissident *Shi'ites* who accept Isma'il as seventh and last imam.
Iwan	Vaulted hall, walled on three sides with a large opening arch and vaulted recess.
Jihad	Striving towards moral and religious perfection. It can lead to fighting "on the path to God" against dissidents or pagans.
Jizya	Personal Tax on non-Muslims within a Muslim State.
Jukha	Woollen blanket.
Ka'ba	(Literally. "cube".) Temple in Mecca, centre of Islamic religion.
Khan	Inn, lodgings for travellers and merchants on the main caravan routes. Store and hostel in large centres. (See also *funduq* and *caravanserai*).
Khanqa	Monastery or hostel for Sufis or dervishes.
Khaznadar	Treasurer. Responsible for State coffers (*khaza'in*) where the sultan or amir's money and gold was kept.
Kiswa	Black silk covering outer walls of *Ka'ba* in Mecca, traditionally donated by Egypt.
Kuttab	Qur'anic Primary school.
Lala	Tutor to sons of a sultan.
Madrasa	Islamic school of sciences (theology, law, *Qur'an*, etc.) and lodgings for students.
Mahmal	Decorated *palanquin* to carry *Kiswa* of the *Ka'ba* to Mecca.
Maliki	One of the four *Sunni* legal schools (Orthodox Islam). Emerged through the Imam Malik (94/713-178/795) and his disciples and spread throughout western Muslim world, including al-Andalus, Spain.

Mangur	Decorative building style traditional of Nile Delta cities, using red (single bake) bricks and black (burnt brick) with white pointing. Mainly used on façade entrances and *mihrabs*.
Maq'ad	Reception hall.
Maqsura	Area of sanctuary in congregational mosques reserved for Caliph or the imam during public prayer times.
Maristan	Hospital.
Mashhad	Sanctuary.
Mashrabiyya	Wooden lattice screens made of turned pieces of wood assembled together to form a window grille.
Mastaba	Long stone bench against an outer wall on either side of entrance to a building. In the times of Pharaohs, the *mastaba* was the tomb of nobles and court dignitaries. It was a truncated pyramid shape with a rectangular base similar to a funerary hypogeum.
Medina	City in north Africa, old Quarter of an earlier city on the scale of European cities of the time.
Mihrab	Niche in a *qibla* wall indicating the direction of Mecca towards which worshippers faced when praying.
Minbar	Pulpit in a mosque from which the *imam* preaches his sermon (*khutba*) to the faithful.
Miqati	(Literally, "he who establishes time".) Astronomer responsible for establishing the beginning and end of the lunar calendar and setting prayer times.
Muhtasib	Employee responsible for *hisba,* overseeing markets and commercial transactions, for checking weights and measures, preventing fraud and for overseeing public hygiene and urban buildings, etc. Alderman.
Murabitin	(Sing. *murabit*) Warrior monks who lived in hospices for pilgrims (*ribats*).
Mushahhar	Building technique using alternating courses of red and white stone.
Muzammala	Recess, housing porous earthenware vases filled with water. Several holes in the top allow air in to cool the water and the atmosphere.
Muzammalati	Employee responsible for supervising clean water.
Naskhi	(Literally "copied") one of the most widespread styles of calligraphy used in Arabic script.

Qabaq	Sport involving target practice.
Qaysariyya	Covered market.
Qabbati	Tapestry.
Qibla	Direction of *Ka'ba*, towards which believers turn to face for prayer. Wall of mosque in which the *mihrab* is situated.
Qubba	Dome. By extension a monument or chamber built over the grave of a saint.
Sabil	Building designed to provide drinking water. Public fountain.
Sadla	Small *iwan* or side *iwan*.
Saqi	Cupbearer also responsible for the sultan's table and drinks.
Shafi'i	One of the four legal schools of Orthodox Islam.
Shaykh	An elder, respected for his knowledge and age. Head of Legal School, a religious title.
Shi'i	(Literally "Scission, section, party") meaning partisans of 'Ali and of his descendants. *Shi'ites* rejected the legitimacy of all caliphs who succeed after the assassination of Ali (40/661).
Sunna	(Literally "tradition") For Orthodox Islam, group of traditions of the Prophet in which legal advisers and theologians find support and foundations to establish the content of Islamic Law arising from the *Qur'an*.
Sunni	Follower of *Sunna*. "Sunnism", a political and religious system opposed to "shi'ism". Sunnites are divided into 4 schools: *maliki, hanbali, hanafi, shafi'i*. Suq-Market
Takhtabush	Open area with high ceiling near entrance to houses or palaces, where guests were received.
Tashtakhana	Place in a palace where the sultan's crockery and utensils were kept.
Thuluth	Style of calligraphy or script.
Turbet	Private funeral area.
Ustadar	Tutor. Responsible for supervising private affairs of the sultan, his residence and treasury matters.
Waqf	Endowment in perpetuity, usually land or property, from which the revenue was reserved for the upkeep of religious foundations.
Wikala	One of many kinds of trading establishments. (See *caravanserai*.)

Zawiya	Establishment reserved for religious teaching designed for training *shaykhs*; includes mausoleum of a saint, built on the site where he lived.
Zellij	Small enamelled ceramic tiles used to decorate monuments or interiors.

SUCCESSION OF MAMLUK SULTANS

BAHRI SULTANS (648-1250/784-1382)

Al-Mu'izz 'Izz al-Din Aybak al-Turkmani (r. 648/1250-655/1257)
Native of Turkistan and husband of Shajar al-Durr, he was the first *Bahri* Sultan.

Al-Mansur Nur al-Din 'Ali (r. 655/1257-657/1259)
Son of Aybak, he succeeded to the throne at the age of 25 years following the violent death of his father. He acquired the sobriquet of al-Mansur "the Victorious" and governed for two and a-half years.

Al-Muzaffar Sayf al-Din Qutuz (r. 657/1259-658/1260)
Defeated the Mongols in the battle of 'Ayn Jalut, Palestine, in 658/1260.

Al-Zahir Rukn al-Din Baybars I al-Bunduqdari (r. 658/1260-676/1277)
Considered the true founder of the Mamluk State, his reign was noted for the buildings and renovations he patronised and his victorious military campaigns. He installed the Abbasid Caliphate in Egypt and remained in power for 17 years. He was the first Sultan to send the *Mahmal* to Mecca to prove himself the defender of the Caliphate.

Al-Sa'id Nasir al-Din Barakat Khan (r. 676/1277-678/1279)
His father, Baybars, named him heir to the kingdom in 662/1264 at the age of 16 years and arranged his marriage with one of the daughters of Amir Sayf al-Din Qalawun.

Al-'Adil Badr al-Din Salamish (r. 678/1279)
Son of Baybars, he succeeded to the throne at the age of seven when his brother Barakat Khan was deposed, only governing for 100 days.

Al-Mansur Sayf al-Din Qalawun (r. 678/1279-689/1290)
Considered the second father of the *Bahri* Mamluk State. His family held power for nearly 100 years. He died in the Siege of Acre in 689/1290.

Al-Ashraf Salah al-Din Khalil (r. 689/1290-693/1293)
Son of Qalawun, he recovered the City of Acre in 690/1291 from the hands of the Crusaders followed by the rest of the cities in Christian hands in Syria, which after nearly 200 years were returned to Islam.

Al-Nasir Nasir al-Din Muhammad (first reign: 693/1293-694/1294)
Son of Qalawun, he succeeded to the throne at the age of seven and governed for over 40 years. He reigned over several periods for he was twice deposed. His era is considered among the most splendid periods of Islamic architecture, witnessing intense building activity and the increasing popularity of *muqarnas*-decorated façades.

Al-'Adil Zin al-Din Katbugha (r. 694/1294-696/1297)
Delegate during Sultan al-Nasir Muhammad's first period of reign, (whom he later deposed).

Al-Mansur Husam al-Din Lajin (r. 696/1297-698/1299)
Delegate to Sultan Al-'Adil Zin al-Din Katbugha throughout his reign. The sultan's assassination put an end to his reign allowing the return of Sultan al-Nasir Muhammad.

Al-Nasir Nasir al-Din Muhammad (Second reign: 698/1299-708/1309)

Al-Muzaffar Rukn al-Din Baybars II al-Gashankir (r. 708/1309-709/1310)
Commander of the Circassian Mamluks acquired in areas to the north of the Caspian
Sea and east of the Black Sea.

Al-Nasir Nasir al-Din Muhammad (third reign: 709/1310-741/1340)

REIGN OF THE SONS OF AL-NASIR MUHAMMAD IBN QALAWUN

Al-Mansur Sayf al-Din Abi Bakr (r. 741/1340)

Al-Ashraf 'Ala' al-Din Kayk (r. 742/1341)

Al-Nasir Shihab al-Din Ahmad (r. 742/1341-743/1342)

Al-Nasir 'Imad al-Din Isma'il (r. 743/1342-746/1345)

Al-Kamil Sayf al-Din Sha'ban (r. 746/1345-747/1346)

Al-Muzaffar Sayf al-Din Hagui (r. 747/1346-748/1347)

Al-Nasir Nasir al-Din Hassan (first reign: 748/1347-752/1351)
Succeeded to the throne at the age of 13 years and ruled for six years, deposed by his
brother, al-Muzaffar Hagui.

Al-Salih Salah al-Din Salah (r. 752/1351-755/1354)
Governed for three years after which he was deposed and al-Nasir Hassan came to
power for the second time.

Al-Nasir Nasir al-Din Hassan (second reign: 755/1354-762/1361)

REIGN OF THE GRANDCHILDREN AND GREAT GRANDCHILDREN OF AL-NASIR MUHAMMAD IBN QALAWUN

Al-Mansur Salah al-Din Muhammad (r. 762/1361-764/1363)

Al-Ashraf Nasir al-Din Sha'ban (r. 764/1363-778/1377)

Al-Mansur 'Ala' al-Din Hagui (r. 778/1377-782/1380)
Son of al-Ashraf Sha'ban.

Al-Salih Salah al-Din Hagui (r. 782/1380-784/1382)
Son of al-Ashraf Sha'ban and last grandson of al-Nasir Muhammad Ibn Qalawun, he
succeeded to the throne as a small child, being deposed by Barquq, who thus put an
end to the Qalawun family.

BURGUI OR CIRCASSIAN SULTANS (784/1382-923/1517)

Al-Zahir Sayf al-Din Barquq (r. 784/1382-801/1399)
First Circassian Mamluk Sultan.

Al-Nasir Nasir al-Din Farag (first reign: 801/1399-808/1405)
Son of Barquq, he succeeded to the throne at the age of 10 years.

Al-Mansur 'Izz al-Din 'Abd al-'Aziz (r. 808/1405-809/1406)
Son of Barquq.

Al-Nasir Nasir al-Din Farag (second reign: 809/1406-815/1412)

Al-'Adil al-Musta'in bi-lah Abi al-Fadl al-'Abbas (r. 815/1412)

Al-Mu'ayyad Sayf al-Din Shaykh (r. 815/1412-824/1421)

Al-Muzaffar Shihab al-Din Ahmad (r. 824/1421)
Son of al-Mu'ayyad Shaykh.

Al-Zahir Sayf al-Din Tatar (r. 824/1421)

Al-Salih Nasir al-Din Muhammad (r. 824/1421)
Son of Tatar.

Al-Ashraf Sayf al-Din Barsbay (r. 825/1422-842/1438)
He invaded the Island of Cyprus taking control of the capital city Nicosia in 830/1426.

Al-Zahir Sayf al-Din Jaqmaq (r. 842/1438-857/1453)
He sought a truce and set out a treaty with the Knights Hospitallers of the Order of Saint John of Jerusalem, based on the Island of Rhodes.

Al-Mansur Fakhr al-Din 'Uthman (r. 857/1453)
Son of Jaqmaq.

Al-Ashraf Sayf al-Din Inal (r. 857/1453-865/1461)

Al-Mu'ayyad Shihab al-Din Ahmad (r. 865/1461)
Son of Inal.

Al-Zahir Sayf al-Din Khushqadam al-Ahmadi (r. 865/1461-872/1467)
He was a Greek native unlike other sultans of Circassian origin.

Al-Zahir Sayf al-Din Yalbay (r. 872/1467)

Al-Zahir Tumurbagha (r. 872/1467)
Greek native.

Al-Ashraf Sayf al-Din Qaytbay (r. 872/1468-901/1496)
Apart from his unusually lengthy reign of 29 years, (most Sultans ruling for shorter periods), his reign was considered remarkable for its military victories. During his reign he had many buildings constructed in Cairo and other Egyptian provinces, Syria and *al-Hijaz*, many of which were characterised by their fine structure, delicate design, beauty and exquisite decoration.

Al-Nasir Nasir al-Din Muhammad (r. 901/1496-904/1498)
Son of Qaytbay.

Al-Zahir Qansuh Abi Sa'id (r. 904/1498-905/1499)

Al-Ashraf Ganbalat (r. 905/1499-906/1500)

Al-'Adil Sayf al-Din Tumanbay (r. 906/1500)

Al-Ashraf Qansuh al-Ghuri (r. 906/1500-922/1516)
A Sultan fascinated by architecture and the fine arts. He was assassinated in 922/1516 at the age of 76 at the Battle of Marj Dabiq, to the north of the city of Aleppo, against the Ottoman Sultan Salim.

Al-Ashraf Tumanbay (r. 922/1516-923/1517)
Last Sultan of the Mamluk State, he only governed for three months. On the orders of the first Ottoman Sultan to enter Egypt, he was hanged from Bab Zuwayla.

HISTORICAL, SCIENTIFIC AND LITERARY PERSONALITIES

'Ala' al-Din Aqbugha, Amir
Ustadar under Sultan al-Nasir Muhammad Ibn Qalawun, he founded the Madrasa al-Aqbughawiyya in the Mosque of al-Azhar.

'Ala' al-Din Taybars, Amir
Captain of the armies and *khaznadar* during the reign of Sultan al-Nasir Muhammad Ibn Qalawun, he founded the Madrasa al-Taybarsiyya in the Mosque of al-Azhar.

'Abd al-Rahim al-Qina'i
A descendant of al-Husayn Ibn 'Ali Ibn Abi Talib, cousin and son-in-law of the Prophet Muhammad. He was born in 521/1127 in the city of Targa, Ceuta, and settled in the city of Qina', in Upper Egypt.

Abu al-Mahasin Ibn Taghri Bardi (812/1409-874/1470)
On the death of his father (815/1412), atabek in 810/1407 and viceroy (na'ib al-sultana) of Damascus, Abu al-Mahasin Ibn Taghri Bardi was raised by his sister and grew up surrounded by qadi (s:nda). In 836/1432, he took an active part in Barsbay's campaigns in Syria. A historian, he is author of: Manhal al-Safi', a biography of sultans and great amirs from 650/1248 to 863/1458; Al-Nujum al-zahira fi muluk Misr wa al-Qahira, the history of Egypt from 20/641 to the mid-9th/14th century; and the Hawadith al-Duhur, chronicling the economic and historical events of the years 845/1441 to 874/1469.

Ahmad al-Maqrizi (765/1363-845/1442)
Historian born in Cairo into a well-to-do family, he held several administrative posts and was a teacher and Imam. He lived for 10 years in Damascus and later in Mecca before returning to Egypt. One of his major works is; *Al-Mawa'iz wa-l-I'tibar fi-dhikr al-khitat wa-l-athar*, known as *Al-Khitat*, is on the topography of Fustat, Cairo and Alexandria and an overview of the history of Egypt. His history of the Ayyubids and Mamluks (*Al-Suluk li-ma'rifat duwal al-Muluk*) refers to economic factors. He also wrote on famine and inflation in Egypt.

Badr al-Din Hassan Nasr Allah
Under Sultan Barquq he held the post of *muhtasib* in Cairo, and during the reign of al-Mu'ayyad Shaykh he was in charge of the sultan's personal affairs, in particular, his residence and treasury. Under Sultan Jaqmaq in 842/1440 his possessions were confiscated.

Bashtak, Amir
Son-in-law of Sultan al-Nasir Muhammad Ibn Qalawun, he was one of the most influential *amirs* of his time.

Faruq I
Last King of Egypt, descendent of the family of Muhammad 'Ali, he acceded to the throne in 1936 at the age of 18 years, but was deposed following the military coup of July 1952.

Galal al-Din Abi al-Fadl al-Suyuti
Born in 849/1445, he is considered one of the most important writers of encyclopaedias on Islamic and Arab sciences.

Gawhar al-Lala, Amir
An emancipated slave, he was *lala* to the sons of Sultan Barsbay.

Gawhar al-Qunquba'i al-Habashi, Amir
Khaznadar of Sultan Barsbay.

Ibn Battuta (703/1304-767/1368?)
Moroccan traveller born in Tangiers comparable to Marco Polo. At the age of 21 years, he started a pilgrimage to Mecca, which led him to discover the Near East, the east coast of Africa, India, China (as far as Beijing) and the countries around the Volga. On his return to Morocco in 750/1349, he set off again in 753/1352-754/1353 towards regions to the south of the Sahara: Mali, Timbuktu, Aïr (Nigeria). Towards the end of his life, he dictated the tale of his studies to a learned man named Ibn Juzay, who finished the work in 757/1356.

Ibn Iyas
Historian of the Ottoman conquest of Egypt and educated in the City of Cairo, he is renowned for his knowledge in science and literature. He wrote *Bada'i' al-zuhur fi waqa'i' al-dhuhur*, which deals with the events of the 16 years of government of Sultan al-Ghuri, the last monarch of an independent Egypt.

Ibn al-Nafis
Egyptian academic, he put an end to the Greek Doctor Galenus' greatest mistake (pp. 129-201) on intraventricular communication, by discovering the principle of pulmonary haematosis in the $7^{th}/13^{th}$ century. Author of the encyclopaedia *al-Shamil fi al-tibb*.

Jaharkas al-Khalili, Amir
Amir *akhur* under Sultan Barquq.

Mamay al-Sayfi, Amir
Muqaddim alf (Commander of a troop of a thousand soldiers) of the Mamluk army under Sultan al-Nasir Muhammad Ibn Qaytbay.

Manjak al-Silahdar, Amir
Amir *al-silah* in the reign of Sultan Hassan Ibn Qalawun.

Muhammad 'Ali (r. 1220/1805 and 1265/1849)
Succeeded to the throne in Egypt in the name of the Ottoman Caliphate of Turkey and is considered the true founder of modern Egypt.

Muhammad Ibn Bilik al-Muhsini
Supervised the building of the Madrasa of Sultan Hassan.

Qanibay al-Sayfi, Amir
Amir *akhur* under Sultan al-Ghuri.

Qurqumas, Amir
Delegate to Sultan al-Ghuri and *atabek*, he died in 916/1510.

Qusun, Amir
Held the post of *saqi* and married one of the daughters of Sultan al-Nasir Muhammad Ibn Qalawun.

Salar, Amir
Held a key post during a difficult period at the beginning of the 8th/14th century and was stoned to death in 709/1310.

Sarghatmish, Amir
Atabek under Sultan Hassan, his success awoke a hostile reaction in the sovereign who had him assassinated in 759/1358.

Shaykhu, Amir
One of the *amirs* of Sultan al-Nasir Muhammad Ibn Qalawun, he assumed supreme control of the armies. Assassinated in 759/1357.

Shihab al-Din Abi al-'Abbas
Became famous for *Kitab al-istibsar fima tudrikuhu al-absar*, his scientific treatise on the rainbow. He died in 984/1285.

Shihab al-Din Ahmad Ibn Tuluni
An architect, he is behind many Mamluk buildings such as the khanqa and Madrasa of Sultan Barquq.

Singar al-Gawli, Amir
He held several posts in Egypt and her provinces under the reigns of Sultan al-Mansur Qalawun and his son Muhammad. During the reign of the latter, he was named delegate to the Sultan and governor of Jerusalem, Nablus, Galilee and Gaza, cities in which he had numerous mosques built. He died in prison in 745/1344.

Taghri Bardi, Amir
Governor of Aleppo, he was the *atabek* who invaded the Crusader kingdom of Cyprus during the reign of Sultan Barsbay. He died, assassinated at the hands of the Mamluks, not long after having been named great *dawadar* to Sultan Jaqmaq.

Al-Tunbugha al-Maridani, Amir
Son-in-law of Sultan al-Nasir Muhammad Ibn Qalawun, he held the post of *saqi* and went on to govern Aleppo.

Yashbak min Mahdi, Amir
Atabek under Sultan Qaytbay.

FURTHER READING

ARNOLD, T. W., *Preaching of Islam. A History of the Propagation of the Muslim Faith*, Westminster, 1896.

ATIL, E., *Art of the Mamluks*, Washington, 1981.

BARRAU-DIHINO, L., "Deux traditions sur l'expédition de Charlemagne en Espagne" from *Mélanges d'Histoire du Moyen Âge offerts à M. Ferdinand*, Paris, 1925, pp. 169-179.

BREND, B., *Islamic Art*, London, 1991.

CLOS, A., *L'Egypte des mamelouks. L'empire des esclaves (1250-1517)*, Paris, 1996.

CRESWELL, K. A. C., *The Muslim Architecture of Egypt*, vol. II, Oxford, 1959.

DENOIX, S., *Décrire Le Caire Fustat-Misr d'après Ibn Duqmaq et Maqrizi. L'histoire du Caire d'après deux historiens égyptiens des XIV^e-XV^e siècles*, Cairo, 1992.

Description de l'Égypte published by the order of Napoleón Bonaparte, AAVV., Cologne, 1994.

IBN AL-ATIR, A., *Annales du Maghreb*, trans. and notes by Fagnand, Algiers, 1898.

IBN BATTUTA, M., *A través del Islam*, intro., trans. and notes by Serafín and Federico Arbós, Madrid, 1987.

IBN BATTUTA, M., *Travels in Asia and Africa: 1325-1334*, trans. and selection by H. A. R., Gibb, London, 1983.

IBN BATTUTA, M., *Voyages d'Ibn Batoutah*, Arabic text with translation by C. Defrémery and B. P. Sanguinetti, Paris, 1914-1926. Reprint of the 1854 edition, Paris, 1969.

IBN IYAS, *Le journal d'un bourgeois du Caire*, trans. and notes by G. Wiet, Paris, 1955.

IBRAHIM, L., *Mamluk Monuments of Cairo*, Cairo, 1976.

LEWIS, B., *The World of Islam*, London, 1976.

LEZINE, A., "Les Salles Nobles des Palais Mamelouks", *Annales Islamologiques*, 10, 1972.

MAQRIZI, A., *Al-Maqrizi wa-l-I'tibar fi dhikr al-khitat*, annotated translation of the text by Maqrizi by A. Raymond and G. Wiet, Cairo, 1979.

MAQRIZI, A., *Al-Maqrizi's Book of contention and strife concerning the relation between the Banu Umayya and Banu Hashim*, Manchester, 1980.

MOSTAFA, M., "Miniature Paintings in some Mamluk Manuscripts", *BIE*, 11, 1970-1972.

PAPADOPOULO, A., "Religious Architecture in Egypt under the Mamluks", *Azure* 7, 1980.

Prisse d'Avennes, *Islamic Art in Cairo*, Cairo, 1999.

RAYMOND, A., *Le Caire*, Paris, 1993.

REVAULT, J., and MAURY, B., *Palais et Maisons du Caire du XIV^e au XVIII^e siècle*, 3 vols., Cairo, 1975-1979.

ROBERTS, D., *Yesterday and today Egypt*, lithographs and diaries by David Roberts, R.A. texts by Fabio Bourbon, Cairo, 1996.

WIET, G., *Les Mosquées du Caire*, Paris, 1966.

AUTHORS

Gaballah Ali Gaballah

He studied Egyptian Antiquities at the University of Cairo and was awarded his Doctorate at the University of Liverpool, England. He taught for a long time in women's education at the University of Cairo until being named Dean of the Faculty of Antiquities of the same University. He is Secretary General of the Supreme Council of Antiquities and a member of numerous national and international organisations. Author of five books and over 20 studies, he was awarded the National Prize for History and Antiquities and the Honorary Award for the Science and Arts of Egypt.

Abdullah Abdel Hamid El-Attar

Born in 1943, he graduated from the Arts Faculty of the University of Cairo in 1966 and wrote his dissertation on Islamic Antiquities in 1976. Since graduating, he has worked at the Supreme Council of Antiquities in the field of archaeological excavations and the renovation of Islamic monuments in Cairo. He has taken part in conferences and belongs to the executive department of ICCROM. Abdullah has travelled to Morocco, Spain, Japan, Brunei, Syria, Jordan, Palestine and Qatar and he is currently Under-secretary of State for Coptic and Islamic Monuments at the Supreme Council of Antiquities.

Mohamed Abd El-Aziz

Born in 1942, he obtained his university diploma in Islamic Antiquities at the University of Cairo, where he finished his BA and Doctorate in the same specialist subject. He is currently Director General of Coptic and Islamic Monuments in the Supreme Council of Antiquities. Mohamed has written several works on the antiquities of Lower Egypt where he has worked for a long time.

Salah El-Bahnasi

Born in 1951, he specialised in Art and Islamic Antiquities, and was awarded his Doctorate in the same discipline at the University of Cairo in 1994. He has considerable experience in the renovation and conservation of Islamic antiquities. Salah is currently lecturer in the Faculties of Arts and Fine Arts at the University of Al-Minya, and at the Higher Institute for Hostelry and Tourism in Giza. The author of numerous research papers and studies on Islamic art, he has also written several books on the Islamic antiquities of Egypt and of other Arab countries.

Mohamed Hossam El-Din

Born in 1955, he graduated from the Faculty of Antiquities at the University of Cairo in 1977 and was awarded the highest honours in his Doctorate at the University of Asyut in 1994. In the field of education, he has worked as a teacher and advisor at the North American Centre for Research in Cairo. He has worked on numerous archaeological excavations and on projects for the renovation of monuments, documentation and publication, and since 1982 on Islamic antiquities. He has published several books, among them are *Khan al-Khalili* and *Rosetta: founding, flowering and decadence*.

Medhat El-Menabbawi

Graduate of the Arts Faculty of the University of Cairo where he studied Coptic and Islamic Antiquities, he has broad experience in archaeological excavations, renovation of monuments, and scientific research. Medhat is Director General of the Northern area of Cairo for the Supreme Council of Antiquities and a member of several committees of the Supreme Council of Culture. He has written over 50 studies and essays.

Atef Abdel Hamid Ghoneim

Born in 1944, he graduated from the Faculty of Arts at the University of Alexandria in 1976. Throughout his professional life he has been involved with museums and has given many conferences for young people on raising awareness of history. He has travelled to many countries accompanying Egyptian archaeology exhibitions and is currently Director General of the Archaeological Museum of the Supreme Council of Antiquities.

Ali Ateya

Born in 1949, he obtained his diploma in Islamic Antiquities at the University of Cairo in 1975. He has broad experience in archaeological excavations and in the renovation of monuments through his work with various foreign archaeological expeditions to Giza and Wadi Natrun. He is Director General of the Supreme Council of Antiquities.

Tarek Torky

Born in 1960, he obtained his Diploma in Islamic Antiquities at the University of Cairo in 1982. He has worked in the Centre for Documentation of the Supreme Council of Antiquities since 1987 and is currently Inspector of Antiquities and Assistant Secretary to the Permanent Committee of Antiquities at the Supreme Council of Antiquities.

Gamal Gad El-Rab

Born in 1965, he graduated in Aesthetics at the Arts Faculty Department of Islamic Antiquities, University of Asyut. He has worked on training programmes in antiquities for secondary schools organised by the Supreme Council of Antiquities. He currently works as an Inspector of Antiquities at the Citadel.

ISLAMIC ART IN THE MEDITERRANEAN

This International cycle of Museum With No Frontiers Exhibitions permits the discovery of secrets in Islamic Art, its history, construction techniques and religious inspiration.

Portugal

IN THE LANDS OF THE ENCHANTED MOORISH MAIDEN: Islamic Art in Portugal

Eight centuries after the Christians reconquered their lands from the Muslims, towns of the ancient "Gharb al-Andalus" (western Andalusia) have preserved the Legend of the beautiful enchanted Moorish maiden whose spell was broken by a Christian prince; the artistic route of Muslim presence in Portugal also expresses, through a subtle interdependence between constructive techniques and decorative programs, popular regional architecture. The exhibition gives the visitor a clear view of five centuries of Islamic civilisation (the Caliphate, Mozarabic, Almohade and Mudejar Periods). From Coimbra in the confines of the Algarve, palaces, Christianised mosques, fortifications and cities all of which affirm the splendour of past glories.

Turkey

EARLY OTTOMAN ART: Legacy of the Emirates

Highlighting this exhibition are the works and monuments most representative of the finest period of western Anatolia, the cultural and artistic bridge between European and Asian civilisations. In the 14th and 15th centuries, the transition to a Turkish-Islamic society led artists of the Turkish Emirate to elaborate on a brilliant artistic union culminating in Ottoman art.

Morocco

ANDALUSIAN MOROCCO: Discovery in Living Art

From the beginning of the 8th century, Islamic Moroccans looked beyond the Pillars of Hercules (Gilbraltar) and settled in the Iberian Peninsula. From then on, both shores shared the same destiny. From continual cultural, social and commercial exchange animating this extreme of the Maghreb for more than seven centuries, sprang one of the most brilliant facets of Muslim civilisation. Authentic Hispano-Maghreb art left its stamp not only on resplendent, monumental architecture, but also in the characteristics of the cities and traditions of extreme refinement. The exhibition reflects the historic and social wealth of the Andalusi (Andalusian) civilisation in Morocco.

Tunisia

IFRIQIYA: Thirteen Centuries of Art and Architecture in Tunisia

Since the 9th century, without breaking with traditions inherited from the Berbers, Carthaginians, Romans and Byzantines, Ifriqiya was able to assimilate and reinterpret influences from Mesopotamia, through Syria and Egypt, and from al-Andalus (Andalusia). This is a unique form of syncretism, of which numerous vestiges prevail even today in Tunisia, from the majestic residences of the Muslim sovereigns in the capital, to the architectonic rigor of the "Ibadism of Jerba".

The visitor is invited to look at existing *ribats,* mosques, *medinas, zawiyas* and *gurfas* (large rooms containing bedroom suites) to witness their imprint on a land abounding with history.

Spain I- Andalusia, Aragon, Castilla La Mancha, Castille and Leon, outskirts of, Madrid
MUDEJAR ART: Islamic Aaesthetics in Christian Art
The art of the Mudejars (Muslim population remaining in Andalusia after the Reconquest) has an unquestionably unique place among all expressions of Islamic art. It deals with the visible manifestation of a splendidly cultured cohabitation with a unique understanding between two civilisations that, in spite of their political and religious antagonism, lived a fructiferous artistic romance. Applying schemes, although rigorously Islamic, the Masters of Works and Mudejar artisans, famous for their outstanding knowledge in the art of construction, erected for the newly arrived Christians innumerable palaces, convents and churches. The selected works, chosen for their variety and abundance, testify to the exuberant vitality of Mudejar art.

Jordan

THE UMAYYADS: The Rise of Islamic Art
Following the Arab-Muslim conquest of the Middle East, the seat of the Umayyad Dynasty (661-750) was moved to Damascus, where the new capital inherited a cultural and artistic tradition dating back to the Aramaean and Hellenistic Periods. Umayyad culture benefited by this move from the frontier between Persia and Mesopotamia and between the countries of the Mediterranean world. The position was favourable for the emergence of an innovating artistic language, in which a subtle mixture of Hellenistic, Roman, Byzantine and Persian influences, produced architectural order and decorative originality. Through the diversity of the works presented, the exhibition also offers the opportunity to reflect on the Iconoclast phenomena.

Egypt

MAMLUK ART: The Splendour and Magic of the Sultans
Under Mamluk domination (1249-1517), Egypt became a prosperous commercial route-crossing centre. Great riches came to the country. Cairo was one of the most powerful, secure and stable cities of the Mediterranean basin. Scholars from all over the world came to settle there, attracting their followers and students. Mamluk architecture and decorative art displays the vitality of commerce, the intellectual energy and the military and religious force of this period. Characterised by elegant and vigorous simplicity, the purity of line is similar to modern models. The works selected between Cairo, Rosetta, Alexandria and Fua represent the height of Mamluk art.

Palestinian Authority

PILGRIMAGE, SCIENCE AND SUFISM: Islamic Art in the West Bank and Gaza
During the reigns of the Ayyubid, Mamluk and Ottoman Dynasties, numerous pilgrims, from all over the Muslim world came to Palestine. This dynamic tide of religious fer-

vour gave a decisive impulse to the development of *Sufi* thought, through the *zawiyas* and *ribats,* which multiplied all over the country. Various study centres welcomed the most distinguished scholars. In this way, they obtained considerable prestige and conditions became favourable for the expansion of refined art, which conserves its power to fascinate, even today. The monuments and Islamic architecture proposed for the exhibition clearly reflect these great dimensions of pilgrimages, science and sufism.

Italy - Sicily
ARAB-NORMAN ART: Islamic Culture in Medieval Sicily
An Island in the middle of the Mediterranean, Sicily is a land of encounter, where various cultures have coincided and adjusted mutually, reaching a new harmony. Unique in the European panorama, Arab-Norman architecture, relatively speaking, is different from that found in the Islamic world. The exhibition presents it from the standpoint of its uniqueness and provides some codes for interpretation permitting better identification. An attentive visitor will better appreciate the admirable fusion of elements, originating from Byzantine, Arab and Norman cultural spheres, employed in this art, which is as original as it is refined.

Algeria
WATER AND ARCHITECTURE IN THE DESERT: The Pentapolis of the Mzab
More than 1000 years ago, 600 km. south of Algeria, the Capital, a structured urban nucleus was founded, which with time and the enormous tenacity of its inhabitants, became the present Mzab. The Ibadites settled there at the beginning of the 9th century when it was an inhospitable, extremely arid desert region. Between 1012-1353, they constructed five cities with a sophisticated irrigation system. Inspired by a rigorous philosophy rejecting ostentation and superficiality, Ibadite architecture produced authentic masterpieces of such pureness and so functional in nature that it inspired masters like Le Corbusier. The exhibition permits one to discover the exemplary management of space and water through the history of the Pentapolis.

Spain II- Catalonia
ISLAM IN CATALONIA: A Cultural Pivot in the Border Region
As a product of the expansion of Carolingian countries toward Islamic Andalusian territories, Catalonia was born on a frontier, in an area where mutual fertilisation of two cultures became evident. The innumerable castles and towers located on the fringes of bordering Islamic territories witnessed not only the conflictive nature of the residents, but also cultural interchange and reciprocal influences, traces of which are patent in the architecture, gardens and decoration, and also in the linguistics and the toponymy and even some popular traditions today. The proposed trail underlines these particulars and shows examples of neo-Arab architecture such as those produced by the Catalan architect Antonio Gaudi, a renowned architect of the 20th century.